Designing Interactive Digital Media

Nick Iuppa

Focal Press
Boston • Oxford • Johannesburg • Melbourne • New Delhi • Singapore

Focal Press is an imprint of Butterworth–Heinemann.
Copyright © 1998 by Butterworth–Heinemann

 A member of the Reed Elsevier group

All rights reserved.

The materials set forth in this book are in no manner the opinion of or otherwise endorsed, approved, and/or the responsibility of Viacom Inc., Paramount Pictures Corp., Paramount Digital Entertainment or any of their affiliated companies.

No part of this publication may be reproduced, stored in a retrieval system, or transmitted in any form or by any means, electronic, mechanical, photocopying, recording, or otherwise, without the prior written permission of the publisher.

∞ Recognizing the importance of preserving what has been written, Butterworth–Heinemann prints its books on acid-free paper whenever possible.

 Butterworth–Heinemann supports the efforts of American Forests and the Global ReLeaf program in its campaign for the betterment of trees, forests, and our environment.

Library of Congress Cataloging-in-Publication Data
Iuppa, Nicholas V.
 Designing interactive digital media / Nicholas V. Iuppa.
 p. cm.
 Includes index.
 ISBN 0-240-80287-X (pbk.: alk. paper)
 1. Interactive multimedia. 2. Digital video. I. Title.
QA 76.76.I59I97 1997
006.7—dc21 97-3003
 CIP

British Library Cataloguing-in-Publication Data
A catalogue record for this book is available from the British Library.

The publisher offers special discounts on bulk orders of this book.
For information, please contact:
Manager of Special Sales
Butterworth–Heinemann
225 Wildwood Avenue
Woburn, MA 01801-2041
Tel: 617-928-2500
Fax: 617-928-2620

For information on all Focal Press publications available, contact our World Wide Web home page at: http://www.bh.com/focalpress

10 9 8 7 6 5 4 3 2 1

Printed in the United States of America

Designing Interactive Digital Media

Contents

About the Author ix

PART I: BACKGROUND AND OVERVIEW 1
 1 The Possibilities 3
 2 Digital Victory 7
 3 Interactive Television 13
 4 The Internet 19
 5 Pushing Technology 25
 6 CD-ROM 29

PART II: TOOLS OF THE TRADE 37
 7 Interactive Design 39
 8 Design Documents 43
 9 Flowcharts and Site Maps 53
 10 Human Interface Design 65
 11 Prototyping 73

PART III: INTERACTIVE INSTRUCTION 87
 12 Basic Structure 89
 13 Exercise Design 97
 14 Compendium of Interactive Learning Exercises 115
 15 Test Construction and Evaluation 125

PART IV: INTERACTIVE ENTERTAINMENT — 133
 16 Basic Structure — 135
 17 The Adventure! — 141
 18 Comics and Games on the Internet — 151
 19 Game Shows — 157
 20 Special Development Tools for Motion and Animation — 163

PART V: OTHER INTERACTIVE APPLICATIONS — 167
 21 Corporate and Informational Web Sites — 169
 22 Commerce Systems — 181
 23 The Virtual Immersive Experience — 195

 Index — 203

To

Ginny,

for years of helping me chase those
interactive rainbows

Case sat in the loft with the dermatrodes strapped across his forehead watching motes dance in the diluted sunlight that filtered through the grid overhead. A countdown was in progress in one corner of the monitor screen.

And one and two and—Cyberspace slid into existence. . . .

—William Gibson, *Neuromancer*
1984

About the Author

Nick Iuppa is one of the premier designers of interactive media. His works include highly successful and award-winning games, instructional material, point-of-sale systems, and entertainment productions. He has worked for world-renowned entertainment companies, like Walt Disney Productions and Paramount Pictures, and Silicon Valley Giants, like Hewlett-Packard and Apple Computer.

After graduation from the University of Notre Dame and Stanford University with degrees in communication, Nick went to Hollywood to work with famed animation director Chuck Jones and celebrated children's author Ted Geisel (Dr. Seuss) on *How the Grinch Stole Christmas*.

Nick left Chuck Jones when MGM closed its animation unit and joined Walt Disney Productions. There he worked in the Disney Story Department on several award-winning television programs for *The Wonderful World of Disney*. Later, as a freelancer, Nick designed and wrote dozens of educational films, games, and multimedia kits for Walt Disney, including such best-selling series as *Winnie the Pooh and the Value of Things* and *Growing Up Healthy*.

Nick moved into the corporate world, where, as vice-president and head of creative services for Bank of America, he supervised the production of hundreds of instructional and educational videotapes and wrote and produced *People Skills*, one of the first major interactive video presentations used in corporate training.

Nick continued to mix entertainment, educational, and instructional programs as he designed and wrote a series of interactive video games and mysteries for Worlds of Wonder, the toy company that created Teddy Ruxpin, Laser Tag, and other toy sensations.

In 1983 Nick became vice-president of Media production at ByVideo, a creation of Atari founder Nolan Bushnell. The high-profile ByVideo Shopping Company brought Nick and his colleagues international recognition for their design of an automated, computerized shopping process.

In the 1980s and early 1990s Nick worked for both Apple Computer and Hewlett-Packard as a designer, writer, and manager of interactive media devel-

opment. His projects included interactive broadcasts, advanced learning simulations, and instructional games.

Recruited by Paramount/Viacom in 1993, Nick turned his attention to designing original stories and other content for Viacom Interactive Services. Still with Paramount today, Nick is vice-president and creative director at Paramount Digital Entertainment, where he designs and creates original entertainment programming and manages a staff of highly skilled designers, developers, and artists.

Nick has written four books on interactive media design and development. He also presented his theories on managing creative people in the humorous compendium entitled *Management by Guilt*, published by Fawcett.

Nick has been married for over 30 years to Virginia Iuppa, a junior high school teacher. They make their home in Northern California. Two of their three children also work for major developers of interactive media.

Background and Overview

1

The Possibilities

Very surprisingly, before the World Wide Web, CD-ROMs, or even digital video existed there was *interactive video*, an exciting, if unfulfilled, technology that was the precursor to audio compact discs and digital video discs (DVDs). It was delivered on laser discs that often carried computer control programming in the second audio channel of the disc itself. Interactive video is a good place to start our exploration of interactive digital media, perhaps for no other reason than it was there right at the start.

In the early 1980s, people looked at the interactive video they were flipping through on their laser discs and thought that it was digital. The thinking may have come from advertisements for laser discs or other media that tried to cash in on "digital," one of the great buzzwords of our times.

The truth is that the technology that laser discs used was digital. The video was not. Up until very, very recently no one was able to mass-produce high-quality video using digital technology—not in a way that could find a mass audience with the appropriate playback equipment waiting on the other end.

So, for over a decade, interactive video has been produced either in very primitive, low-quality, and limiting digital formats or in analog formats that allow users to manipulate only *chunks* of video in a rather "clunky" form of branching. The fact that interactive video pioneers had to resort to low-quality digital video or nondigital video to create interactivity may explain why the early forms of interactive video never really succeeded.

On another front, in the gaming industry, highly interactive digital formats that required *everything but video* were sharpening interactive graphic presentations and animation since the very birth of "PONG." If you twitched, the game reacted, and if you couldn't twitch fast enough, you couldn't win the game.

Nevertheless, these twitch games (in spite of their great popularity in an enthusiast's marketplace) were outside the monster markets that were capable of bringing boundless profits to companies engaging in, say, television. What seemed to be missing in twitch games was video, but every time game companies tried to bring real video (analog or digital) into their games it either slowed the game down too much or changed its character so completely that they were not able to achieve

the effects they wanted. As of now, there never really have been any true interactive *video* games with mass market success.

So far, the ten or more years of work that have gone into creating analog interactive video or limited digital interactive video have made us more and more frustrated, but still more and more aware of the design possibilities that true digital media technology will eventually bring. At last it seems we know exactly where we can go given the right technology.

And that brings us to the very topic of this book. We will look at the design of interactive digital media, the formulas and formats that have been discovered since the mid-1980s, and show how they can guide us to better use of the new fuller, richer media we now possess.

WHAT THIS BOOK WILL DO

This book will review the various digital media and their uses, placing a renewed emphasis on their ability to offer *interactivity*. We will also clarify the definition of digital media to mean more than animation, television pictures, and movie clips and begin to give serious attention to 3D environments, communications technologies, PUSH technology, high-resolution graphics, and the extreme importance of digital audio. Without getting too technical, we will look at digital video technology and see how the expansion of the capabilities of video imaging allows for greater and greater interactivity.

We will also look at the formats and formulae that have evolved since the mid-1980s, what they have taught us, and how they fit into the new capabilities that have opened up. We will study the latest delivery mechanisms for interactivity and digital media, from the World Wide Web, to CD-ROMs, to the new DVD technology, even virtual environments, and we will see how the accelerating evolution of those technologies has begun to shape the design and substance of interactive media itself. We will consider interactive television and see if, when, and where this most promising of all interactive media will arrive.

We will review some of the tools and practices of the trade of interactive design, including the creation of site maps and flowcharts and the writing of design documents. We will see how these latest forms of digital media can now be applied to entertainment, games, information systems, and education. And finally, one more time, we will look at where the whole business can take us.

But before we do any of that, to put things into true perspective, let's take a moment to look at the ultimate destination of interactive digital media. It was articulated brilliantly by Ray Bradbury in the early 1950s. I had a personal experience with that vision in a very unique way, and it is clear that I have never been the same since.

MY INTRODUCTION TO INTERACTIVE MEDIA

One of my earliest childhood memories is of a particular broadcast of the radio series *Dimension X*. I was about 6 years old. The story presented on the radio that

night was an adaptation of "The Veldt," an episode from the science fiction book *The Illustrated Man* by Ray Bradbury.*

I remember that my parents had gone out to the movies and left me alone in the house with a teenage babysitter and a great big console radio. What could I do when the girl picked up the phone and called her best pal to talk the night away? I turned on the radio.

The radio drama that was presented on *Dimension X* that night had to do with a futuristic house that offered its well-to-do owners the ultimate babysitter: a "PlayRoom" whose walls were floor-to-ceiling television screens. If the parents wanted to go out for the evening (as mine had so thoughtlessly done), they simply left their children behind to be taken care of by the latest media technology (as mine had also done).

The PlayRoom in that fabulous house had the technology to create dozens of different environments for children to play in. As far as I could tell, the children controlled their play environment by sending orders with their minds telepathically.

Of course it wasn't long before the little brother and sister in the story found their own favorite place to be (it happened to be my favorite place as well). It was sort of the domain of Tarzan, Jungle Jim, and Sheena Queen of the Jungle; it was the heart of darkest Africa, the African Veldt.

Needless to say, after the children's first night in the PlayRoom, the roaring of lions and trumpeting of elephants became common in the household. It kept the parents up every evening, and it wasn't long before they became concerned about the PlayRoom and the amount of time their children were spending there.

In the end, the parents even forbade their children to play there, locking the door and insisting that they were going to have the entire PlayRoom dismantled and sent back to the manufacturer. This, of course, is not the kind of thing that parents should do to children, at least not in a Ray Bradbury story.

Well, I was right in tune with the kids when they broke into the PlayRoom on the very last night it was part of the house. I was thrilled as they summoned up their favorite locale and saw again the prides of lions lounging in the sun and the herds of elephants lumbering across the plain. I was also in full support as they jumped out of the PlayRoom and slammed the door behind them, trapping their worried parents who had came running into their domain to see what was really going on. Remember, I, too, had been left alone to entertain myself while my parents went to the movies, and all I had to entertain me was a magical box (the radio) and the power of my own mind.

I won't spoil the story by telling you what happened to the parents as they came face to face with those elephants and lions. Instead I'll just say that the story does seem to be the best introduction any kid ever had to the concepts and the possibilities of interactive digital media.

In the story, the children were surrounded by a virtual immersive experience. Moreover, to some degree, they controlled the sequence of events. However, they did not control the effects of their choices: the interactive system answered their

* Ray Bradbury, *The Illustrated Man* (New York: Doubleday & Co., 1958).

directives with responses of its own, much to the dismay of their parents, but to the great betterment of interactivity.

Because I heard this story when I was 6 years old and have had it in the back of my mind all my life, I find it hard to believe those critics and media experts who say the average person would rather sit passively and watch a drama than interact with a truly immersive experience. Obviously, their image of interaction (and maybe even drama) is different from mine.

Sure I'd rather watch TV passively than go through most of the kinds of interactivity that media producers have been serving up until now. But what about a simulation with the power of "The Veldt." I'm no longer of a mind to feed my parents to the lions, but I wouldn't mind sitting on a virtual beach at Kona, listening to the waves, watching the sunset, having the experience of my own personal paradise. I think I'd prefer that to the best episode of *Seinfeld* any day of the week. And I like *Seinfeld* a lot.

2
Digital Victory

It may seem almost unnecessary to talk about the shift from analog to digital video. The stage was dramatically set by the emergence of computers as movie production tools, the success of CD-ROM games, such as *Myst*, and the coming expansion of network television into digital broadcasting.

It seems like many people know some part of the story of the movement to digital. The problem is that everyone knows their own particular part of the story without understanding the whole. Moreover, there is a lot of confusion over various aspects of the coming of digital video. People, who, for example, know all about consumer electronics might confuse high-definition TV with digital video or laser discs with digital video. Others might know something about multimedia computers and so confuse analog video that runs in a window on a computer screen with digital video. Likewise there are those who are involved in the broadcast or cable TV industries and so confuse interactive television with digital video. So, for a brief moment let's look at what digital video is and what it is not and especially what digitization can bring to interactive video.

DIGITAL VIDEO ON TELEVISION

Anything digital exists because we are able to reduce it to components that are either ones or zeros. Computers work because every piece of information that exists in them has already been translated into sets of ones and zeros. Translating *video* into ones and zeros has the potential and the promise of giving us television with video images of a much higher quality than the current analog standard (though shortly we will see why this might not always be the case). Digital video also has the potential for creating a whole lot better broadcast system than the current NTSC system used to broadcast television pictures in America today.

Unfortunately, from a television broadcast point of view, making the move to digital television means replacing every single piece of functioning broadcast equipment with a new version that does things digitally. It is extremely

expensive, especially because it means replacing every single functioning TV set in the world as well. The current solution to the problem of introducing digital television without making everyone's TV set obsolete overnight is to create parallel TV channels. So, for example, today's NBC TV Network will exist as both Channel 4 NBC: Analog as it is now, and Channel X NBC: Digital with the same programming, but presented in a higher quality digital format. Then people can gradually buy digital TV sets over time and eventually NBC: Analog would just give way to NBC: Digital.

The plan for the emergence of digital TV as announced by the Federal Communications Commission (FCC) in April 1997 calls for digital TV to be offered by Christmas 1998, the parallel systems to coexist for 9 years, and the analog TV to be discontinued at that point. Consumers who can't afford the new digital TVs and VCRs can buy a $100 converter that will allow them to view digital TV on analog sets.

High-definition television (HDTV) is not necessarily the same as digital television, and in recent years TV set manufacturers have wanted to introduce nondigital HDTV that would have a wider screen aspect ratio and slightly better dots-per-square-inch resolution, but would still not offer the standard of quality that has been set for true digital TV. With TV set manufacturing standards so high that TVs seldom need to be repaired or replaced, this was a way for TV set manufacturers to offer a slight improvement in picture quality to spur sales. This nondigital HDTV might have also delayed the introduction of true digital TV. Fortunately for consumers, cooler heads and government regulation prevailed and the TV manufacturers were told something to the effect of "let's make this switch once and only once, okay?"

The result is the current plan to phase in digital TV. Currently the FCC is allowing an even higher definition form of TV to be offered by stations that want to go beyond the quality standards of digital video. In the future the term *HDTV* will be reserved for that ultra-high-quality form of digital video that goes beyond the quality requirements of digital TV as set by the FCC.

DIGITAL VIDEO ON COMPUTERS

All video that appears on digital television will, of course be digital video; but just to complicate things, digital video already exists and is already everywhere, but not on television, of course. It exists on computer screens, on CD-ROMs, on floppy disks, and of course, on the Internet.

Putting digital video on computers complicates things because doing so brings up all kinds of technical issues, such as the size of the picture, the size of the computer's memory, the size of each movie file, the speed of the computer, and the access speed from the delivery mechanism (Internet or CD-ROM.) To deal with these issues of speed and size digital video had to be compressed.

The easiest way to understand video compression is to think of a strip of video as a series of pictures some parts of which change, some parts of which don't. In a video of Yosemite Falls, the granite cliffs stay the same, the falling water moves. Analog pictures paint the whole picture in every frame. Digital video remembers the parts of the picture that don't change and doesn't bother to paint them on every frame; instead, it only changes the parts of the picture that do change, in this case the falling water.

It seems clear that setting up a system that remembers some parts of pictures but not all of them would take a lot of computing power, and it does, but miraculously computer companies have been working diligently on this digital video compression and have gotten better and better at it.

The super high quality that you would expect to get from a digital video was immediately whittled down by issues of computer speed, size, and compression so that the earliest compressed video looked like somebody's scratchy old home movies shown on a rickety, old, "out-of-sync" projector.

Fortunately, once a working digital video compression architecture was put in place for computers (one of the earliest and best was Apple Computer's QuickTime; the one that will eventually be the standard is MPEG, whose specifications were established by the Motion Picture Experts Group), the next step in the task was to restore the quality of the video image so that compressed digital video looked more and more like analog video tape. Little digital movies that looked like flickery slide shows were improved and improved until now, again depending on your computer, they can be compared with first-generation VHS tape.

As compression quality gets even better, media producers are hoping that soon they will be able to compare digital video with what is really the standard for high-quality screen images in the entertainment industry, 35-mm movie film. And as the process of digitization and compression gets better and better on computers, the technology is getting so good that it is finally meeting the expectations of distributors of entertainment media who are ready, once again, to offer compressed digital video as a new delivery medium to consumers.

After a decade of trying and failing with various kinds of video disc technologies, Sony, Phillips, and the rest of the video technology companies finally feel that they have a digital video disc format that will capture the attention of the mass market the way audio compact discs have done. They call this new technology digital video disc (DVD).

DIGITAL VIDEO DISC

Digital Video Disc is a digital format of laser technology that offers greatly expanded data storage capabilities (4.7 gigabytes, up to 133 minutes of high-quality motion pictures on a single side of a disk). There are many implications of this integrated solution for video, audio, and computer data. One way to think of it is

to imagine a compact disc that offers all the advantages of laser discs (including exceptionally high-quality video images and sound) plus all the advantages of digital video.

What are the advantages of digital video other than the fact that it can be delivered to the computer or sent over the Internet? Well, digital video images or movie frames, if you want to think of them as such, even if reconstructed by the memory of the computer from parts of previous scenes, exist in files and are called up from and put back into those files. They don't exist as sequential images on a strip of film or tape. That means you don't have to play linearly to get from one to the other. And you don't have to jump around through time and space to get from image #1 to image #7,368, either. You get instant access to any frame at any time.

Better yet, because those images are digital and are only made up of ones and zeros, they are broken down into their most basic elements so you can change parts of any one frame or of many frames. You can download them onto your computer where you can use software to take them apart and put them back together again. You can do it on a routine basis. You can take that background of the Serengeti Plain and add lions on top of it sometimes and not at other times. You can send elephants rumbling across the hill, or not. You can lay a giant map graphic on top of everything and show where you would have to travel to traverse this part of the veldt. You can manipulate digital images to the extent that your skills, software, and your computing power will let you. And with the right computer, that's a lot.

This ability to play with images, to create new ones, to lay them on top of each other, to assemble parts of images onto other parts of images, and keep things changing all the time is one of the advanced functions of DVD that we will talk a lot about soon. But even the more basic functions of DVD are very nice.

Basically, DVD lets you do simple things, such as change the audio track of a movie, not to a different language but to one of eight of different languages. It also allows you selectively to skip scenes so that you can, for example, set your player to R, PG-13, or PG versions and skip over the parts of the movie you don't want your young children to see (parental lockout).

You can change the point of view of any one scene from a long shot to a close-up with up to nine different angles so you could, for example, change camera angles in a DVD of the Superbowl. (Why should some sports show director force me to watch a long shot when I want to focus on Steve Young instead of the whole San Francisco offense?)

Now I can also focus on Madonna up close and personal in the DVD of one of her concerts, or look at the whole stage, or focus on her funky guitar player or on the crowd. This "You be the Director" feature of DVD may prove to be one of the most enjoyable and entertaining. After all there isn't much difference between channel surfing and camera angle surfing. Flipping around within a DVD show may be far more rewarding than flipping around between channels, and it is every bit as couch potatoish.

DVD has built-in copy protection. So, you can't buy a movie on DVD and bang out a duplicate for your sister in Duluth and your mother in Tampa. That point may not appeal to you or me, but it does appeal to the movie producers, and, because it will allow them to sell you every movie for about $25, you'll probably buy three copies and give them away rather than take the time and energy to copy them.

Here's another point. Because DVD is digital, lots of digital graphics can be added to the video pictures. In a deluxe version of a DVD football game, for example, viewers will be asked to predict the plays that will be called, the user's "correct call total" will appear on a virtual scoreboard in a real-image ballpark. There also will be stats there and information that Mr. and Ms. SportsFan have asked for specifically.

Above and beyond all this, DVD offers the challenge of interactive storytelling, a new art form that is a major step in the direction of virtual immersive experiences like the PlayRoom. That's where the greatest challenge lies, where the greatest opportunity lies, and that may just be the ultimate payoff of the technology.

3

Interactive Television

Interactive Television (ITV) sprung up early as a mutation of the media technological revolution. It got an early start because cable companies, TV networks, and telephone companies were fighting to see who would become the leader in delivering TV programming to millions of TV viewers all over the country and all over the world. What was new, what was worthwhile? What could give one group of companies an advantage over their competitors? These three sets of corporate giants needed to know. They saw it as a survival issue, not only because of the competition but because of one historical lesson that was too recent to forget.

THE NEAR-DEATH OF THE MOVIES

The TV networks and cable companies remembered the early days of TV and what happened to the movie industry as a result of TV's arrival. Movies were the rulers of the entertainment industry in the 1920s, 1930s, and 1940s. But in the early 1950s television started to emerge and took a giant sized bite out of movie profits. Foolishly the leading moviemakers (with a very few exceptions) decided to treat TV as a rival. In spite of the fact that the movie industry had vast experience with the very processes that went into TV production, the movie companies decided to fight television rather than embrace it. This fight took place in the courts, in advertising and marketing, and in any other public forum that would listen. Throughout the 1950s, the movie industry lost business, lost skilled workers, and almost lost its very existence to an alternative technology that delivered what should have been its own products.

 As profits shrank, new movie technologies, such as Cinemascope, 3D, and VistaVision proved weak ammunition in the battle against the major benefit that TV offered. The benefit, of course, was convenience. People would rather have a smaller entertainment picture, a black-and-white picture, a fuzzy picture, if they could get it just by walking into the other room, flipping a switch, and rolling into their favorite easy chair.

Decades later, when the movie industry recognized the error of its ways and began to gain a greater and greater foothold in the TV business, they vowed never to make the same mistake again. They also vowed that, if any reasonable new technology ever began to emerge again, even if they didn't understand it, they would try to play some part in it, just in case the new technology turned out to be the alternate delivery mechanism that TV turned out to be in the 1950s.

Nurturing new technologies is a nice vow, but one that takes a lot of money and goes against the "survival" instincts of most species, especially corporate executives. So, very soon both network TV and the movie industry failed to recognize the opportunity of cable TV and treated it, too, as an adversary rather than a partner. In the early 1990s the cable wars were drawing to a close and interactive TV looked as if it might be the next big battleground. For once the rival industries decided to work together.

A HOST OF PLAYERS

Actually there were more participants in the interactive TV game than there were in the afore-mentioned battle between television and the movies because so many different kinds of companies could benefit from the emergence of interactive TV (ITV).

Phone companies were banned from owning cable networks in the states in which they operate. Yet with their vast delivery resources and services, phone companies would make an ideal operator of cable TV services to the home. Cable companies know this and it scares them. A few regulatory changes and their world could be very different.

The TV networks, still smarting from their efforts to survive the arrival of the cable industry, also recognize that the phone company could take all the business away from the cable companies and present a newer, more powerful adversary. Phone companies in the cable business would change the face of television so completely that the very existence of the TV networks could be at risk again.

Meanwhile movie companies have been looking for better and better ways into the TV market. Fox, Paramount, and Warner Brothers finally started their own networks. They also wondered about other things they could do to improve their position.

TV manufacturers, such as Sony (which already owned a movie studio), were interested in anything that will help them sell more TVs and improve their power within the entertainment industry; ITV looked promising to them.

Finally, to top it all off, a new player arrived, the computer companies (software and hardware), who saw golden opportunities to use computer technology to improve interface design (making everything easier for consumers to use). They also saw a way to get into the glamorous movie business.

So, for a lot of reasons cable companies, TV networks, phone companies, movie studios, manufacturing giants, and computer hardware and software companies all said to themselves, "We don't know what this interactive TV stuff is, but we have to participate in it, study it, and make sure that we don't miss the boat if it becomes a big success."

BANDWIDTH

To some degree interactive television (ITV) is two things, a new form of TV delivery and a new art form that affects programming and its content. In both cases one of the key technical issues is bandwidth. Bandwidth, again in nontechnical terms, relates to the amount the broadcast band any given medium uses and any given distribution mechanism provides.

Cable TV companies have mighty rivers of bandwidth. They put a big, broad coaxial cable right into your home like a great big pipe that spills the most demanding, least efficient of all media types (analog video) right into your living room. Phone lines offer very little bandwidth, but then it takes very little bandwidth to send and receive analog voice signals.

As noted, video is the most demanding of all media. To stay with our pipeline or river metaphors, it is Niagara Falls pounding out mega-gallons of signals that need mightily rivers or huge pipelines to carry it. To be useful carriers of video, telephone companies (with their rivulets of bandwidth) had to find ways to make video bandwidth smaller while going through the laborious process of expanding their delivery system from narrow pipes to giant aqueducts.

A similar problem applied to computer companies who were faced with the fact that video processing takes up vast amounts of computer memory and very fast computer processors. So, while computer companies made faster processors and machines with more and more memory, they, too, looked for more efficient ways to deal with video images.

The problems really are compounded when the limitations of phone lines run into the limitations of computing power right on the desktop of the average consumer. It happens every day in the world of the Internet. Delivering video to your desktop over phone lines and then having it play on your computer is really still one of the most demanding things that you can try to do. Analog video has to be made smaller; it has to be compressed. As we have said, when video is compressed, it doesn't take the mighty Mississippi to get it where it is going. And it's easier for computers to process. But something else happens, too. As noted, the way to compress video is to digitize it, turn it into digital sound and picture, but, amazingly enough, when you do that the digital video suddenly becomes capable of all the advantages of digitization, image manipulation, random access, response generated by artificial intelligence. In other words, this whole drive to compress video also gives it the ability to be very

interactive. Around 1992, the entertainment industry and all those who supported it decided that this was something they were ready and willing to explore in a very big way.

THE INTERACTIVE TV CABLE TRIALS

In the early 1990s several cable companies and entertainment content providers employed rafts of creative talent to explore the possibilities of adding interactive TV to their lineup. They wanted to find out who would watch, what it would do to their ratings, and what it would cost.

Even early on in the process it became clear that programming for interactive television could only happen in areas that had more bandwidth than typical neighborhoods. So, regardless of the amount of compression that was done, the trials were held in communities that had been newly outfitted with the latest fiberoptic cabling (the Mississippi River of cable). That way they could test every idea that they came up with without worrying about bandwidth and compression.

A variety of programs were tested, including game shows, local information guides, on-line shopping systems, TV program guides, on-line communication systems, and the most popular ITV product of them all: Movies on Demand.

Movies on Demand, are, in the words of the sages at MIT's media lab, a no-brainer. As slow as pay-per-view cable is to evolve, going to your TV, browsing through a list of movies, finding the one you want, calling it up at the click of a button, and then having it start at the exact time you ask for it (no matter when you ask for it) has to succeed.

So, Movies on Demand pretty much became a mainstay of the interactive TV trails. So did interactive program guides. Program guides are just "TV Guide-like Information Grids" shown on your TV screen. If they were there, you would use them. But remember now the key thing about interactive program guides is that they are *interactive*. That means that you can scroll back and forth through the grid to find the *channel* you want and the *time* you want and even ask questions that would allow you to find more information. You might not buy a special TV set to get these features, but if they were part of your interactive TV service, you certainly would take advantage of them.

Interactive Shopping was another mainstay of the ITV trials. It is easy to visualize. Think of the Home Shopping Network without the need to pick up the phone. Just enter a few numbers on your remote control (including your credit card number) and you bought it, baby!

Interactive news was another interesting feature tested in the cable trials. Not only could you program your TV to present the news whenever you want it, but you could edit it so that you would only get information that you are interested in. So, when the next OJ-like court room circus came around, you asked your ITV system to show it at the top of each days news and you'd get it. Or ask that it be completely stricken from your TV and you'd never see it at all. What a feature!

Another benefit of interactive news as presented in the trials, was that it let you find out your selected, latest sports scores, and see highlights of the game whenever you want to. The same held true for weather; get just the weather information you want whenever you want it. News, weather, and sports information on demand on your TV screen.

And don't think that local news services and public affairs operations were to be put out of business by ITV. Every major city was to have local information on demand, including local entertainment info. Get a listing of local restaurants with today's specials, see what's going on at the downtown hot spots or with the local sports franchises. Find out what movies are playing, what parks and museums are open. The key to these local info guides was not just that the information was there, it was that it was Interactive and you could search and find the details that you wanted instantly.

ITV game shows were constructed in several different ways. In two of the most common designs, games were either created and played locally among members of the community or were created so that they were prerecorded nationally, but with all possible outcomes available. As each set of home viewers played along, their scores were recorded and shown on the screen. Moreover, the on-screen participants reacted to the home viewers' answers and score. "And you, 'home viewer,' you are the winner!"

Interactive television communications services were like transferring the capabilities of online chats and bulletin boards to the home TV screen. Want to talk to grandma in upstate New York? Call up the ITV chat and type away. Of course, this feature changed the configuration of the TV set remote control. It had to be a keyboard and the pursuit of the perfect remote for ITV turned into a long and difficult adventure. For now let's just say that the design of individual TV remotes varied greatly in the ITV trials.

So those are the rather obvious applications of interactive television and they are really no secret. It is the details of those designs that differentiate them and make them special. Examples of these concepts have been shown to the public in trials conducted by major media companies in many cities.

There is, of course, one very important additional kind of programming that could have been tried in the interactive television trials but as far as I know was not. That is the Interactive Story: the interactive drama or comedy. A lot will be said about interactive stories later in this book. For now it should be time to recognize that the evolution of the form of the interactive story will probably be like the evolution of the form for the novel, the stage play, the feature film, or the symphony. It is the creation of a major new kind of art, and this fact may explain why ITV developers have been so reluctant to experiment with it. The interactive story may very well change the world of entertainment forever. But there also is no doubt that it will be extremely expensive to work out.

In the mean time, the creation of the simpler forms of ITV were expensive enough. In fact, the creation of ITV programming turned out to be so expensive that many backers of the cable trials decided that, considering the fact that the

hardware infrastructure needed for nationwide ITV might not be in place for another 10 to 20 years, it might not even be worth continuing the tests for the time being. So, quite a few companies backed away from ITV tests by the mid 1990s. Too bad. What should have come out of those pilots were new forms of programming that pointed the way toward the Bradburyesque future and playrooms for all. It didn't quite happen that way.

Some good things were learned, however. And the best part of the whole process may have been the fact that the very best ideas were saved and put to use in far less expensive, more limited, but clearly more immediate and popular medium. I think it was a medium that consumers settled for because they had been sold the concept of the information superhighway so successfully that they had to have one, and, if they couldn't get it with ITV (over their TV sets) as they had been promised, they'd take it on their computers. The nice thing was that it was already evolving in the form of the Internet.

4

The Internet

I was once told about a most intense corporate survival meeting. There, the head of the company supposedly told the assembled leaders of his interactive television department why he had decided to walk away from the interactive television projects that they had been working on for three years and head off in a new direction, to develop programming for the Internet.

Attendants at the meeting said that the secret of this manager's sales skills had always been his teaching ability. He understood things so clearly and presented them so well that the sheer clarity of his presentation made people buy his ideas. So it was on this day, to a handful of dedicated people who did not want to have their interactive TV projects shut down, that he began.

His message was simple, and it had only three parts. First, the interactive TV trials that the company had been dedicated to for the last 3 years were being suspended because the company had decided that the infrastructure was not in place and could not be in place for decades to come. Second, anyone working in the interactive TV development group had a job if they wanted it in the development of programming for a new medium on-line, the World Wide Web. Third, and this was the most important of all, eventually, according to the manager, as the Web evolved and the technology improved, all the ideas, all the concepts they had been working on for interactive TV could be accommodated by the Web itself until, through a slowly evolving process, the World Wide Web would turn into interactive television.

The success of his arguments and the clarity of his reasoning convinced everyone in that room to transfer allegiance and take up the slowed-down, static, and yet popular banner of the Internet and begin creating media for the World Wide Web.

Six months later it appeared that everyone was an experienced Web site designer and had work that was published in prominent areas in cyberspace. The boss, the world's greatest salesman, on the other hand, had long since given up the game and was off to start a new company. Apparently he wasn't able to convince himself of his vision. Too bad, because, in fact, he was absolutely right!

THE ORIGINS OF FILMMAKING

At Stanford University in 1966 one of the required texts for graduate students in communications was a book call *Theory of Film* by Zigfried Kracauer. The essence of the book was the chronicle of the struggle for control of the soul of the movies by two warring factions, the documentary filmmakers, whose origins could be traced to photography and seen in the works of the Lumière brothers and Robert Flaherty, and theatrical filmmakers, whose origins were in the theater and could be seen in the works of George Meliès and later in all of Hollywood. Both groups brought their own focus and their own point of view to filmmaking. Both shaped their early works in their own way, and eventually both were challenged to work together on war propaganda films in Long Island, New York. Anyone who knows this story knows that films were never the same after that and that movies such as *On the Waterfront* and all those that came after it had as much of a documentary feel as they had a dramatic feel.

THE ORIGINS OF INTERACTIVE DIGITAL MEDIA

In my mind the evolving art form that is to be interactive digital media also has its roots in two technologies. One is the linear story orientation of movies and television. The other is computer technology, which is the control system that allows for user involvement and interactivity.

To the extent that interactive digital media is born of movies and television, it is largely linear story telling with parallel scenarios and branching and all the other features that we will be describing shortly imposed on the linear story. To the extent that interactive digital media is born of computers it is, in fact, user-involved. To this end the user will not choose to sit idly by and read or just turn pages. The essence of the computer experience is *involvement*, so any medium that is born of the computer is born of user involvement.

The good news about the argument that manager was said to make was that, although interactive digital media could not arrive through ITV in this decade, its arrival through the Internet was already invoking a more highly interactive, more user-involved kind of system than could ever be created by the cable and broadcast networks.

The current struggles to find the formats and the formulae for interactive story telling on the Internet show just how difficult the birth of a new art form can be. Because it is born of the computer, all the right questions are being asked, all the right paths are being explored, all the right experiments are being conducted and they are being conducted, right out there in the open where everyone can see and learn from them. So, with that as background, let's look at the world of the Internet and see how it is evolving.

WHAT DOES THE INTERNET LOOK LIKE

There are a lot of things that the Internet, or the World Wide Web part of it anyway, can be compared to. In its earliest days, for example it could be thought of as being very much like the page of a magazine, such as *Time, Newsweek, Esquire, Elle, Cosmopolitan,* or *Wired*. If you wanted a conservative-looking site, it looked like a conservative magazine, such as *Time* or *Newsweek*. If you wanted a site that was farther out, it looked like *Wired*. The Nickelodeon site looked like the *Nick Magazine*. There was a headline, there were a few pictures (originally many of them were in boxes so they really looked like *Newsweek*), and there was text, lots of text.

Figure 4.1 shows an example of one of my early personal pages: headline (or masthead), pictures, and text. Pretty simple. Pretty boring. But it is a case in point.

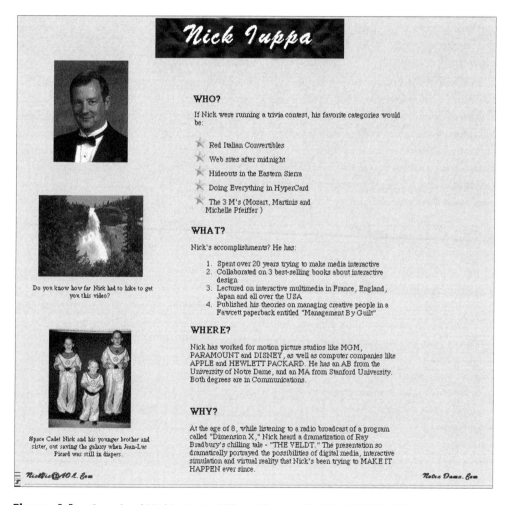

Figure 4.1 Sample of Nick's Ancient Home Page on the World Wide Web

But even in the earlier days, there were two other kinds of things on all Web pages, and they made the pages very much unlike magazines. Every Web page had navigational elements, links, or buttons that took you somewhere else. (Those script lines of text at the very left and right lower corner of the page are navigational controls.) The second Internet item that you never see in a magazine was a place to put in your own information and have it delivered to the site automatically. Services such as America Online, while not originally offering the graphic blandishments of the Web, did offer one thing that was far closer to the essence of what on-line is all about, It was called Chat. Chat offered people a place where they could go and communicate with each other, live. Conversations began. Friends were made. Whole communities of interest formed around topics.

Gradually pages as simple as mine began to change. Even then my waterfall moved in a simple animation, with a little more effort I could have made it into a QuickTime movie that you could download and save on your computer screen whenever you wanted to see it. Web sites these days offer waterfalls with streaming video that you don't have to download and that include the sound of the rapids. More important, they are broadcasting live from the site of the falls 24 hours a day: site cams.

You no longer go into the best sites and meet a static page that looks like a magazine. Sounds welcome you, there is motion. The pages are not as conservative as mine was, they are bright and alive, and their "look" represents the best features of the designer's work. Their text is not straight program code text as mine was. Now it is composed in a variety of bright and colorful fonts that match the mood of the page. Often you have to ask to see the text version because the message is provided by sound in streaming audio.

VIRTUAL REALITY

There is more going on on Web sites nowadays than even animation, site cams, and streaming movies, there are virtual reality experiences where you can get a 360° view of a place by moving your cursor, which turns into a hand and pushes the scene to the right or the left. You should, and will soon be able to, move down corridors and around corners. A technology called Virtual Reality Modeling Language (VRML) has been promising this 3D walk around ability for a long time. It's coming.

In the mean time there are chat rooms where you don't have to appear as a disembodied block of text with a screen name. You can choose an image to represent you, an avatar, who will appear in the chat space and help you communicate the persona you want to express. You can play a game in which other people in the chat space are portraying characters from a story each with their own goals and agenda.

Meanwhile activities, games, and adventures are popping up that allow you to work little puzzles, do little skill-building activities, or just have fun. Java,

Shockwave, Flash, Liquid Motion, and other new technologies are creating high-level interactive experiences that take place right on-line—and are more fun that watching *Jeopardy* (in reruns anyway).

Of course, you can shop and can search databases in sites that tell you about whole lines of products. Consider movies on home video. You can track them down by actor, director, genre. You can find out where they are rented in your neighborhood and even buy them on-line. You can search TV program schedules, find out what's on TV today or tomorrow. Track your favorite show and find out which channels are carrying it, in what city.

THE INTERNET ON TV

Something very interesting is starting to happen. New kinds of TV services are emerging, NetChannel, DirecTV, and others are providing access to the Web through your television. It started with interactive programming guides (sort of a TV guide on-line) that would present program listings, allowing you to search through channels, days, and times. But these services wanted to offer more than on-line program guides, so now they have put the Internet itself on your TV screen.

What's next? Original programming that offers interactivity as part of its basic content? Sounds like interactive television to me. Sounds like that manager's original premise was right, the Internet is turning into interactive television. And that would be profound, very profound, except that something even more profound is starting to happen. It turns out that the opposite of passive TV isn't interactive TV, it's aggressive TV; these are TV and digital media services that come after you, that push their way right into your living room and onto the screen of your computer and your TV whether you want them there or not. It's coming. Read on!

5

Pushing Technology

PUSH is a buzzword that means sending media right into the face of the computer user, not waiting for them to call for it the way they do now when they turn on their TV sets and flit from channel to channel, not even the way they do now when they access the Internet and use their browser to seek a new Web site. PUSH isn't even what computer users do now when they open a CD-ROM game, build their character, and head out across the vast reaches of some virtual domain. PUSH doesn't wait for you. It's in your face. It jumps out at you like the PointCast Business Network. The PointCast Business Network is a news and information service that delivers stock quotes, weather reports, and up-to-the-minute news from sources like CNN and *The Wall Street Journal* right to your desktop whenever your computer is idle.

Figure 5.1 shows a SmartScreen from the PointCast Business Network's Weather channel which offers an up-to-the-minute satellite map as well as a ticker with stock quotes. It hooks up to the Internet just long enough for information updates and then brings the pictures and headlines right to your screen and into your face.

A lot of Web designers are starting to incorporate PUSH technology into the latest designs. They want to offer you the most recent updates to the Web sites they build in a way that makes them jump right on to your computer screen of their own volition and then lets you link into the site where you can pull the rest of the information to you.

It's not such a jump to extending PUSH to the rest of your world, to the satellite map and travel services that many of us are finding in the cars we rent when we visit "select cities." Messages could push their way in among the street maps and other travel information. PUSH can jump into the TV shows I am watching on Saturday afternoon so that the Notre Dame football score will update itself on my screen every time my alma mater experiences a change in fortune. The point is, I tell the system to push the Notre Dame score into my televiewing any time, anywhere, but PUSH will soon be able to take it even further, right into the displays on my rental car's travel service, too.

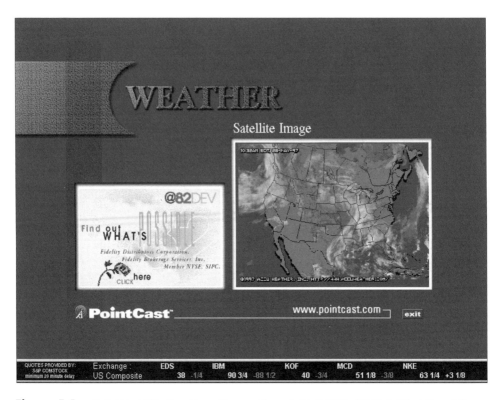

Figure 5.1 PointCast Weather SmartScreen Copyright © 1996–97, PointCast Inc. All rights reserved.

PUSH will download that same information automatically across the screen of my computer, onto the billboards that I drive by, onto the walls of my den, which will be programmed at some future date to make me always feel that I am surrounded by my favorite mountain peaks, on my favorite trail in the High Sierra. It will keep the room 5° cooler to capture a little more of that crisp mountain air. (The Department of Energy will like that.)

PUSH slams every key play of every Notre Dame game into my face no matter what I am doing because I have asked my system to do it. I can find them on my Newton when I check my appointments at any time during the game. Those key plays will certainly interrupt me if I happen to be writing my next book on my computer, and then, with the click of a button, I can pull the rest of the game to me as well.

PUSH media is ubiquitous in a way that helps me understand what the word means. It appears on the info panel of my new microwave oven so that I see it as I am getting ready to reheat last night's lasagna. It's on the dashboard of the family minivan (the one without the travel navigation system). It's everywhere.

Of course, if you don't care about the Notre Dame scores, you can ask for USC or the Miami Dolphins, the price of your hi-tech stock, the progress in the war in Bosnia, the weather in upstate New York, or anything you want to know all the time. And you can get it for free because all this info has a small nonmonitory price, advertising.

Jeep (for example) has identified me as a potential customer, and so they have an interest in plastering their name, their image, their purple mountains' majesty everywhere I look. They'll pay big bucks, too, for that kind of targeted advertising. When the latest Jeep ad shows up on my desktop I can click on it and pull up the Jeep Web site. Then I will get all of my questions answered—maybe even make a deal with my local dealer on-line and pick my new car up that evening.

PUSH is not all info bits and ads, though, it also means learning. New reference tables and exercises show up on my desktop or TV so that, as I'm watching *Star Trek* I can delve into the 1920s' speakeasies that Commander Ryker is visiting in the Holodeck. I may do it right in the middle of the show. I can pause the episode long enough to do my research and then I pop back into the story. Now we have push and pull going on at the same time. Maybe I even want to visit a few virtual speakeasies and hear a few of the classic tunes that were so popular at the time. Maybe I want to call up the script of the movie *The Sting* and compare that mob menace with the organizations that are threatening Ryker in his virtual experience. Maybe the card game in *The Sting* catches my interest, so I get into a virtual card game of my own while *Star Trek* is still on hold waiting for continuation at my command.

There is a lot of pushing and pulling going on now, and maybe all of this isn't happening on my computer, maybe it's on my TV set or the wall-size "living wallpaper" in my den (the one with the High Sierra peaks). That wall, after all, is really a gigantic monitor that I can interface with using a specially constructed keyboard that I keep beside my favorite chair.

Get it? The next most obvious phase in the evolution of media is PUSH, which brings with it PUSH/pull and a world of in-your-face media that jump out and get you so that you can dive in and find more. But now, let's take the next, biggest, and most fateful of all steps. Let's say I decide to get back into *Star Trek* and join Ryker in the Holodeck and walk the streets of Chicago in 1924. I meet virtual people and real people (on-liners who represent themselves with avatars). They are occupying the same virtual space. I can move forward or turn around and retrace my steps. The experience is totally immersive, and suddenly nothing can push its way into the environment. *I have escaped!* I have just entered the world of a new kind of theater that is a total experience in which I can immerse myself. This theater is currently so popular in story that it must surely be the next big idea in entertainment.

PUSH is just omnipresent, in-your-face multimedia. It's showing everywhere. Ray Bradbury's PlayRoom, on the other hand, is a virtual immersive experience and may be the next great art form. All of the digital media we have considered so far are pointing in that direction. And so it is only appropriate that the last medium we have to consider may be the one that has the most to tell us about this new form, which all our storytellers and soothsayers tell us is coming next. Just as they predicted the submarine, the rocketship, and flight itself.

6

CD-ROM

While I was having my adventures with interactive video, interactive TV (ITV), and the Internet, in a parallel universe similar adventures were occurring in the world of interactive video games and CD-ROMs. Now, CD-ROMs are, more than anything else, a storage medium. Like a blank piece of paper, the silvery discs can hold collections of images, volumes of text, whole novels, or even encyclopedias. In the case of Microsoft, they now hold entire Microsoft Bookshelves.

Digital video discs (DVDs), like CD-ROMs can also be used to store data to the tune of 4.7 gigabytes per disc. So in some ways they are just a CD-ROM with even greater storage capacity, and they are already being touted as the probable successor to CD-ROMs. One of the unique things about both media is the vast amounts of storage space they offer. There is space certainly for as much text, as much audio, as many still or moving images as any designer could want. Add to that the computer's ability to search and retrieve information instantly within that space, and you have a system that, for pure information retrieval anyway, is far superior to a printed book. This technology is offering a revolution in knowledge access.

THE CD-ROM AS INFORMATION SOURCE

Of course, CD-ROMs and DVDs do have a problem. Their content is fixed. Whatever information they hold is locked in. It can't be updated. Even the pending *recordable* DVD formats will require some updating system that is outside the basic medium itself. The updating issue, even for read/write DVDs is what makes it almost certain that the proper place for all "look-up" information sources (encyclopedias, dictionaries, glossaries, atlases, etc.) will eventually move from fixed media such as CD-ROMs to the Internet.

Of course, first there will be that much-talked-about marriage between CD-ROMs and the Internet. In that arrangement film clips, animation, and audio will be kept on a disc and the most volatile data will be downloadable from the Net.

But as the Internet gets faster and faster, that marriage will almost certainly end in divorce.

Another factor contributing to the breakup will be the insatiable media appetite of all information seekers. There will never be enough pictures, enough movies, enough animation, and enough audio. Users demand very specific information, and to feed the diverse, information-specific needs of everyone more and more media is required. No matter how much media you add to an information source, it never feels like it is enough. Even the Internet with its near infinite supply of information and media in some content areas is woefully lacking in others. The hungry information seeker really wants every possible nook and cranny to be filled in with audio and video. This point has to be painfully clear to those hearty souls who are laboring to add media elements to the various CD-ROM encyclopedias and other reference works. That is why, in the end, the Internet itself has the best chance of filling the media/information void. Although it is doing so unevenly and imperfectly, the Net is, in fact, evolving into (maybe more than anything else) the ultimate encyclopedia.

Having looked at the pure storage capacities of CD-ROMs and considered their ability to perform as sources of information, let's shift focus to a different kind of CD-ROM application. I think that it has the most to teach us about digital media design. I'm talking specifically about games, all kinds of CD-ROM games, but especially the most successful, most cutting-edge ones, those that will help shape the future of interactive digital media.

CHARACTERISTICS OF THE GREATEST CD-ROM GAMES

There is no doubt that *Myst* (Figure 6.1), the fantasy game that first came out in 1993 and remains a bestseller today, still is the definitive work in the medium. For one thing it defies culture and gender; it is popular with everyone. Moreover, it really doesn't require a special set of skills to play. Patience and attention to detail are more important than the ability to react quickly to sensory motor stimuli.

Myst is more an abstract experience than anything else. It uses magnificent graphics, animation, and small amounts of well-placed video. Perhaps, most important of all, *Myst* takes full advantage of the sound capabilities of CD-ROM to create a feeling that is often as frightening as any of its more horrific counterparts.

The sound, the color, the music, and the extremely high-quality art all combine to give the user the intense feeling that they are entirely, entirely *alone*. As you play the game, that sense of "aloneness" sometimes seems reassuring. (You're so alone you begin to feel that nothing can harm you.) But at other times your aloneness makes you feel frightened or even desperate.

There is already a feeling among some game designers that this kind of cross-cultural success may not ever happen again. At least not in the same way. Maybe not. There certainly may be a very long time before a multimedia product has the kind of cross-cultural appeal that *Myst* does.

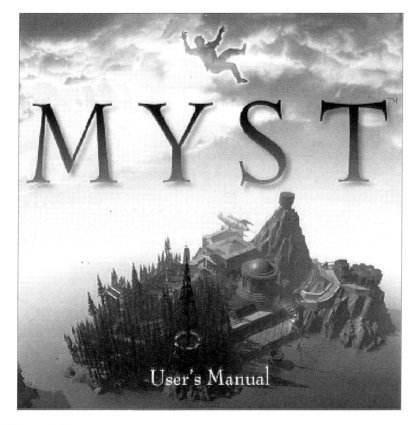

Figure 6.1 The Game *Myst* © 1993 Cyan Inc. Image from Myst ® Cyan Inc.

But surely there are hints in the success of *Myst* that point the way toward other future multimedia masterpieces. One of the most amazing secrets of *Myst* is that its roots tap into a quality that the most successful interactive video games all share. They are all addictive.

Think about it! If you have played *Myst*, you know how many hours you had to put in just to get inside the space ship. You asked your friends for advice, got hints, and you still needed hours. Why did you keep playing? It is the addictive quality that the designers of *Myst*, and of all good games, have tapped that keeps you awake into the night until you find that it's morning and you haven't gotten any sleep at all.

What is addictive about games and how can this quality be translated to the other worlds of digital media? A few key characteristics of addictive games are:

- *The environment.* After all, this is where the game takes place and hence what it is all about. Giving you a location to play lies at the heart of games. This was the major function of Bradbury's playroom, and you can see how central it is.
- *Playability.* This is determined by the feeling of control, your ability to move a character through space, and the concentration required to do so.

- *Quantity and quality of the interactions.* What are you doing, how often do you do it, what is the essence of the interaction? Does the variety of the interactions make the world seem boundless? Are the interactions immersive? Game designers tell me that this, more than anything else, is what you get hooked on.
- *Interface design.* How you get things done, the less complex the better, but it has to be as complete and as good as the best interface designs out there because the mass of players will compare it to all the others and expect the same functionality. Also, it should be language-independent, offering the ability to navigate without words or text instructions. An interface like this offers worldwide accessibility.
- *Levels of play.* Is there some place you can go to after you succeed at the first level, world, episode, or chapter? Are there things you can do after you master this local and this set of requirements? Once players have learned a set of skills, they want to apply them in new situations. Elevating a game to other levels has long been a secret of good game design.
- *Replayability.* What happens when you go back to an old place? Do you find it impacted by your progress in the rest of the game? Have people and places changed, grown older, moved around. Replayability gives a game a great sense of realism.

So, if it is possible to learn lessons about interactive design that translate from games such as *Myst* to interactive television programs and other kinds of digital media, they probably grow out of that short list of characteristics. Designers of interactive digital entertainment should make sure that their stories contain a rich environment and meaningful interactions over which the players have a feeling of control. They also need to create and present an interface that is simple, complete, and functional. Finally, they need to build interactive designs that offer progressive levels so that players can experience a sense of growth and progress.

There might not be much argument about our ability to learn interactive design lessons for games such as *Myst*, but are there also lessons to be learned in the non-stop action world of teenage boys and their "shoot em up" adventures? What are they? To find out, let's take a look at one of the most successful action strategy games.

COMMAND & CONQUER

"World domination in a box!" *Command & Conquer* may be very fast-paced and its objectives may seem a little primitive, but they are easy enough to understand: "build bases, muster forces, lactate your enemy." (See Figure 6.2.)

Command & Conquer is a real-time, 3D battle game. The game is all about control of the earth's most valuable mineral, tiberium. "In a world where covert surveillance reigns supreme and savage combat is the norm, players have to take sides in an all-out race for global control." So says the *Command & Conquer* Web site.

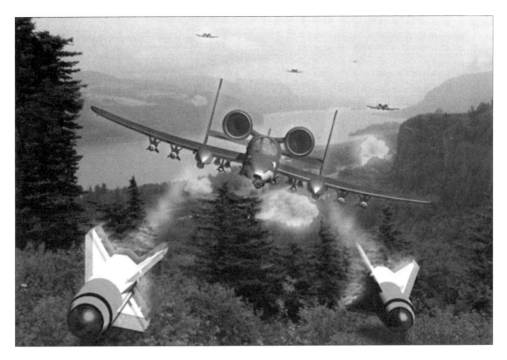

Figure 6.2 *Command & Conquer.* Copyright © 1996 WESTWOOD STUDIOS, INC. All rights reserved. Command & Conquer is a registered trademark, and Westwood Studios is a trademark of Westwood Studios, Inc.

Which side do players choose? It just depends on how nasty they want to be. They can side with the humanistic GDI or the cruel Brotherhood of Nod. But in the end, no matter whom they side with, they'll have to be . . . "aggressive without mercy, because their enemies certainly will be!"

Everyone I talk with about action games tells me this is one of the very best. What is it about *Command & Conquer* that they feel sets it apart? Certainly the quality of the 3D graphics is critical, but so, too, is the use of audio and animation and, of course, there is the basic functionality: the realistic environment, playability, interaction, interface design, and levels of play.

Is there a general lesson in such games for interactive digital media designers? One article in *Entertainment Weekly* magazine thought not. The writer suggested that action games such as *Command & Conquer* appeal to an increasingly highly skilled set of game players whose attention span is so brief and whose focus is so mercurial that trying to generalize from their interests to that of the mass population is a waste of time.

I don't think so. First of all, the same rules that we listed that worked so well in *Myst* still work for interactive television and action games. Moreover, action games, more than any other kind of game, are about pacing, and pacing, as any good movie buff will tell you, is critical to all of the lively arts.

If there is anything wrong with *Myst* it is its lack of pacing. It is almost a static, lost world, and so its pacing is naturally the pace of the users who are feeling

their way around. I'm not saying that all games should operate with the breakneck speed of *Doom* or *Command & Conquer*, but they do require pacing and the beats that are being counted in that pacing are the beats between interactions.

An action game is paced by the beats between activities. The really good ones happen very fast, and the user controls each beat. The same kind of interactive pace has to be maintained in the flow of an interactive story. It's a complex and difficult thing to extrapolate from the rapid-fire shoot-em-up of an action game to the number of interactions per minute demanded of people viewing an interactive TV show or other forms of digital media, but the truth is that that pacing better be there or the show won't feel interactive. There is another valuable lesson we can learn from interactive action games, but that lesson is to be learned more from what action games will soon become rather than from what they are now.

MULTIPLAYER GAMES

The bigger the game environment gets, the more you are playing against the computer. In almost all of the current crop of games the computer is called upon to create opponents for you, the personalities and the situations that you, as a player must come up against. The computer's ability to create personalities for you to play against is done through artificial intelligence (AI).

In some on-line games users send messages to fictitious characters and the computer generates responses based on word recognition and other factors. The problem is, as games get more and more complex and the skills of the players increase, the ability of AI to provide realistic characters and meaningful responses falls further and further short of the task. Alone AI just cannot generate the kinds of opponents that feel entirely real. It can't come up with the answers that respond to every nuance of the question. And those of us who are completely addicted to games know it.

The solution, of course, is multiplayer games, where the opponent is not the machine, but other living breathing players who can outmaneuver you and outthink you.

If you have played both AI games and multiplayer games you know that there is just no comparison. A multiplayer game just feels more natural. Or to put it another way, people do things that computers would just never think of doing. Feelings enter into the way the game is played. Playing games against real people is always better.

The new generation of games will be multiplayer games, whose graphics and audio reside on CD-ROM or DVD, but whose interactions take place on the Internet. (Yes, in this case the marriage of CD-ROM and the Net *will* work.) Soon you will be able to do battle, form alliances, build empires, all the cool stuff that games are made of, while planning and scheming with your allies and plotting against your opponents. Your character becomes more and more *you*. The oppo-

nents you are facing become more and more *them*. And the *them* is real because it is real people, people you can chat with, people you can strategize with and against, people you can outwit or who can outwit you.

The future of the most advanced games is sure to go in this direction. It combines the best of graphic elements with the interpersonal powers of the Internet. People can retain the anonymity that is so much fun, they can play roles, and they can have all the action they want.

It is the process of immersing real people in fantasy interactions that will lead to the next generation of games and experiences beyond games: high-level simulations involving real people, experiences that immerse people in whole other worlds. Wasn't that what Ray Bradybury's PlayRoom was all about?

The virtual immersive experience may be a long way off technologically, but we are already building the elements that will make it happen. We are evolving all the little strands that will someday allow us to weave our own PlayRoom (Ray Bradbury), Holodeck (*Star Trek*), or Matrix (William Gibson).

Now that we've taken a quick look at all the digital media types, it's time for a slower, step-by-step review of all the elements of all the technologies that make media interactive. Our purpose (again) is to train designers to create interactive experiences. There will be a lot of attention paid to the Internet where so much is happening today. We will also look at those forms of training, entertainment, and sales where interactions and transactions occur as a matter of course. We'll be cognizant of the coming power of PUSH technology. But we will be even more aware that we are teetering on the edge of an even newer, more powerful medium: the virtual immersive experience (VIE).

The VIE will be more relaxing than the most passive television show, it will be a more powerful sales tool than telephone solicitation. It will be more educational than any but the very best of teachers. It will be as adrenaline-jacking as *Command & Conquer* or even stepping into the front lines during the invasion of Normandy.

Certainly all the technologies that will create this new medium, this VIE, are not yet in place. But this revolutionary new experience is so close that we can reach out and touch it. More important, any good endeavor to create interactive media of any form must now consider its possibilities and potential. It's where art and technology are really going.

Tools of the Trade

7

Interactive Design

To understand the process of interactive design you have to realize that it begins when designers ask themselves one question. It is a question that applies to interactive information systems, learning systems, games, and especially interactive stories. It is *the* question that novices in the business of interactive design either forget to ask or ask too late in the design process. When that happens their creations become linear works with minimalist interactivity.

"Minimalist interactivity" is my name for a few, very important, but extremely fundamental activities, that form part of any interactive experience but should never be considered the interactive experience as a whole. The mistake is to think that adding minimalist interactivity to a linear program makes it truly interactive.

My list of the most notorious "minimalist interactivities" include page turning, lookups, side games, and talkabouts. Let's review them one at a time and then come back and consider that fundamental design question I said designers had to ask themselves before creating any true interactive system.

PAGE TURNING AND NAVIGATION

It is remarkable that some designers consider the fundamental navigation of a linear or even branching story the heart of its interactivity. The fact that users can progress through a story in a linear fashion, skip ahead, or review what they had previously read is so fundamental to any interactive system that it can hardly be considered the heart of the experience, any more than turning the pages in a novel or jumping from article to article in an encyclopedia can be considered the essence of enjoying a work of fiction or doing research. Good clean, clear navigation is critical to the success of any interactive experience, but it is so basic that its excellence has to be a foregone conclusion.

Navigation is still an issue to be dealt with, it is still hard work. However, after all these years of experience in interactive design, people who call themselves

interactive designers but cannot put together a simple, workable, and intuitive navigation system and interface for their designs; people whose users are heard to ask the terrible question "But what do I do now?"; designers such as these should surely consider another line of work.

If you are afraid that you fall into that category and you don't want another career, it's time to do some developmental testing. And when the developmental testing reveals users who utter the unthinkable phrase "But what do I do now?," congratulations at least on doing the testing, but please, check out my review of interface design in Chapter 10.

LOOKUPS

Here's another part of interactivity that is clearly not the whole experience. Searching for information is interactivity of sorts, but it is probably not the interactivity of choice. It is a very fundamental and very important function of any interactive system. It's what makes interactive encyclopedias easier to use than hardbound encyclopedias. In an interactive story it is the beginning of the adventure, but it not the adventure itself. So the lookup part of interactivity, is only the beginning of what interactive digital media can be.

In our classic tale "The Veldt," the children in the story went to the African plain and visited with the animals that were there. They were surprised and even frightened by them. Looking up a list of locations, learning more about the animals was good preparation for the adventure. Choosing to go to the veldt from among the other locations that were available to them, deciding which animals were present when they arrived, these were interesting lookup and selection activities for the children, but they were not the interactive adventure. Being on the African plain and interacting with the environment, that's what made the adventure real. In the case of Ray Bradbury's tale, or course, it was far too real.

SIDE GAMES

Anything with a little interactivity *tacked on* is not really interactive at all. Moreover, programs with a little interactivity tacked on often act as bad representatives of the interactive design art and as such, reduce the chances of acceptance and success for all efforts at interactive media.

It has often been said that interactivity is not something that consumers understand or care about. The reason for that may very well be that there are so many bad examples of the interactive programming, so many examples of linear programs with a little interactivity tacked on.

So, what do you tack on to interactive media? Well the most obvious thing to add to an interactive adventure is a little game that you play on the side. You can stick a little multiple-choice quiz at the end of what is supposed to be an interactive

lesson, but all you really have then is a lookup and selection of one lesson out of many followed by a little tacked-on side game.

Side games are even more deadly in interactive stories. Imagine a puzzle that is thrown in the middle of an adventure. For example, you are trekking across the universe and suddenly you are confronted with a puzzle that you have to complete to steer the ship. It is so complex and distracting that it destroys the continuity of the story, and because there is no way around it, the puzzle becomes a dead end that frustrates you and eventually leads you to abandon the adventure completely.

Another, better, but still imperfect, interactive side game is the activity that accompanies a linear story. It does not interrupt the story because it is not really part of it. Instead you go through the linear story and then play the game after the story is complete. At least it doesn't interrupt the story, but then it doesn't add any involvement for the participant either.

Chuck Jones produced a brilliant, but rather linear, version of *Peter and the Wolf* on CD-ROM. To add interactivity to the experience, someone added a nice little game where the players helped Peter escape the wolf by jumping across a river from floating log to log. It was a nice, cute interesting game, but it was not integrated into the story. A perfect example of a side game.

TALKABOUTS

Talkabouts are actually a wonderful activity and they take advantage of one of the most popular aspects of on-line services, one that will eventually become parts of interactive television, I'm sure, that is, the chat or bulletin board function. Talking about an interactive story or adventure is great fun. It may be the second best thing about being in an interactive adventure. But it is not the adventure itself. Unless the group discusses things so that they can take action, they are only observers of the scene.

In an interactive lesson, talking about solving a problem or finding the right way to do something is still not the same as solving the problem or doing it the right way. There is a lot of value in talkabouts, and they certainly are interactive, but until they provide more than an aside to the adventure or learning experience (as in the on-line role-play game described in Chapter 17), they are not the highest form of interactivity and people who include them in their designs must realize that they are not delivering the whole interactive experience.

THE BIG QUESTION

So, where does that leave us? We have reviewed four fundamental interactive elements that many people believe lie at the heart of any good interactive program. But we said that those techniques are only secondary activities and anyone who

builds an interactive adventure or a learning system around them is creating a very incomplete experience.

What is the answer to designing a truly great interactive experience? For me, whether you are designing a CD-ROM, an on-line system, or an interactive TV program the key to success is to ask yourself one question: *"Who are the users and what is their role?"*

In an interactive story you have to ask yourself what characters the users play, how they become part of the story, and how their actions and decisions affect the progress of the story. In a learning system you have to ask yourself who the learners are and what are they doing that will make for an effective learning experience? In an interactive game you have to ask yourself who the players are, what their role in the game is, and how they play that role. If they are golfers in a golf game, they had better be playing golf. If I'm a lover in a soap opera, someone had better be loving me or rejecting me or at least acknowledging me.

When you ask, "Who are the users and what is their role in the interactive experience?," you automatically take your interactive creation to a much higher level, one in which the users are the focal point of the experience and their activity becomes the most important elements in the experience. Even in stories with strong linear elements and characters who are strong and self-determined, the game users and their role must be paramount.

8

Design Documents

A group of interactive television designers and sales people flew out to Las Vegas for a big convention. There, they finally managed to corner media buyers from a major manufacturing company. The buyers were ready to listen to a pitch about a new concept for an interactive TV show. The ITV sales group had prepared a complete sales pitch: a concept statement, benefits to the manufacturer, even a preliminary budget and timeline. The sales and marketing gang started the pitch with the story of their company and its success. It helped.

Then came a presentation featuring the concept statement. The buyers liked it—a lot. Marketing moved to the more client-centered parts of the sales presentation: description of the target audience, benefits to them as a sponsor. The conversation got hot, then it gradually began to lose energy and cool off.

"We need to see something more concrete," the manufacturing folks said finally. The marketing people stumbled around, "What could be more concrete than a well-prepared sales presentation?" And then every one turned and stared at the lead *designer!* She swallowed hard and simply said, "I'm putting together a preliminary design document. It should tell the whole story."

Marketing heaved a sigh of relief. The manufacturing execs grinned. Everyone was happy, and far closer to getting to produce an interactive TV show than they had been when they ate that two-dollar mega-breakfast at the Sands Hotel that morning.

Of course, a design document is the most complex of all the documents that are required to get an interactive project from the talking stage to the finished product. At that point, however, the manufacturing executives wanted detail and that is what the design document would give them.

When you know the full range of documents needed to create an interactive product, you stand a better chance of mentioning the right one at the right time and gaining the credibility that comes with it. So, let's go through the typical documentation needed to create an interactive project. Let's see how all the documents fit together. Of course, the required documents may vary a little from company to company. But, generally, this description fits most of the companies I have worked for and will, if nothing else, serve as an electronic trail that you can

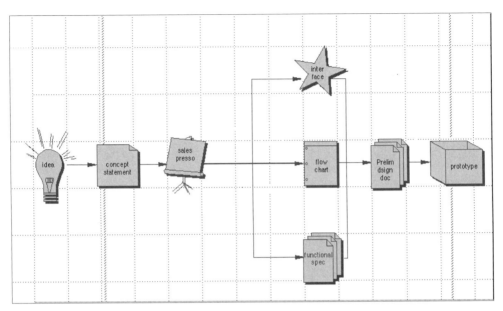

Figure 8.1 Flow of Documents

follow. Figure 8.1 shows the flow of documents, starting with the idea and going on to the concept statement, sales presentation, as well as the flowchart, interface design, and functional spec (which are included in the design document).

THE CONCEPT STATEMENT

The first document that is usually created in the evolution of an interactive product is called the *concept statement*. Once two or three or seven people have talked through their ideas, making notes on napkins, and drawing rough flowcharts on white boards, someone has to articulate the idea. The document that comes out of that effort is call a concept statement. Occasionally, the concept statement may not really exist on paper; it may exist only in the producer's or designer's head and be presented in sort of a live dramatic story telling. This is very much how it happens in Hollywood, at least for those producers who have reached a high enough level to be able to get directly in front of the right people.

Because a riveting storyteller is still one of the best presentation methods in the world, having the concept as an unwritten idea is a reasonable way to go. It is very dramatic. It also lessens the chances of having the idea stolen by someone. Of course, no matter how good the presenter and how much interest he or she generates in the idea, eventually someone is going to insist that the idea be written down. So sooner or later you are faced with creating a written concept

statement anyway. Here's my advice. Make it short. One paragraph may not be enough, six pages is way too much. Think about the essence of the story and what is the most interesting and exciting thing about it, and write that into your first sentence. Think about the interactions—what is the role the user plays in the story, and include this element in the statement. Then keep going till you've said everything that it takes to get the concept across. Then rewrite and rewrite until the concept is crystal clear. Shorten in the process, too, don't ramble. Whenever you have two sentences that basically say similar things, take one of them out or at least combine them. When the concept is down to less than two pages, you're there.

Of course, what your prospect will most likely say is, "This is a great first stop, but I need more details." To which you should respond that you'll have a complete sales presentation on Friday.

THE SALES PRESENTATION DOCUMENT

The sales presentation document contains the concept statement (now boiled down to key points), plus all the information that sponsors want to know about the project. That is, what will it do for me, which customers or clients of mine will it reach, how much will it cost, when will it be done?

Here's an outline of a typical sales presentation document:

Title page, with graphic
Objectives of the program
Benefits to the sponsor
Demographics of the target audience
Concept statement
Description of the interactivity
Definition of the look and feel
Background on key development players
Timeline and budget considerations

The ideal length for a sales presentation document is no more than 10 jumbo-type bulleted point pages. That form is great for the prospective buyer of the concept and for the seller as well. Having been on the receiving end of sales presentations, I know that 20- to 30-page sales presentations in 9-point, single-spaced type are usually rejected based on the form of the presentation alone. An even better approach than a printed sales presentation is a computer-projected presentation using an application such as Microsoft "Power Point."

As it becomes time to give the sales presentation to the prospective client, rehearse so that you are ready to do the job well. Then call ahead and make sure that the client's office or the facility where the meeting will be held is capable of showing your presentation. Just to be safe, print out the presentation, too. You

Figure 8.2 Title Page of Power Point Presentation

Figure 8.3 Objectives from Power Point Presentation

can fall back on the printed copy if the equipment isn't there or won't work for some reason. You can also use the printed presentation as a handout.

The sales presentation has to be fully formed and worked out. If it isn't, you won't get past the first meeting. Figures 8.2 and 8.3 show two frames from a Power Point sales presentation that attempts to sell a mythical Web site designed to support an equally mythical television series.

DESIGN DOCUMENTS FOR PROTOTYPES

Let's assume for simplicity's sake that the meeting goes extremely well and you are given a go-ahead (without the five or six additional meetings that it usually takes to sell an interactive product). At this point the most likely course of events is that you will be asked to create a prototype or pilot.

In the interactive business, a *pilot* is a complete example of a product, a full episode of an interactive TV show, for example, or a completely rendered and fleshed-out Web site. A prototype is a sample of key parts of the product that exemplify the mechanics of the entire project. Because of the complexity that interactivity adds to products, companies seldom go immediately to the pilot stage of a concept. It is far more likely that you will be asked to create a prototype. But you will need a design document even for that.

The design document evolves. The preliminary design document will most likely be far different from the final version. But from the first the design document has to contain a *flowchart* or site map of the interactive experience, an *interface description*, and a *functional specification*, which is a screen-by-screen or interaction-by-interaction definition of what happens. The design document should also specify the media elements that must be obtained or created for putting together each part of the prototype.

As mentioned, it is critical that the prototype feature enough of the functionality of the final work to ensure that it offers a good representation of the final interactive experience. This is something that has to be reviewed throughout the creation of the design document. You have to keep asking yourself whether you are truly representing the finished product with your prototype. As more and more of the requirements of the final product reveal themselves and more and more of the limitations become clear, be ready to change your definition of the prototype if that is necessary.

As each of the components of the design documents are created, they may go through a review, discussion, and approval process. For example, it is quite likely that the flowchart of the site will be created and circulated to the creative development team, the clients, and even some management decision makers. As the flowcharts are reviewed, the details of the design are actually worked out even further. This working out of the flow of the project will necessitate changes to the flowcharts and feed into meetings on the mechanics of the interface and all the interactions that happen in the experience.

For example, in our mythical TV show *High Sierra Mission*, the flowchart shows how a simple mountain rescue mission in a remote canyon turns into a full on race to save the residents of a small village from a disastrous flood. The flowchart for this adventure reflects a series of decisions that the users (who are also the only ones who can save the village) have to make.

In working through the mechanics of the flowchart, the hero's decisions require that the interface take on a certain kind of functionality. At first there may only be simple navigation through mountainous terrain and simple "yes–no" choices to be made. Then, as the design evolves, multiple choices may be necessary. As the designers of the interactive experience continue to develop the details of the story, it may become clear that various new kinds of decisions are cropping up in the story that were not in the initial concept. There may be conditional "if–then" choices that have to be introduced. These discoveries effect the flow of the adventure and are limited by the capabilities of the technology (can the interactive system remember preconditions, accumulate them, and sort them out?).

These factors all become reflected in the capabilities of the interface, which will be in flux until every eventuality of the prototype design has been explored. Working out the details of the story in a flowchart affects the design and functionality of the interface, and that in turn is also changed by detailed design decisions that are made as each of the interactions are explored.

When the mission team encounters the injured parties at the bottom of a 1,000-foot cliff, they may need special capabilities that were not planned in earlier versions of the interface. Is there, for example, a language issue and a translation capability needed, if so, that functionality has to be added to the interface as well.

All these kinds of things are worked out in the preliminary design documents, modified as the details are fleshed out and realized in a final design document that then can be given to writers, directors, programmers, art directors, graphic artists, and any other person who are contributing to the creation of the prototype.

Formats for Design Documents

Having reviewed the purpose and evolution of the design document, let's just take a moment to explore how to actually create one. Making flowcharts and defining the human interface are complex tasks, and so we have set aside Chapters 9 and 10 to talk about them. Most of the detail of the actual interactive design, however, is told in something called a functional specification or spec, which identifies each major segment of the interactive design and defines the features and the functions that happen there.

Generally the creation of the functional spec is something like filling out pages and pages of a form that asks for specific information about each frame of the Web site (if it is a Web site) or each interaction in a CD-ROM game or training program. Figure 8.4 shows the worksheet one company used to prepare

Item No.	Kind of Item	Objective	Content	Format
5.D	Question 1	The student will be able to recognize the act of paraphrasing a customer statement	Customer: (says something) Teller: (paraphrases customer's words)	Motion sequence followed by freeze frame with choices: 1. Paraphrasing 2. Amplifying 3. Non-clarifying
5.D.1	Repeat question	Same as 5.D	If you would like to hear the question again press ____.	Menu
5.D.2	Feedback: incorrect	Same as 5.D	You didn't get it right.	Feedback frame
5.D.3	Feedback: correct	Same as 5.D	Correct. The teller paraphrased what the customer said.	Freeze frame highlight
5.D.4	Menu: incorrect	Same as 5.D	If you would like to: -repeat the question, press ____. -obtain more instruction, press ____. -go to the next question, press ____.	Menu
5.E	Question 2	Student will be able to recognize disagreement as non-clarifying.	Customer: (says something) Teller: (disagrees)	Motion sequence followed by freeze frame with choices: 1. Paraphrasing 2. Amplifying 3. Non-clarifying

Figure 8.4 Functional Specification Worksheet

functional specs for training programs. Here is a description of the component parts of that worksheet. (The part of the functional spec used in this example came from an instructional interactive video.)

- *Item number.* A breakdown of the interactive sequences or elements, usually a number followed by a letter followed by a number, and so on. The letter-number "combo" allows you to identify parts of the same item, such as different feedback sequences relating to the same decision point. To number the sequences in the prototype, you must dissect the content, break it down into its smallest pieces, organize it, and get rid of any confusion that might arise when story lines branch. To do that you have to arrange those overlapping sequences into some kind of order. Perhaps the best way to do that is to follow the story line in linear fashion, and, when you come to a decision point, insert the simplest branch as the first unit right after the decision point, then place the longest branch at the end of the set of responses.

- *Kind of item.* The major kind of activity or interaction that is happening at this point in the presentation. Is it a decision point, navigation through virtual space, a discussion with other users (chat session), a question, a twitch game, a puzzle, or just a linear sequence?

- *Objective.* Tells the purpose of each item, what effect it will have on the whole experience. What are the consequences of taking the action? (The hero's objective is to rescue the survivors and warn the village about the pending flood.)

- *Content.* A detailed description of the content presented in each sequence. It can be an outline of the kind of activity taking place or words from a script.

- *Format.* The way the content is presented, linear video, still frame, motion followed by still frame, graphic overlay, chat, virtual environments, and so on.

Remember, the purpose of the functional spec is to communicate the organization and interactive strategies you've come up with. If you don't do it accurately or completely, the writer and director will have little or no sense of how the interactivities work, or, worse, they will make up their own—and usually that means linear thinking.

Figures 8.5 and 8.6 show functional spec templates for entertainment and informational Web sites. The names have changed, but many of the items are similar to the previous form. The reference to "frames" here has to do with the fact that the site is designed with frames technology that divides the page into sections (frames). It is a good way for the designer to identify the active areas within each page. In this case the designer works with templates because there will be so many pages to this Web site. This is an important way to simplify the creation of complex sites.

Figure 8.6 shows a functional spec for a site that requires maintenance. As such the maintenance schedule and the methods for updating the site are listed and considered. Note, too, that this site expects advertising so part of the frame content is an area set aside for ads.

Project:
Screen Name:
Description of Screen:
User Interactions:
Frames within the Screen:
Template (see attached numbered diagrams of each):
Media Elements & Graphics:
Navigation Controls & Icons:

Figure 8.5 Functional Spec Outline 1

> Screen Name
> Purpose/Description
>
> *Frame Content: Description and Links*
> Banner and Title
> Text
> Images
> Navigation
> Advertising
> *Updates/Maintenance and Related Tools*
> *Other Media Elements*

Figure 8.6 Functional Spec Outline 2

We have looked at a series of forms that can be used to create the functional spec, one of three pieces that go into a complete design document. The two other elements require very special skills. Those are the flowcharts and the interface design. We'll look at them in Chapters 9 and 10.

9

Flowcharts and Site Maps

Flowcharting is an integral part of the interactive design process. It is done to communicate sequence, decision points, branching, and the flow of information in interactive multimedia. In traditional linear media there is no need to document the various paths a viewer can take through the program because there is only one path. In interactive television (ITV), the Internet, CD-ROMs, and other interactive digital media, flowcharts not only show all possible paths a viewer may take but also indicate the various activities that will take place along the way, such as video motion sequences, subroutines, games, tests, or transactions. On-line flowcharts are often called *site maps*.

Quite a few programs have been created to allow developers to create flowcharts electronically. One of my favorites is Inspiration from Inspiration Software. It's a simple click-and-drag program with pull-down menus that allow you to create flowcharts with a variety of standard flowchart notations as well as unique symbols and icons.

Figure 9.1 shows a simple site map created with Inspiration. I couldn't resist the temptation to substitute some of Inspiration's more fanciful icons. We'll soon learn that what I've made is definitely a "level-one" flowchart. For a more traditional look at the standard kinds of flowchart symbols, check out the several pages of Figure 9.2. Note that access to the variety of icon images for Inspiration is achieved through pull-down menus under the symbols on the little toolbar shown in Figure 9.1.

LEVELS OF FLOWCHARTS

Flowcharts are used for a number of different purposes. They are used to communicate general program flow to executives, clients, and writers; to indicate the organization of all parts of the program to production staff; and to indicate the mechanics of the program to software engineers. As the needs of one group are quite different from those of another, there are three levels of flowcharts, each designed for a specific purpose:

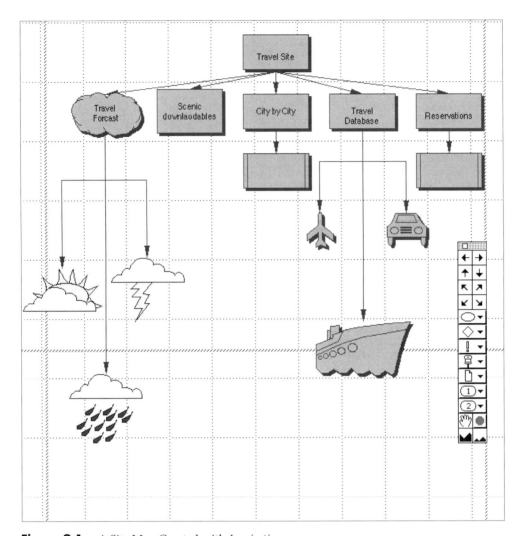

Figure 9.1 A Site Map Created with *Inspiration*

1. *Level 1 flowcharts.* To communicate general program flow to clients and decision makers prior to scripting stage.
2. *Level 2 flowcharts* To indicate complete organization of all parts of the program to production staff and writers.
3. *Level 3 flowcharts* To indicate the mechanics of the program to computer programmers.

Level 1 flowcharts document the paths available to the user or viewer and are based on the information developed in the concept statement. Level 1 flowcharts are frequently used to "sell" the interactive program to clients. For this reason, they are sometimes even embellished with illustrations and mounted on large presentation boards. A good set of level 1 flowcharts should accompany the design documents.

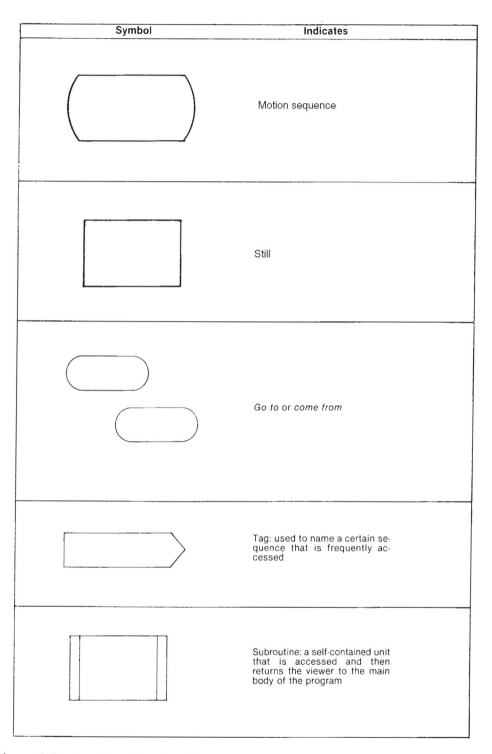

Figure 9.2 Traditional Flowchart Notation

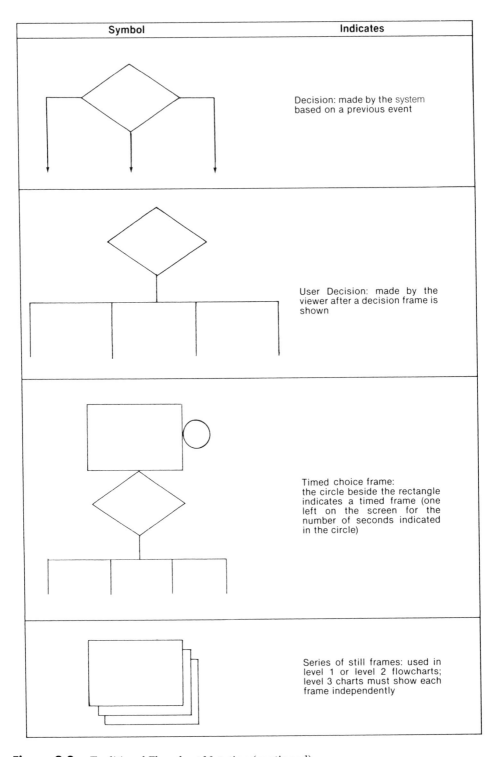

Figure 9.2 Traditional Flowchart Notation (continued)

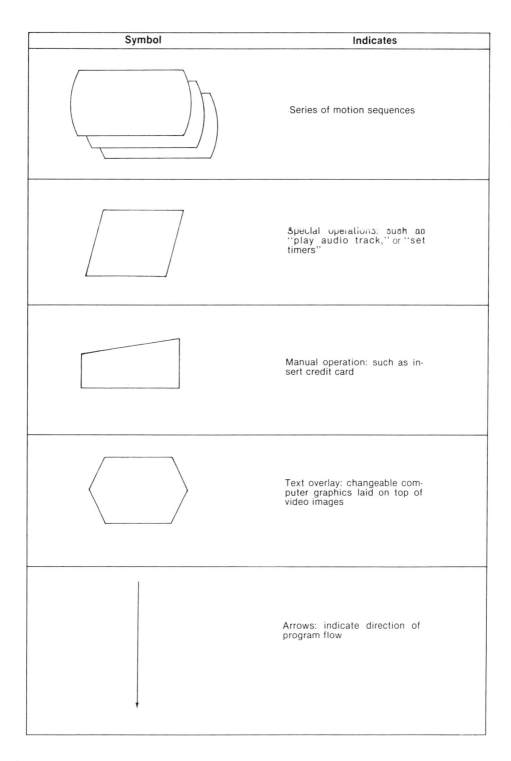

Figure 9.2 Traditional Flowchart Notation (continued)

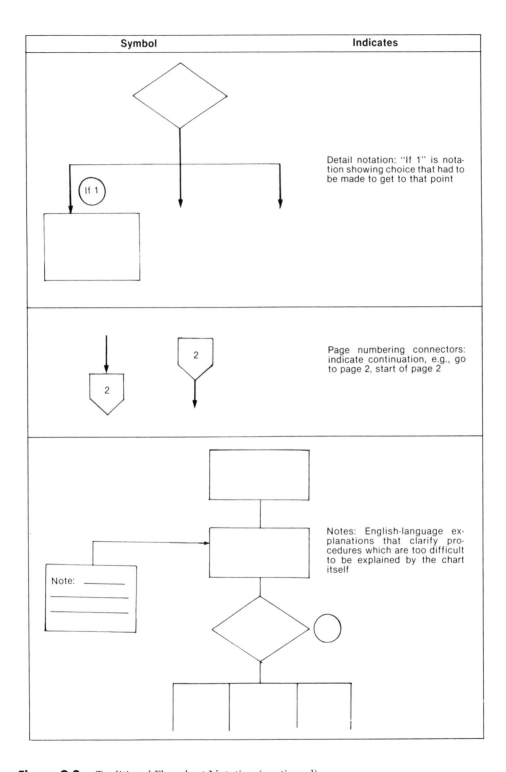

Figure 9.2 Traditional Flowchart Notation (continued)

Level 2 flowcharts add in all the details of the program, but leave out the mechanical instructions needed by computer programmers. Sometimes they are complete enough to serve as the basis for a prototype since prototypes generally do not include the completed content of all parts of the program.

Level 3 flowcharts contain all the program details, mechanical instructions, counter instructions, frame numbers, etc. It takes intense concentration to develop level 3 charts. However, the effort is necessary because the program won't work if level 3 charts are incorrect.

Designing flowcharts requires three basic characteristics: a logical mind, tremendous patience, and strict attention to detail. The general process is to identify each content element to the smallest unit (the page, frame, cel, or screen), label each element, and connect the elements into a logical flow. Then, you should check and recheck to see that all necessary details, including loops and computer instructions, are present. Level 1 and level 2 flowcharts are often done before scripting begins. Level 3 charts are often completed during or *after* production so that refinements in the script can be incorporated into the program.

Figures 9.3 and 9.4 show level 1 and 2 flowcharts, using the flowchart notation described earlier. Each chart combines the symbols into a unified sequence. All three charts present the same sequence with increasing levels of detail.

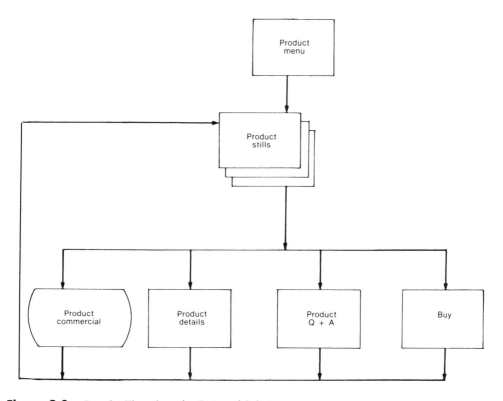

Figure 9.3 Level 1 Flowchart for Point-of-Sale Program

60 Part II • Tools of the Trade

Figure 9.3 presents a level 1 flowchart of a "point-of-sale" laser disc, featuring the menu that will lead to one of several product stills. The still, in turn, leads the viewer to a choice of activities relating to the product.

In the level 2 chart shown in Figure 9.4, terms are used to identify key blocks of information. Words that are repeated are abbreviated: for example, "Product Still" is abbreviated PS. The flowchart makes all parts of the program clear and can be used by production personnel to begin work on the video and other sequences. However, level 2 charts, even though they are detailed enough to create prototypes, cannot be used by software engineers to create the final code.

The level 3 flowchart shown in Figure 9.5 is so detailed that it must be done in code to get all the information on the page. The amount of detail makes any superficial assessment of the chart's accuracy impossible—it must be worked through step by step. Using this chart, the software developers can create an acceptable interactive product.

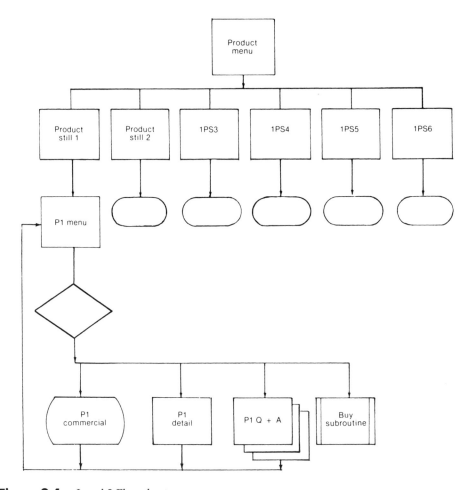

Figure 9.4 Level 2 Flowchart

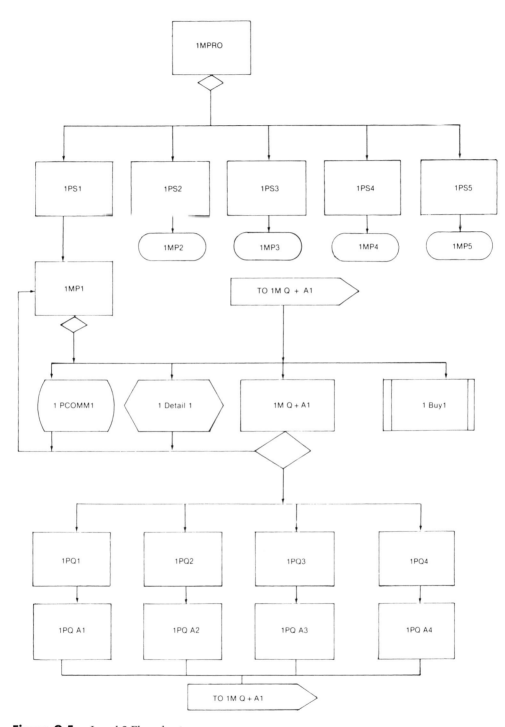

Figure 9.5 Level 3 Flowchart

The Gantt Code

The level 3 flowchart shown in Figure 9.5 uses a variation of the code invented by Rodger Gantt, a Bank of America instructional designer. The Gantt code, as we call it, uses activity names or code numbers to represent all elements of an interactive video program. Although the Gantt code was constructed for instructional material, the principle could apply to other types of interactive programs as well. Of course, thanks to MS-DOS, we are all used to making up code names for items, and we are certainly free to use any code we want. The important thing about the Gantt code is that it is complete, intuitive, logical, and extensible. As such it is, at least, a good model for program designers and flowcharters.

In Gantt's system, the activities are named, abbreviated, and numbered. The main purpose of the code is to create a clear-cut shorthand that designers and programmers can use to identify activities. It saves writing time and provides for greater consistency when program elements are being discussed. Each element of the code is explained in the following tables.

The major building blocks of an instructional interactive program are demonstrations, exercise questions, and test questions. These are represented in the Gantt code as follows:

Demonstration	DEMO
Exercise question	XQ
Test question	TQ

Other blocks include introductions, reviews, previews, and various types of menus:

Introduction	INTRO
Review	REV
Preview	PRE
Test pass menu	MTP
Test fail menu	MTF
Review menu	MREV
Preview menu	MPRE

In addition to exercise questions (XQ), there are three different kinds of exercise feedback: correct, incorrect, and common feedback (a single response that works for all answers, right or wrong). There are also drills with questions and feedback:

Drill questions	DQ
Drill feedback	DF
Exercise questions	XQ
Correct feedback	XCF
Incorrect (false) feedback	XFF
Common feedback	XCOM

In programs that have more than one lesson, a number usually precedes the item to indicate the lesson:

 Lesson 1, demonstration 1DEMO
 Lesson 1, review 1REV
 Lesson 1, exercise question 1XQ

As there can be several activities of any kind in any lesson, the activities are given numbers, which are placed *after* the lesson number and item code:

 Lesson 1, demonstration 1 1DEMO1
 Lesson 1, demonstration 2 1DEMO2
 Lesson 1, demonstration 3 1DEMO3
 Lesson 2, exercise question 4 2XQ4
 Lesson 2, correct feedback 2XCF5
 for exercise question 5

Similarly, because there can be more than one incorrect (false) feedback to each question, the number of the feedback is indicated by a point after the activity number:

 Lesson 2, exercise question 5, 2XFF5.1
 incorrect feedback 1
 Lesson 2, exercise question 5, 2XFF5.2
 incorrect feedback 2

In flowcharts, those numbers would also be used to indicate different feedback corresponding to choices in a multiple-choice question. For example, Figure 9.6 shows the sixth exercise question in Lesson 3, which has three incorrect possibilities and one correct choice.

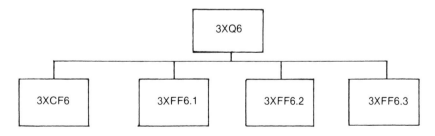

Figure 9.6 Feedback Segment Flowchart in Gantt Code

Thus far, we have discussed flowchart and site map design notation and the automated process for creating them with software such as Inspiration. We

also reviewed the three levels of flowcharts used to communicate information about the organization of interactive multimedia to various clients, scriptwriters, production personnel, and programmers. In the upcoming chapters, we will examine the basic design principles used to create and organize the major building blocks of interactive digital media. Let's start with the design principles relating to human interface, the most important building block of all interactive experiences.

10

Human Interface Design

One of the most important considerations when designing any interactive multimedia system is the way it works with people — or, more appropriately, the way people work with it. The point at which a person and an interactive system come together is called the *human interface*. Many people are aware of the battle between Microsoft and Apple computer that effected the latest versions of Microsoft Windows software. To put it simply, Microsoft was eventually able to provide a much more user-friendly interface by employing principles similar to those that had been used in the design of the Macintosh operating system.

With that in mind, it seems clear that one good place to start in the study of interface design is to look at the principles that were written down and followed in the creation of the human interface that changed the very nature of the way people and machines work together.

THE APPLE HUMAN INTERFACE GUIDELINES

The basic principles for the design of the Macintosh human interface are worth studying. The principles are published in *The Apple Human Interface Guidelines*, a book that is available to the general public. Here is a summary of the principles it presents:

- Simple design is good design.
- People deserve and appreciate attractive surroundings. A mess is acceptable only if the user makes the mess.
- Good design must communicate, not just dazzle.
- Objects should look like what they do so that the user can recognize them and point to them.
- Consistency should be valued over idiosyncratic cleverness.
- The transfer of skills is one of the most important benefits of a consistent interface.

- The environment should appear to remain stable, understandable, and familiar.
- There should be little or no difference between what the user sees and what the user gets.
- The user, not the computer, should control the action.
- The interface should stimulate the feeling that the user is in charge of the system, and it should be fun to use.
- The user should be kept informed of what's going on via messages (presented in dialog boxes).
- The user should be allowed to do anything reasonable and be forgiven if a mistake is made.
- Generally the interface should use metaphors.
- These metaphors should be supported with audio and visual effects.
- Animation, when used sparingly, is one of the best ways to draw a user's attention to a place on the screen.
- There should always be a way out.

Consistency of Interface

The way Apple wrote these human interface guidelines seems to indicate that, although consistency is a valuable commodity, effective interface design does not require strict adherence to tight constraints. Rules governing consistency probably don't carry down to the level of the exact shape or placement of individual icons or buttons or the shape and wording of menus. In fact Apple puts this principle into practice in its own design environment, where lack of consistency is the byword. HyperCard, for example, offers 12 different kinds of "standard arrows" in its "Icon menu," as well as four different kinds of question marks that can be used to indicate "Help."

The fact that a question mark *always* indicates "help" is well in keeping with the human interface guidelines. The shape of the question mark and other design considerations are areas in which creative freedom can and should be exercised.

In spite of all this, it is important to remember that *icons* (such as the question mark) should never mean one thing in one place and something else in another. So, if the question mark means "help" in one of your programs, it should never be used to indicate "main screen" in another.

According to the Apple guidelines, program structure and flow are also very important. So, the number of screens or menus (the path) that it takes to get to an activity is critical. The more direct the path, the better. A direct path is far more important than whether the buttons taking you there are black arrows, white arrows, or arrows at all.

Tools

In addition to buttons, menus, and structure, many multimedia programs, be they CD-ROMs or Web sites, employ special tools. One tool is a bookmark that

Figure 10.1 A Set of Multimedia Tools from Apple Training Program

can be placed at the point in a program you are leaving for easy access when you return. Another is a notebook tool that allows you to take notes on the material. There can also be a map so that you can know where you are and a search feature that allows you to locate items. In Web sites search features are often provided by one of the "over-the-counter" search engines that are currently on the market.

When I worked at Apple we determined that tools such as these should always be considered whenever we plan the creation of a multimedia learning program, even though their exact use may or may not match the objectives of the project and therefore may not absolutely be required in every program. If there was justification for *not* using these tools, then they were dropped. Otherwise, we felt they should be included. Figure 10.1 shows a set of interactive multimedia tools from one of Apple's major multimedia learning programs.

Look and Feel

The *look* of a multimedia program and the production values it takes to get that look are important. As stated in the guidelines, "Users deserve and prefer an 'attractive look' to their experience." As a general rule, the look should be designed to match the objectives of the program. This implies that the program is designed to appeal to a specific audience. Because audiences vary, there will be a need for a variety of looks to the programs you create.

On the entertainment side, we created one look for the Web site that promoted the film *Indian in the Cupboard*. It was a little boy's room, and it gave the sense that this was a safe haven that a little boy could turn to when he needed to be alone, a special place. It is pictured in Figure 10.2.

A very different look was created for the movie *Clueless* with its focus on teenage girls, high-end Beverly Hills fashion, and gaudy taste. The top of the menu page for that Web site is pictured in Figure 10.3. Although this image does not feature the cast of the film, the color, design, and even the vocabulary should be clear.

Figure 10.2 Amri's Room from the *Indian in the Cupboard* Web Site. TM and Copyright © by Paramount Pictures. All rights reserved.

Figure 10.3 Banner of Menu Page for *Clueless* Web site. TM and Copyright © by Paramount Pictures. All rights reserved.

Navigation

Whatever links may be imbedded in a home page graphics, or exist as text, it has become common practice to repeat these navigation controls in a single consistent strip that can be found along the top, side, or bottom of each page or screen. In Web design this strip is called the navigation or *nav bar*.

The nav bar usually consists of links that are represented as words, or icons. The number of links on the control strip can feature certain very common functions becoming more and more standard as they appear indispensable to the operation of systems.

The indispensable controls on the control strip generally appear to be those that move the user between major blocks of information. Next in importance are those controls that take the user to adjacent pages within a given area. The controls that move the user through the immediate space of the segment are called *navigational controls*; those that move the user between major blocks of material are called *global keys*.

Navigational Controls

Navigational controls operate on the premise that the user has both to be able to move forward and backward through informational frames, and have the ability to jump out of any part of a particular segment to the end of that segment or the beginning of the next. *Netscape* and other Web navigators provide next and previous controls on their own control strip (as part of the interface) so it seems obvious to rely on those controls. However, they are not permanent. Users can close down those controls, as can program designers who make that part of the running of the site, so navigation controls generally have to be present on the pages of the site and designers should plan to put them there.

If you use the book metaphor common to some Web sites, the typical navigational control might be words that say "next page" or "previous page." They can also be represented as arrows.

Global Controls

Global keys take users completely out of the sequence they are in. They can offer to take users back to the main menu, or they can give users the ability to access a help menu that leads to a variety of instructional segments. Other global keys can allow users to "quit" the program or they can give users the ability to call up a search function. Most commonly, however, global keys take users between the various major segments of a site.

The most useful control strip configuration might contain a combination of global and navigational controls that are arranged so that the order of the controls has some logical relationship with the position of the segments in the program. Figure 10.4 illustrates such a control strip from the *Clueless* movie promotion site. Note that the names of the different areas of the site are included, as well as global controls to the main menu and out of the site to the home area, in this case the Paramount home page.

Figure 10.4 Nav Bar from the *Clueless* Movie Web Site. TM and Copyright © by Paramount Pictures. All rights reserved.

THE EXPERIENCE

Beyond, buttons, menus, and look is the whole *experience.* The hierarchy that contributes to the consistency of the sense of experience is:

- Program structure
- Program flow
- Production values (image quality, use of sound and video)
- Look of the production
- Consistent use of icons
- Design and utility of menus
- Design and placement of buttons
- Transitions

If the sense of tension that is present in any action adventure film is transferred to the images, the language, and the sound effects of the site itself; if the activities share the same theme; if even the names of the areas and the buttons that go to those areas share the feeling; if the pacing of the use of the site is also exciting, then we have created a Web experience that matches that of the film and helps people expand the theater experience to their computer screens.

But this unique experience can't happen if the designers of the site are locked into a rigid structure. For this reason, it is the "spirit" of the previously noted *Apple Human Interface Guidelines* that makes sense, and that "spirit" does not encourage strict adherence to design regulations. Perhaps the best way to implement this point of view is to allow developers to create their human interface designs in unrestricted environments and then to compare their designs to the guidelines and adjust accordingly. If the new solutions appear to be *"not better, just different,"* they should not be used. Then you can go back to the old tried-and-true methods about placement of links and access to tools. If you follow this practice, you can then have the best of both worlds, appropriate design and consistent user interface.

MAXIMIZING THE CAPABILITIES OF THE MEDIA

One major goal governing guidelines for human interface design should be that those guidelines do not limit the capability of developers to use new and fuller applications of interactive multimedia technology. Everyone needs to develop, or at least *seek* to develop, programs that take full advantage of these technologies. This means creating designs that push the envelope for the use of media and those designs should only be scaled back when the harsh realities of the medium's limitation can no longer be denied. Am I saying that you should always design video into your Web sites? I'm saying design them the way you want them to be, and then back off to simpler solutions later. Keep trying to put new media elements into your sites or your applications, keep pushing that envelope.

THE STABLE INTERFACE

The principles and the tools of human interface design are stabilizing rapidly and, as we discover the best tools, icons, buttons, and menus to convey given ideas, we lock in on them and make them available to everyone so people everywhere can share the common experience and transfer that knowledge across various Web sites, programs, and systems.

The trick for all of us is to make our creations so transparent that users do not need to learn them — they must be intuitive. With the democratization of the Web and the popularity of CD-ROMs, usage of multimedia has become all pervasive and now most people pick up the use of the human interface as quickly as they find and bookmark the location of a site. It is the exception rather than the rule now when a Web site's interface is so poorly conceived that people cannot figure out its navigation within a few quick mouse clicks.

11

Prototyping

Some developers feel that prototyping is the part of the creative development process that is the most fun. It requires that you actually make a working model that will let users experience the look and feel of the new product. In doing so, however, you don't have to build out the product in every detail. So you get to concentrate on all the features and the magic of the new product without having to add the detail of the more mundane, more repetitious sections. In that sense, the prototype is like the level 2 flowchart. It represents all the different kinds of interactions that are possible without actually following all of them to their necessary conclusions. Even prototypes of interactive stories need not show every possible outcome. They can show a few of the paths that can be taken and still give a sense of the kinds of interactions that are possible.

WHY PROTOTYPE?

The following list provides five good reasons to prototype:

1. A well-executed prototype is the best way to sell your project to a prospective client. Nothing sells a product better than a working model, and a prototype is at least a partially working model. Moreover, it is a milestone and a buyoff point that make it easier for the client to say "Yes!" If there is resistance to starting the project, you simply point out that you will show the clients a prototype within a reasonably short time and they can revise it as much as they want. In addition, if they don't really like the way things are going at that point they can stop the project right there. So why not at least sign on through the prototype phase.
2. A prototype of a multimedia project can prove that the technology is the most effective way to present the material. A sales training exercise that uses student role-playing to simulate customer interviews can be effective; it can also be tedious. However, a simple prototype using digital media

can demonstrate the power of the technology for this application and help you and other decision makers determine whether or not it is worth doing.
3. By establishing design specifications (and eliminating failures early), prototyping can make production faster and more effective. Design alternatives can be tested early by a small development team. Therefore, when production swings into high gear, all the hard decisions will already have been made.
4. In the process of creating a prototype, you can experiment with various strategies and tactics. Be as innovative as you dare—the risk is minimal and the rewards can be great. By exercising a little unbridled creativity, you might discover a way to present your material that is totally new and remarkably effective.
5. If you have never created multimedia, prototyping can be an excellent way to gain experience in the development process. By starting with a small project, you can discover the processes and the pitfalls on a small scale, with limited risk.

Demos versus Prototypes versus Pilots

A few years a go I worked in a multimedia R&D group where we made a clear distinction between demos, prototypes, and pilots. Each one had a special place in the product sales process, and each one cost significantly more than the previous. Demos were samples or illustrations of a work. Prototypes were working models that showed the feel of the whole thing and some of the parts in full detail. Pilots were complete products, programs, or productions that (like television pilots) were a single full-blown example of the work, but not of several episodes in an ongoing series.

So demos showed one path through an interactive program while presenting sample content. Even though the sample was supposed to be interactive and would show examples of menus and buttons, it was really linear. If six buttons were presented that led to six different choices, only one choice would work and the demo would follow that one path. It was as realistic as possible in the pursuit of that path. The other five sections were not developed so they could not really be shown at all. Very often the demos would be created on videotape. They were not meant to be operated *by* the user, they were meant to be demonstrated *to* the user. This usually required a salesperson to do the demonstration.

In an on-line Web site dedicated to sports scores and news, we would prepare a videotape with images of sporting action, presentation of scores, and sports headlines. Menus would feature buttons that went to various places. Viewers might actually see the buttons being clicked, but only one path would be taken. Salespeople might explain what was happening and how the interactions were being completed. They might even pretend that the interactions were under their control. But they would not be. The video only showed one path through the material and as such only had to contain content relative to that path. Nevertheless, when presented correctly, the video demos gave the audience a good sense of what the experience would *look* like.

Prototypes on the other hand were meant to give the users a sense of what the experience would feel like because they would be operated by the user. You could literally turn the prototype over to a group of people and let them bang on it, play with it, operate it, make it work. Because of this, the prototype often had to contain features that told where each path led. If paths were not complete or if interactions were not available, something would have to come up and say "not yet available" or "under construction" or words to that effect. Nevertheless, prototypes were never meant to be completed. They were a working model of part of a system, perhaps a complete module, but never the whole thing. So a prototype of the sports information system we were describing would have real clickable buttons and lots of articles and information that could be accessed. One or two of the simulation games at lower levels of the system would work, but they wouldn't all have to work. If there were on-line scores to be presented, some of them would appear during the presentation, although they definitely would not be up-to-date or changeable.

Pilots, on the other hand, were completed programs or presentations. Every path went as far as it could go. All the information was complete. If general updating was available because the system was hooked into some information source that offered updatability, that was there, too.

What was not available was the creation of new content that would give the presentation the feeling of being an ongoing series. So, again, going back to our sports example, a pilot created during football season would have all the contents of a complete program. It would be tied into a wire service so that up-to-date football scores could be presented. It might even contain a fully functional model of a virtual reality football game. But no new content would be created for the pilot. The scores would update because they would be hooked into a system that automatically updated scores. The games could be played because they were self-contained units, but there would be nothing about what would happen in another sport whose season would begin next month. That was another show and the pilot only presented one complete program.

If you estimated the costs of a demo, a prototype, and a pilot you would get costs such as these: $25,000 for the demo; $75,000 for the prototype, and $250,000 for the pilot. In such a structure you can see that far more prototypes than pilots were done. But beyond that, when you looked behind the numbers of the demo and the prototype, you would find that the real costs of producing a video demo illustrating the use of an interactive product and the real costs of producing a working prototype of the product were really quite similar. The cost difference could very well be nothing more than profit for the developer. You'd have to know the real functional specs of each kind of demo and prototype, of course, but knowing the kinds of elements that go into each, it is possible that the video demo and the prototype require similar kinds of elements and end up costing about the same.

So, in that case why not shortcut the process, save the cost of the demo, and go right to the prototype? Unless you have some big sales meeting in which you are forced to present a demo to a large group of decision makers, going right to the prototype is a very good idea.

Levels of Prototypes

There can be many levels of prototypes depending on the degree of functionality you want to show. But there are some fundamental things that *have to* be in a prototype. Let's just list those and say that if you want to pay for more functionality, doing so is an interesting, but not necessarily a wise, decision.

Prototypes have to show:

- The look and feel of the menus and navigation system
- The general metaphor for the system
- The graphic style of the system
- The branching structure of the system
- Samples of the media elements that will be in the system
- Samples of flow of the story through key branching points
- Samples of any game or VR functionality
- Samples of any other unique and special features of the system

You could sum up that checklist in a single sentence. Prototypes have to show the look, feel, functionality, and *magic* of an interactive system.

Tools for Creating Interactive Prototypes

New tools for creating prototypes are appearing all the time. Surprisingly enough, one piece of software stands preeminent today as the tool of choice for creating most interactive prototypes. We'll spend some time reviewing that one tool and then consider its oldest, but still most serious rival, and then an entirely new methodology for creating prototypes.

MacroMedia Director

MacroMedia Director is the most evolved, the most stable, and the most versatile tool available today for creating interactive prototypes. Beginning in the mid-1980s as VideoWorks, Director evolved from the somewhat novel functionality of creating small animations with accompanying sound to being the engine that drives many of the great multimedia programs that exist today. Even today, while many of the elements that become part of a multimedia program are put together in Adobe PhotoShop, and SoundEdit Pro, Director takes control of these elements and tells them how and when to perform.

Jason Robert's great "how to" book on Director, *Director5 Demystified*, gives a great set of lessons on using the program. If you want to learn Director, buy the book, dedicate a few hours a day to reading through the lessons and doing the exercises that are called for, use the materials provided on the CD-ROM, and then, as soon as possible, get a real project and start employing the software to your own ends. You'll be amazed at how easy it is to learn.

This book is not a "how to," but it does hope to offer some insight into the elements that make up interactive multimedia. To that end, here is a summary of

Director's functionality from Jason Robert's chapter on *A Guided Tour of Director* with a few added points from me:*

- Director has four main windows, the Stage, the Cast, the Score, and the Control Panel (Figure 11.1).
- Director's files are called movies.
- All action takes place on the Stage window, a blank area that you can size and position anywhere on the computer screen. The action on the Stage is controlled by a control panel that advances, pauses, rewinds, or resets the action.
- The action is created, however, in the Score window (Figure 11.2). The process of experiencing the action is known as Playback. Hitting the play button on the control panel sends a cursor known as the Playback Head, through the score that effectively performs your movie by sequentially processing the score information.

Figure 11.1 Director's Control Panel Window

Figure 11.2 Score Window

* J. Roberts. *Director 5 Demystified* ©1996 by Jason Roberts. Reprinted by permission of Addison-Wesley Longman Inc.

- The elements of multimedia (graphics, sounds, digital video, even other director movies) are stored and accessed in the Cast window (Figure 11.3). They are known as Cast Members. Some cast members are *embedded*, which means they reside entirely in the Director movie. Others are *linked*, which means that their actual data remain in an external file.
- Each column or vertical row in the score represents a relative moment in time. Cast members placed in Cells in a column will show up on the stage at the given moment during playback.

Figure 11.3 Director's Cast Window

Figure 11.4 Director's Paint Window

- Each Channel, horizontal row, in the score represents a layer on the screen. There are specialized channels for sound transitions, tempo, and color palettes.
- Images and on-screen text can be created in different ways. They can be imported from outside programs such as PhotoShop or created internally in the Paint Window, director's own graphics creation tool (Figure 11.4).
- *Lingo* is everywhere. The control language of Director can be *attached* to a cast member or *be* a cast member in its own right. It can also be placed in locations in the score.

A final note on Director. It does feature its own tool for translating Director movies into Web content. It is called Shockwave. Run your movie through Shockwave, and it is available to anyone who has access to it and who has a Shockwave plug-in. Of course, Shockwave plug-ins for the internet and all those issues are discussed further in Chapter 20.

This is a very cursory review of the elements of Director, but I hope, one that at least shows you the complexity and the mechanical procedures required to create prototypes with the authoring system.

HyperCard

Up until very recently HyperCard lacked a good deal of the audio and animation functionality of MacroMedia Director. Nevertheless, HyperCard still is the software program that made multimedia popular. And, even if your product will finally end up being created on some other authoring system, building a prototype in HyperCard is still the quickest and easiest way to get it done. Moreover, HyperCard 3.0 is promising to return with a vengeance. So for those who want a prototyping tool that is quick and easy to learn, here is a brief overview of HyperCard.

HyperCard was the brainchild of Bill Atkinson, the Apple innovator who created major portions of the Macintosh operating system and the MacPaint program. Atkinson's intent was to put the power to develop software into the hands of Macintosh users, thereby creating a software development environment "for the rest of us."

HyperCard was released in August 1987 and immediately defied description. It has been called a database manager, a presentation tool, a programming system, and a "personal toolkit for information," among other things. Through the examples presented in this book, or from your own experience, you may already be familiar with HyperCard.

The basic unit in HyperCard is the "card," a single screen of information modeled after the familiar 3×5 file card. You might make notes or draw pictures on a file card; you do the same thing with the cards in HyperCard. Cards can contain text fields, graphics, and buttons. A group of cards is called a *stack*.

Within a stack you might have several groups of cards that look and function the same way, but that have different text and/or graphics. For example, the menu cards (which allow the user to select from a list of items) might all have a

central text field displaying a large font, with buttons for navigation. These may be located in the same place on each card. The menu cards could all share a common "background," which defines where the text and buttons appear and how operations are performed. In addition to menu cards, your stack could include item cards that share a different background from that of the menu cards. The item cards could display several text fields and have room for graphics.

Creating Buttons Cards, background, stacks, text fields, and buttons can all be programmed to respond to user actions. This programming is done in HyperTalk, the native language of HyperCard. This powerful language is English-like and is very easy to read and understand. As an example, a button on a card might behave as though it was saying to itself: "When the user points to me with the mouse and clicks, I'll go to the next card." The HyperTalk language (or "script") for this action is:

```
on mouseUp
    go next card
end mouseUp
```

When you create a button, you can define how it looks and behaves by selecting options from the "button info" dialog box (Figure 11.5).

The button "goNext" is a rounded rectangle button that will highlight automatically when clicked. To edit the script of this button, you simply click the Script... button. By clicking Effect... you get a list of 23 "special effects" to choose

Figure 11.5 Button Info Dialog Box

Figure 11.6 HyperCard Icons

from, such as zoom, dissolve, barndoor open, iris close, checkerboard, venetian blinds, stretch, and shrink. The effect you select will be used when your script takes you to another card. When you click the Icon... button you are presented with an extensive set of icons from which to choose (Figure 11.6).

If you don't find an icon you like, you can create your own using the built-in icon editor.

For a more complex example, a button on a card might have the property: "when the user points to me with the mouse and clicks, I'll ask what 3 plus 4 equals and evaluate the answer." The script for this action is:

```
on mouseUp
    ask "What is 3 plus 4?"
    if it is 7 then
        put "You're right!" into message window
    else
        play "boing"
        put "Sorry, you're wrong." into message
        window
    end if
end mouseUp
```

HyperCard Paint Tools HyperCard also includes a set of sophisticated drawing tools that allow you to create graphics. Similar in function to many of the Macintosh paint programs (like its older brother, MacPaint), HyperCard gives you tools such as the pencil, paint brush, spray can, eraser, and paint bucket. You

can use the rectangle, polygon, and ellipse tools to draw shapes and the lasso to capture images and move them around.

For some time HyperCard has allowed you to *display* color drawings, scanned images, or video stills. The painting tools only worked in black and white. There was, however, a set of color tools that allowed for adding color backgrounds, buttons, and text fields. Unfortunately color images created in other paint programs could not be modified from within HyperCard, not until now. With the powers of HyperCard 3.0 color becomes integrated into all of HyperCard development. Check the description of HyperCard 3.0 a little later in this chapter.

Working with HyperCard Stacks Multiple stacks can be open at the same time, allowing the presentation of many different types of information at once. In addition, HyperCard contains several excellent tools for programmers, such as a source code debugging environment that lets you monitor the actions of your script as you step through it one line at a time. There are also windows that keep track of all your variables and messages.

Video and Audio Features The HyperCard package also includes tools for importing and showing video, such as QuickTime movies (Figure 11.7), for tying digital audio to segments of the presentation either when entering and exiting cards, on button clicks, or as timed elements within a presentation. The HyperCard environment is also "extensible," which means that extra features can easily be added.

Figure 11.7 QuickTime Movie

HyperCard 3.0 Take everything we have said about HyperCard and add a new set of capabilities that may make this "first scriptable presentation application" one of the key multimedia tools of the next century. They are all part of HyperCard 3.0.

Key to the update to HyperCard 3.0 is its rebuild on top of the QuickTime media layer (QTML) making HyperCard 3.0 *the* interactive development tool for QuickTime. Along with the marriage of QuickTime and HyperCard comes a full set of color painting tools and full support for color, a step far beyond the limited use of color that has held HyperCard back for so long. HyperCard will now be playable on all players that can run QuickTime from QuickTime enabled browsers to word processors.

Although it will act as it does in its current editions, HyperCard will also be able to display virtual reality applications, 3D, and MPEG. Finally, HyperTalk, the control language of HyperCard, will become the functioning control language of QuickTime, giving it the ability to deal with user interactions. The complete package of HyperCard 3.0 is truly impressive and as powerful and revolutionary a prototyping tool as the original HyperCard was in its day.

PROTOTYPING DIRECTLY TO THE INTERNET

HyperCard can post stacks directly to the Internet. Director movies can be imported to the net by converting them to Shockwave files. So prototypes created in Director, for example, can be reviewed as movies and then posted to the Web for all to see. The problem with that process is that, although it is fairly easy to build a prototype of a Web site in Director, the final version will most certainly not be delivered entirely in Shockwave. The memory requirements of Shockwave are just too great. So, although there has been a tendency to create *prototypes* in one authoring environment and then to deliver the final program in another, many Web site developers are now skipping nonextensible prototypes and building the prototypes directly on the Internet. That process can't, of course, be employed for all CD-ROM or interactive television prototyping, but it does work for the Web.

There are a lot of good reasons for prototyping directly on to the Web. For one, if the final product is to be a Web site, the prototype programming can be a way of creating the actual structure of the site. Then no one will have to go back, take the prototype apart, and rebuild it as a Web document. In this case the prototype simply becomes more and more refined until it is a pilot of the final site and eventually the working site itself. A lot of steps are saved.

Another reason for creating prototypes directly on-line is the ubiquity of the Internet. If the Internet is everywhere, than anyone who has the password to your protected server can look at your prototype without file transfers, zip discs, or other portable media.

Although not all designers are as proficient at Pearl, cgi, Java, and the other programming languages required to create sophisticated Web sites, basic Web building tools, such as PageMill, the fine HyperText Markup Language (HTML) authoring tool from Adobe, are making Web authoring available to more and more designers. A level of sophistication up from PageMill is Net Objects Fusion,

another Web site building tool that works great for prototyping directly to the Web. So, let's take a look at both of them and their development capabilities.

PageMill 2.0

Among the Web authoring tools available today PageMill is perhaps the easiest to use. Its word processor style functionality allows even the novice to get a prototype up and running in almost no time at all.

Ceneca Communications introduced PageMill at MacWorld Boston in August of 1995, and Adobe purchased it almost immediately. It was released to the public on October 31, 1995, and was quickly touted as the easiest way to get up on the Web.

PageMill functions very much like a word processing program. You can enter, delete, and edit text, copying and pasting information between pages or within the same page. It also allows you to drag and drop blocks of text to speed up editing and to revert to the last saved version of your document, just in case the edits you've made don't quite measure up to the original. A Pasteboard lets you keep handy any text or graphic that you will use in multiple locations, allowing you to take full advantage of the drag-and-drop feature. The newly added spell checker will help you avoid errors. You can also format both font and paragraph styles using PageMill's pull-down selection menus and preview your Web pages so you'll know exactly how they'll look when they get posted to the Web. The program invisibly creates all the HTML, so you don't have to, but for those with HTML experience, you can access and edit the code directly for more advanced coding.

PageMill also allows you to easily incorporate graphics, sound, movies, and other multimedia items into your site. Using copy/paste or drag and drop, you can place banners, icons, even background images on each page. Or you can opt for a background color to keep the look clean and simple and to minimize download time. Text color can be customized as well.

Creating links between pages is also quite easy. Just drag the page icon from the corner of your destination page and drop it on to the page you would like to link to it. Or create links to an outside site by highlighting the text as before, clicking in the bar at the bottom of the page, and typing in the Universal Resource Locator (URL) to which you would like the text to link. Other link types, including anchor tags and image maps, are also easy to create.

PageMill is more than just an HTML generation and graphics placement program. Aside from the text editing, art layout, and page linking capabilities, simple systems within the program make it easy to build and use tables and frames and to create forms for gathering information about the individuals who visit your site. Figure 11.8 shows the development environment in PageMill.

There are currently several books on the market that show you how to get the most out of PageMill 2.0. The *Visual QuickStart Guide to PageMill 2* for Macintosh from PeachPit Press uses illustrations rather than lengthy explanations

Figure 11.8 The Development Environment in PageMill

to walk you through the program. Several other books include CD-ROM tutorials and graphic archives to enliven your Web site–building experience, but you'll wind up paying a lot more for these programs.

NetObjects Fusion

NetObjects Fusion allows the creation of the most advanced prototypes and, in fact, is one of the most complete of all tools for the creation of entire Web sites. First developed in November 1995, NetObjects Fusion was created by information architects, navigational specialists, and designers to do more than simply link pages, place graphics, and convert text to HTML. It includes functionality that integrates all the major steps involved in building and publishing a Web site.

NetObjects Fusion begins with a comprehensive site architecting program that allows you to lay out an entire prototype or, eventually, an entire Web site. With each page you add to the chart, links are created. If you have to move a page later, the links are automatically corrected to reflect its new position on the chart. And because your entire site is stored as a single file, you don't have to keep track of a large number of individual HTML documents.

Once your prototype is laid out, it's time for the design. NetObjects Fusion's PageDraw Editor lets you create and place graphics with "pixel-level" control. The MasterBorders feature available in version 2.0 makes it simple to

create a consistent look and navigation. Rather than having to edit each page individually, a single change to the MasterBorder will be reflected on every page. And with one click of a button, a MasterBorder can be converted to frames to decrease load time.

You can also easily integrate additional programming, including HTML, animated GIFs, Java, cgi, and Shockwave. (For more on all these applications, See Chapter 20.) The program even includes a few basic Java and cgi components to help make your site more eye-catching.

Once you've finished your prototype (or your finished site), posting is easy. Simple buttons let you preview, stage, and publish on any server instantly. And you won't have to worry about the layout of your prototype changing once it's out on the Web. A special grid ensures that objects will appear right where you place them, and, because NetObjects Fusion is a cross-platform application with an open architecture, your Web site will be compatible with all Web servers and browsers.

NetObjects Fusion is one of the most complete Web site–building tools. Its integrated functionality makes creating detailed prototypes and fully functional Web sites a real pleasure.

We have given you reasons why you should prototype, and we have pointed out that a prototype need not represent the entire product, just the most interactive elements and the look, feel, and magic of it all. We have suggested that MacroMedia Director is currently the most widely used prototyping tool. HyperCard was the first great prototyping tool, and with its latest incarnation it may be first again. In the mean time there is a greater and greater shift to building prototypes directly onto the World Wide Web, where all necessary parties can watch the product's evolution and where, if the product is eventually to become a Web site, much of the prototyping can serve as actual site development.

Interactive Instruction

12

Basic Structure

The fundamental elements of instructional design are lessons and tests. In interactive media, a lesson is an entire unit of information on a single subject or on a very few related subjects. It also includes any exercises needed to clarify the point. Because exercises strengthen the learner's understanding of the concept, they are part of the lesson, not part of the test. For example, in banking, the subject of debits and credits is taught as a single lesson because the two subjects are closely related and in fact often confused. The exercises that differentiate debits from credits are part of the lesson, not part of the test.

A demonstration explains what something is or how to do it; an exercise lets you practice doing it. Tests are given to find out whether you know how to do it. At best they are practice at actually doing something, even if the "doing" only means cognitive behavior, such as distinguishing one item or another. Maybe the easiest way to tell the difference between an exercise and a test is to see whether there is feedback. Because tests are designed to find out whether a person has learned something, they normally don't give feedback. Their purpose is to find out what you have learned. Exercises, on the other hand, are all about feedback because their purpose is to help you learn.

Figures 12.1 and 12.2 present two basic lesson design formulae. Keep in mind that they show the flow of information in a *lesson;* they are not meant to be universal formulae for *exercises*. The design of exercises is governed by content and objectives, as well as that fundamental question—Who are the learners and what is their role?—as discussed in Chapter 7.

The basic lesson design flowchart in Figure 12.1 indicates that the very minimum you can do when teaching something is to demonstrate it and then ask one or more questions about it in a test. If users answer the questions correctly, they go on to the next lesson. If they fail the test, the lesson and test are repeated.

Figure 12.2 represents a modest expansion of the design shown in Figure 12.1. In Figure 12.2 there are several demonstrations and a multifaceted test. If viewers pass, they go on to the next lesson. If they miss several questions, they start over at the beginning of the first demonstration. If they miss one question, they go back to the part of the lesson that deals with whatever misconception led them to their error (in Figure 12.2, this would be the material presented in Demo 1C). Important details to note are that lessons include both demonstrations and exercises; tests have many questions.

All major kinds of lessons, then, can be summarized with one flowchart, shown in Figure 12.3. However, an interactive training program usually con-

Figure 12.1 Basic Lesson Design Flowchart

Figure 12.2 Expanded Lesson Design Flowchart

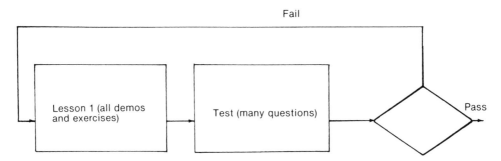

Figure 12.3 Universal Lesson Design Flowchart

sists of more than one lesson. In addition, there are other activities that must be carried out as part of a total training program. Let's move beyond lessons and tests to see how lessons fit together into whole training programs. We will also consider elements that can be added to the overall program design to make it more effective.

LESSON ORDER

Instructional interactive digital media programs are usually made up of several lessons. Let's look at some examples of programs that consist of three lessons each. Lessons can be set up in unchangeable order (Figure 12.4). In that case, the viewer must proceed from one lesson to the next. However, lessons can also be designed so that the learner can pick the lesson order using a menu (Figure 12.5). Finally, lessons can be arranged so that the learner must complete a prerequisite lesson before choosing between other lessons (Figure 12.6).

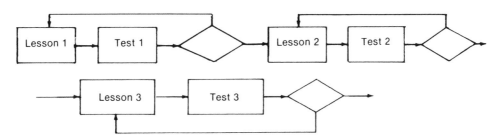

Figure 12.4 Predetermined Lesson Order

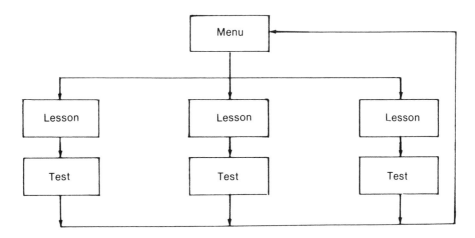

Figure 12.5 Learner-Determined Lesson Order

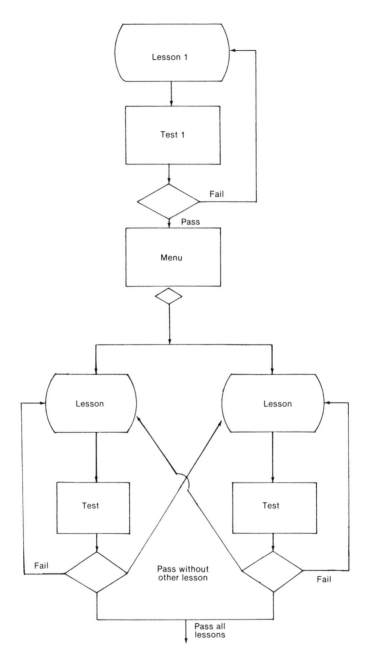

Figure 12.6 Learner-Determined Order with Prerequisite Lessons

INTRODUCTIONS AND EXAMS

In addition to lessons and tests, most instructional designs call for introductions, which include objectives, explanations, and overviews. There are also final exams, which integrate information from *all* lessons.

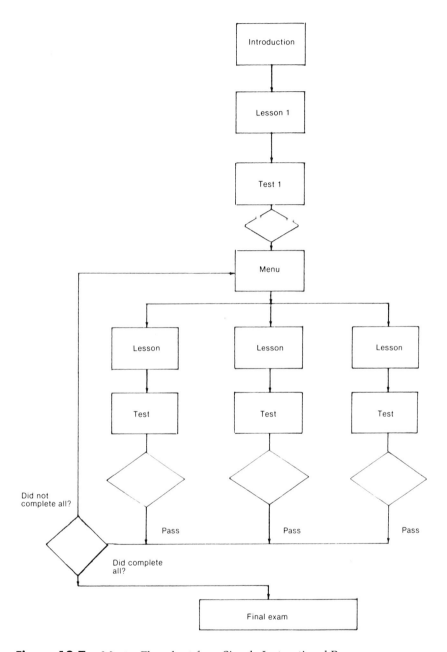

Figure 12.7 Master Flowchart for a Simple Instructional Program

A master flowchart for a fairly simple instructional program, integrating all of these elements, would look like the one shown in Figure 12.7. Note that the "test fail" path is not shown. This omission is acceptable in a level 1 flowchart because it is obvious. However, level 2 and level 3 flowcharts would require it.

ENHANCING BASIC INSTRUCTIONAL DESIGNS

Various techniques can be used to add some sophistication to lesson designs and make them more effective. These include lesson and program reviews, pretests, and even prologs and epilogs to help provide a context for the learning and to build learner interest.

The flowchart in Figure 12.8 shows how you can insert a review in each lesson before the test segment. The design in Figure 12.9 lets the learner review the whole program by skipping from one review segment to another. After completing the test, the learner jumps back to a review and then immediately branches to the other reviews before taking the final exam.

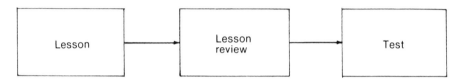

Figure 12.8 Lesson Review Technique

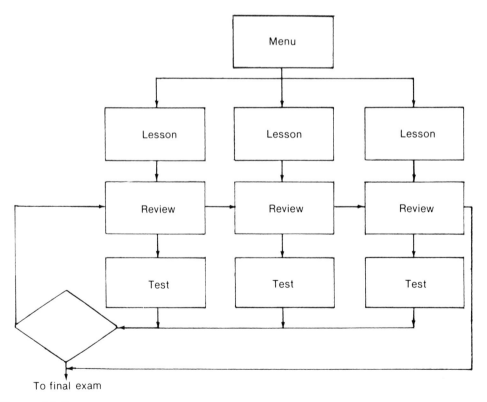

Figure 12.9 Program Review Technique

Figure 12.10 shows how the instructional design can allow for a pretest that permits the learner to skip certain lessons. Here, once the viewer passes the pretest, he or she skips lessons 1, 2, and 3 and proceeds directly to 4.

A fully developed program design flowchart incorporating all of these techniques is shown in Figure 12.11. What should be clear is that, depending on the design techniques you use, you can create one interactive instructional program that will serve a variety of learners who are at different entry levels.

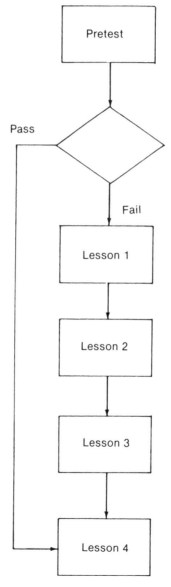

Figure 12.10 Pretest Technique

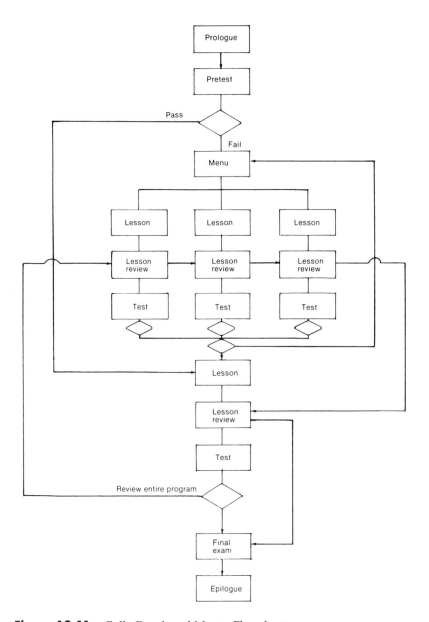

Figure 12.11 Fully Developed Master Flowchart

The flowchart and instructional design techniques presented in this chapter will help you build the framework for your own instructional interactive digital media. In the upcoming chapters, we will examine the design strategies that influence the effectiveness of your program in meeting its objectives. These strategies pertain to the design and construction of exercise and test questions, the heart of all interactive learning programs.

13

Exercise Design

Interactive exercises are most effective if they are simulations of the behavior to be learned. As simulation techniques depend on the kind of learning problem being addressed, there can be no universal exercise formula that will serve every kind of need. In this chapter we will look at several different kinds of instructional exercise designs and the learning problems they address. Moreover, even though a detailed discussion of interactive entertainment designs is coming up in Part 4 of this book, we will also present a few examples of interactive learning exercises that have been adapted to entertainment media and that work very well with that subject matter.

LEARNING PROBLEMS

Because exercises vary with the problems they solve, let's start with a systematic review of the four major types of learning problems.

Discrimination Learning Problems

Discrimination is the ability to differentiate between several items. For example, I once designed a bank training program to teach learner tellers how to tell the difference between three kinds of teller stamps.

The tellers had to be able to recognize when to stamp a customer's check or deposit slip with a "batch" stamp, an "interbranch" stamp, or a "cash-paid" stamp. (Cash-paid was used only when cashing a check or paying on a withdrawal.)

The logical exercise format to choose in this case was a simple three-way multiple-choice exercise, since tellers who were actually performing the behavior were in fact picking one of three items. Figure 13.1 diagrams the part of the lesson dealing with the cash-paid stamp.

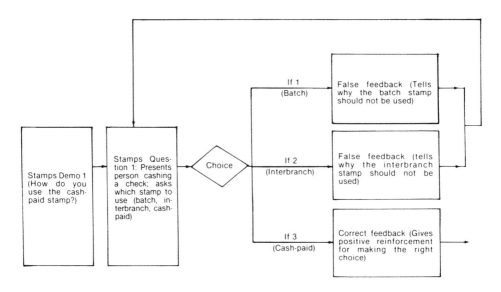

Figure 13.1 Simple Multiple-Choice

As Figure 13.1 shows, upon picking one of three choices, learners were given feedback tailored to the particular choice. If learners selected the correct answer (choice 3), they got positive reinforcement—a pat on the back. There was even some elaboration on why the answer was right before the lesson continued. If learners selected choices 1 or 2 (both incorrect), they got feedback explaining why the particular answer was wrong. The program then looped back, not to the start of the lesson, but to the *question* so that learners could try again.

By using branching, you can design feedback tailored to the learners' responses. Using specially constructed feedback is far better than just repeating a section of the previous demonstration to provide feedback. Tailored feedback can go into detail about why the answer is wrong and can add new insight into the learning experience. Figure 13.2 shows how you can use branching to expand on the simple multiple-choice formula shown in Figure 13.1.

The branch occurs after the first question, where two diverse paths begin. If the learner is right, he or she gets correct feedback and goes on. If the wrong answer is given, the learner is asked a completely new question (XQ2). A correct answer to that question steers the learner back into the mainstream. A wrong answer receives incorrect feedback (XFF2), which really explores the misunderstanding behind the mistakes that were made.

An alternative to the branching just described is *common feedback*. Common feedback is written in such a way that it explains both correct and incorrect answers. There is no branching or looping back following common feedback. Learners proceed directly to the next demonstration or lesson (Figure 13.3).

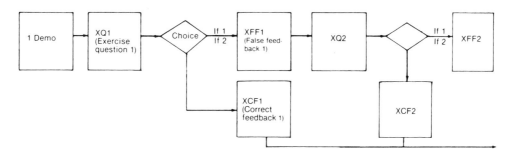

Figure 13.2 Complex Multiple-Choice

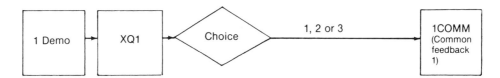

Figure 13.3 Common Feedback

Common feedback is a technique that should be reserved for questions that are part of a series, such as minor variations on the same idea. Common feedback is less specific and therefore less effective than branched multiple-choice, but in many situations it is quite adequate.

An Entertainment Application of Multiple-Choice

National Lampoon offered a great example of applying learning technology to entertainment products in its CD-ROM, *National Lampoon's Blind Date* (Figure 13.4). In that entertainment CD, the user met an extremely attractive young woman and took her on a blind date. His goal in the date was to get invited back to her apartment. The ability to keep playing the game was predicated on being able to choose the right thing to say to her in a series of situations that occurred throughout the evening.

The "things to say" were presented as multiple-choice wisecracks. Discriminations were often hard to make and, of course, the feedback to the wrong choices was usually nothing more than a putdown or even the end of the game. But for those hearty souls who persevered, and that included going back and starting over whenever you made a really bad blunder, you could continue on the date.

One reviewer of the game noted that going out on a real blind date was such a frustrating experience that there was little joy in playing a game that pretty much offered the same kind of putdowns and frustration. A more positive male reviewer, however, pointed out that having a 25% to 50% chance that everything he said to a beautiful woman would elicit a positive response was better odds than he ever had in his life.

Figure 13.4 *National Lampoon's Blind Date.* Used by permission of Trimark Interactive.

Regardless of the users' point of view, the game proved that the application of discrimination exercise to entertainment can be fun. And this was entertainment, not education. There was absolutely no proof that any players of the game learned the best things to say on a blind date.

Generalization Learning Problems

Generalization is the flip side of discrimination. Instead of learning to tell things apart, you learn to put them into groups. The most common type of exercise used to teach generalizations is an identification drill in which a variety of items are presented and must be grouped into several categories.

In *People Skills*, an interpersonal relations interactive video training program I designed for the Bank of America, learners were presented with a series

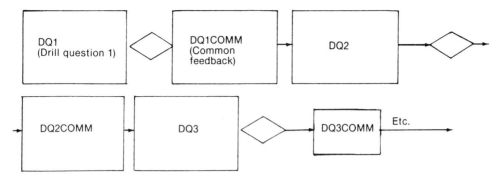

Figure 13.5 Identification Drill

of statements and were asked to identify them as statements that either clarified the conversation or got off the point. In general, learners first worked through exercises that helped establish the basic rules of commonality and identification for the different items and their respective categories. Then, a number of drill questions (DQ) were presented, followed by common feedback for either answer given, as shown in Figure 13.5.

The exercises that teach the basic generalization concepts are as important as the drill. Again, a multiple-choice design works especially well, particularly if you use an inductive multiple-choice format, in which learners draw on previous knowledge to find a new concept. When constructing an inductive multiple-choice exercise, you skip the explanation. Don't present the information needed to perform the task; instead you ask the question and allow the learner to make an educated guess. The positive feedback is the reward for being right, and its power can increase retention. Most learners find this technique quite enjoyable. The following is an inductive question on which stamp to use, from the *Debits and Credits* program. It is inductive because this point was never explained.

> There are three teller stamps: the batch stamp used in many transactions, the cash-paid stamp used *only* in cash-paid transactions, and the interbranch stamp used *only* in interbranch credits.
>
> Which stamp do you use on credits accepted for *deposit* at *your* branch?

Even if you are unfamiliar with banking, your sense of logic may lead you to pick the batch stamp. First of all, you have the odds going for you, since the batch stamp is used in *many* transactions. Second, you know that the interbranch stamp is only used for interbranch deposits. Finally, you could recognize that a deposit is, in principle, not a cash-paid transaction. So the cash-paid stamp is inappropriate.

This type of inductive exercise helps clarify a principle and also helps learners remember what they have learned. I highly recommend inductive exercises, especially when you are dealing with sophisticated audiences.

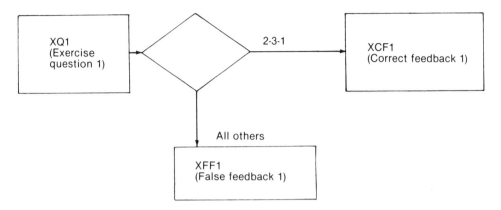

Figure 13.6 Sequencing Exercise

Sequence Learning Problems

Sequencing lessons teach how to get things done in the right order. Many mechanical skills have a sequencing component. For example, changing a spark plug involves several steps that must be performed in the right order or the job won't be done correctly and the car won't work. The types of exercises used in sequencing lessons might include ordering exercises, in which the learner rearranges tasks in the correct order. There is also a variation on the fill-in-the-blanks format, in which the viewer lists tasks in the right order.

In *People Skills*, we had to teach the three steps in greeting a customer — recognize, identify, and stroke — steps that were supposed to be done in that order. We presented learners with steps in this incorrect order, (1) stroke, (2) recognize, (3) identify, and asked them to reorder the activities. For the correct answer we allowed them to press numbers 2-3-1 in succession. The diagram in Figure 13.6 shows a simple way to construct this sequencing exercise.

An Entertainment Application of Sequencing Exercises

In the game we created for the Paramount Home Video Web site for *Mission: Impossible*, we asked users to put the events in a key part of the movie into chronological order. Users needed to take the numbers of the events and rearrange them into the right order. A unique feature of the game was that it had a "ClueBook" attached to each question. The clue was in fact a learning exercise that allowed players to figure out the right answers.

The clue was a click, drag, and bounce Java applet that allowed users to select the icon to the left of the event, drag it to the name of the event and then see if it stuck or bounced off. Although there was a certain amount of trial and error involved in the activity, the most successful users tried to think through the chronology before they began clicking and dragging. It was the thought

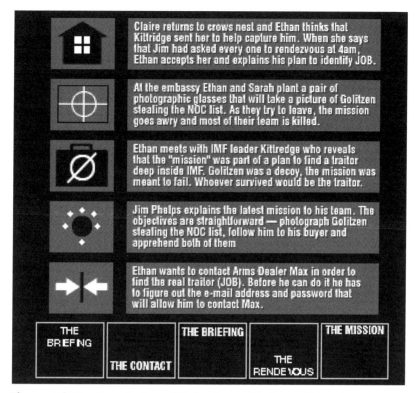

Figure 13.7 Exercise from *Mission: Impossible* Game. TM and Copyright © by Paramount Pictures. All rights reserved.

process combined with the immediate feedback of the drag and bounce that made it fun and effective. Figure 13.7 shows the graphic that was used. Answers were entered in a second frame that used numbers to establish the order.

Psychomotor Learning Problems

Using interactive media to teach psychomotor skills requires simulating of physical activities. Of course, when the activity is to use a computer or to press certain buttons, the job is that much easier.

Psychomotor training is what is going on in all the typist-training CD-ROMs that are on the market. These are the most natural and obvious of all computer-based versions of psychomotor training. *Mavis Beacon Teaches Typing!*, the best-selling typist-training program, demonstrates the ultimate kind of exercise for psychomotor skill training. It's called drill and practice.

Here's what designers should picture themselves saying to learners in drill and practice exercises:

- Here's how you do it.
- Now you do it.
- Now do it again.
- Now do it with this slight variation.
- Now do it with that slight variation.
- Now do it with this slight variation.
- Now do it with that slight variation.
- Now do it again and again until you can do it in your sleep.

Figure 13.8 shows a typical screen from the program. Learners are asked to copy the text, which appears in the line directly below it.

The folks who make *Mavis Beacon* have added some very nice touches to the drill-and-practice formula. There is constant feedback in the program on, for example, your words-per-minute performance that challenges you to increase your words-per-minute target if the system thinks you can. There are also challenges and games that ask you to keep trying to perform as fast as you can. It's an excellent program and an excellent example of this kind of instruction.

Meanwhile, psychomotor training on aiming and shooting weapons is the stock-in-trade of all action video games. It is also the key lesson in flight simulators or race car driving simulators. It even plays a role in on-line trivia games, where getting the answer in quickly is the key to success. Knowing just when to

Figure 13.8 Drill and Practice Screen from *Mavis Beacon Teaches Typing!* Used with permission of Mindscape Inc.

push the button is as important in *Jeopardy* and on-line trivia as it is in saving the universe. But we'll save that discussion for Chapter 19.

Learning Problems and Basic Exercises

This far we have focused on the four major types of learning problems: discrimination, generalization, sequencing, and psychomotor. We have said that the way to pick an exercise design is to look first at the problem to be solved and pick the exercise accordingly. Unfortunately, there is not an exclusive match of exercises to learning problems. The truth is that some exercises can work for almost all kinds of learning problems. Here is a simplified chart that tries to match up exercises and learning problems.

To Solve	Use
Discrimination Problems	Simple multiple-choice
	Complex multiple-choice
	Common feedback
Generalization Problems	Simple multiple-choice
	Inductive multiple-choice
	Matching exercises
Sequencing Problems	Ordering exercises
	Simple multiple-choice
Psychomotor Skills	Simulation games
	Target games
	Drill and practice

Hopefully we have clarified the importance of choosing exercise based on the problems they are trying to solve. Now let's look at more sophisticated exercise designs. Because these designs can solve a variety of learning problems we will no longer organize our review by learning problem but follow one that moves from one related exercise technique to another. Doing so will allow us to build on the information most recently presented. As always we will continue wherever possible to reference the learning problems that the exercises solve best.

INTERMEDIATE EXERCISE DESIGNS

Matching Exercises

To teach generalization skills, three to six items are presented that must then be matched to three or four other items or categories. The items matched can be

individuals or groups to be identified by the appropriate name or category. For example, in medical training, types of symptoms can be matched to certain diseases; in sales and marketing, cars or trucks can be matched to model names. Matching is a realistic and valuable simulation technique.

Internal Matching and Rating

In this technique the computer compares several opinions presented by learners to determine their preference or attitude. For example, in *People Skills*, we showed an argument between a customer and a teller. Then we asked learners to rate the behavior of the teller and of the customer to determine which of the two they favored. The computer compared the two scores and branched to individual paths through the program based on the learner's bias as expressed in their preference.

Rating or matching exercises are excellent techniques for segregating your audience according to their preconceptions. These preconceptions can lead the learners to block out information or show bias toward a certain point of view and therefore need to be taken into consideration when presenting information. Rating or matching exercises are also good discussion starters for group activities, such as on-line chats or interactive classroom situations that are used with groups. Usually there is no right or wrong answer.

Visual Discriminations

Visual discrimination is a variation on a multiple-choice exercise used to teach discriminations. Essentially, several different objects are presented. The viewer is asked to identify certain parts of each object or to differentiate among the objects.

For example, if you want to teach people the difference between similar-looking items or parts of the same item, present the items or parts side by side and ask the viewer to make a choice. An example from banking is the debit/credit discrimination. A learner could be asked which of a dozen different rectangular bank forms viewed is a debit and which is a credit.

Motion should not be overlooked in visual discrimination. Although an interactive video probably can't teach you how to throw a forward pass or play the piano, it can *demonstrate* the correct procedures and teach people to recognize the right way from the wrong way. The idea of interactive piano lessons is not totally inappropriate. There are plenty of complex fingering techniques that are not all that clear when written into the sheet music. A video demonstration that can be repeated until it is well understood is the best presentation device for this sort of thing. Discriminating between the right way and the wrong way will at least help performers know in their minds what *is* the correct way to do something.

Consequence Remediation

This may be one of the most effective types of advanced interactive multiple-choice exercises. Instead of branching from the question to a spokesperson who tells you why something is right or wrong, or of looping back to see a repeat of a lecture or demonstration, consequence remediation shows you the *results* of your choice. It gets you to do things right by showing the negative or positive consequences of your actions. The following is an example of consequence redemption dialog from *People Skills*:

> CUSTOMER: What do you mean you have to place a hold on my checks? Listen, I've been a customer of this bank for 8 years. I've never bounced one check, and if you don't approve this check right now, I'm withdrawing every cent.
>
> TELLER: [This response is choice number 2 of three choices.] Don't talk to me that way, sir. If you really had been a customer for 8 years you'd know that holds are a standard part of bank operations and we have to follow procedures.
>
> CUSTOMER: [Consequence remediation to choice number 2.] Follow procedures? Well then, fine, start following the procedures to close my accounts, period!

[At this point the narrator can come back and offer a commentary on the transaction.]

> NARRATOR: By challenging the customer's authority, you made him feel as though he had to act his toughest. He may still back down, though. Remember, we're trying to clarify the customer's feelings. Try to resolve the situation.

Consequence Remediation in Entertainment

Consequence remediation is one of the staples of interactive entertainment, and we will be discussing it at length in Chapter 14. But just to mention it briefly here, the example previously presented, *National Lampoon's Blind Date*, actually uses consequence remediation. If you don't make the right choice and say the right thing to your date, she will present you with a consequence that will not be at all to your liking. Imagine that you are a wisecracking guy and take a look at the banter from this award-winning game. We have made some right and some wrong selections for you.

> SANDY: I think I should warn you I'm a pretty good pool player.
>
> YOU CHOOSE TO SAY: Go easy on me, I'm just an amateur.
>
> SANDY: That's why there's a bar, it's a great equalizer.
>
> YOU CHOOSE TO SAY: So I guess I need to get you slightly impaired?

SANDY:	This game is a lot like relationships.
YOU CHOOSE TO SAY:	The strategy is to always think one step ahead.
SANDY:	Pool's a game, relationships are work.
YOU CHOOSE TO SAY:	I forbid my chicks to work.
SANDY [gets angry]:	Now part of *you* won't work either.

[She clubs you with a pool cue and you're back to square one. That's what men get for FORBIDDING women to do anything.]

Consequence Remediation is especially powerful when used in any kind of interactive video because the medium can depict the consequence so realistically. It is an outstanding technique for teaching personal interactions or any procedure where improper choices lead to very pronounced consequences. Consequence remediation is also the underlying principle in many of the advanced exercise designs, which we will discuss in the following section.

Nonsequiturs in Consequence Remediation

Notice that in *National Lampoon's Blind Date,* Sandy responds to the player's offer to buy her a drink by getting off the subject and saying, "This game is a lot like relationships." That is a nonsequitur, and it is something that just doesn't feel quite right.

As a designer or a writer you may find yourself forced into building nonsequiturs in your interactive conversations. Your users may be asking themselves, "Do they really want the character just blindly to change the subject right now?" The truth is that you may have no choice. So many different branch points may be coming together at that single response point that the answer may not make perfect sense with each path. But consider that people in real life do change the subject without bothering to respond to the previous statement, and, just as transcripts of real speech do not always read as cleanly as written dialog, so too nonsequiturs are a real, although sometimes awkward-sounding, part of natural conversations.

Of course, occasionally nonsequiturs are of such high quality that they seem almost brilliant. My favorite example of this kind of nonsequitur comes not from the semi–grown-up world of blind dates, but from the childhood world of *Peanuts*.

Linus often confides in his sister Lucy, trusting her with some profound observation about our place in the universe and the meaning of life. Lucy always shows her superiority with a comment that is pure nonsequitur and total put-down at the same time, such as: "I prefer eggs for breakfast."

ADVANCED EXERCISE DESIGNS

In this section we will consider still more advanced types of interaction. As has probably become clear, usually, the more advanced the exercise, the more branching is employed.

Spiderwebs

Branching generally leads people to think of the learning tree, in which one decision leads to two more choices, each of which leads to two more choices, and so on. The problem with decision trees is that decision making, or human discussion, seldom works that way. Actually, there is a great deal of redundancy in decision making. In arguments or even friendly discussions, people keep returning to the same points. Usually they have a goal and they stick to it. So, in the end, real conversations find people limited to a few logical remarks and a few probable conclusions.

Producers of interactive digital media want to limit possible options, and rightly so. No one is really going to produce a dialog in which the conversation branches off into an infinite number of possibilities. It's impractical and impossible. More realistic and far less expensive is an exercise called the *spiderweb*. It operates on the same principle as the decision tree, but differs in that certain responses are repeated, as they would be in real life (people keep coming back to the same points).

In *People Skills* we wanted to show a loan rejection interview. We knew that the loan officers really had no choice but to stick to his guns and turn the applicant down no matter what she did. Figure 13.9 presents a graph and summary of the beginning of the rejection interview.

You can see that, despite the fact that there is a wide variety of choices, several responses keep reappearing, just as they would in real life. The loan officer (Joe) has figured out what to say to the customer in advance. That's only logical, as is the idea that he would respond with the same or similar words in situations in which he was confronted with extreme anger. Officers are trained on how to say "no" and how to deal with customer anger. It's part of the job.

Spiderwebs are an excellent technique for simulating a discussion. The viewer takes control of the responses of one party in the discussion and selects the best response to statements by the other person. There are several options for each response, and each response in turn generates a new statement. Because many choices lead to the same response, the exercise does not go on forever, but, instead, eventually resolves itself in one or two logical outcomes.

A spiderweb takes 3 to 15 minutes for a viewer to work through, but it takes a skilled designer and a talented writer to make it work. If you are going to try spinning spiderwebs, make sure that you check to see what happens when you follow every path. Do they all connect? Do the right answers sound reasonable? What happens when several paths come back together? How bad are the nonsequiturs?

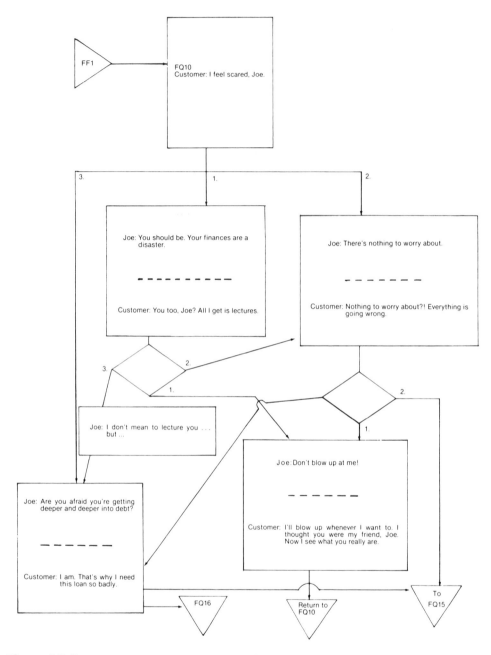

Figure 13.9 Loan Interview Illustrating Spiderweb Design

Invisible Spiderwebs

Unfortunately, in real life, conversations don't come to a screeching halt when you are faced with three or four well-defined choices. In real life, if you don't make a decision by a certain point, the conversation continues, probably along the same path.

To achieve this same effect in your interactive programs, design them so that they open "decision-making windows." Inform the learners at the outset that, if they indicate a choice anytime during a given period designated by some icon or some other identifier as a "window," the program will branch. If they don't do anything, the program will just continue as though they did nothing.

What kind of choices would learners be making in one of these invisible spiderwebs? In a program dealing with interpersonal relationships, you may just indicate positive, negative, or neutral feelings. Looking back to our discussion of the loan officer interview in *People Skills*, let's say you are in a discussion with a loan officer and are asked to push certain buttons whenever you feel a certain way. If you do nothing, the program proceeds in a neutral middle-of-the-road course. But if you indicate positive or negative feelings, the program branches, and the other person responds accordingly. In this case, your positive and negative feelings are probably reflections of what would be your body language or facial expressions. The system, not having a body to express language, relies on indicators of feelings.

What I am describing in the case of invisible spiderwebs is a program that does not come to a halt and wait for the learners to make decisions; it responds to opinions that are indicated while it is going on and continues whether those opinions are expressed or not. The flowchart for that program actually looks like a spiderweb, but because the questions (in this case the decision-making windows) are not visible to the viewer, it is indeed an *invisible* spiderweb.

Evaluating Exercise Construction

In designing instructional programs, there is an underlying principle that tests the appropriateness of any learning activity you create. Does the exercise simulate the skill you are trying to teach? Ask yourself, "What does the learner *do* in this exercise?" Also ask yourself, "Is the learner doing what I am teaching?" For example, in *People Skills*, learners were asked to choose the response that *paraphrased* what a customer said. Here is the exercise we used:

> CUSTOMER: As I was saying, my wife and I just moved into town. Got a new job, new car; ain't got no house yet. Been looking around. Kind of found a place. Thought you folks might be able to help us out.
>
> LOAN OFFICER: Response #1: Sounds like you want a home loan.
>
> RESPONSE #2: How does your wife like it out here?

Let's examine carefully what is really happening in this example. Choice #1 does paraphrase the customer's response. However, choice #2 is so far removed from paraphrasing that, although it is a standard remark in opening a conversation with a customer, it is clearly not the correct answer. Choice #2, in fact, is an example of what *not* to do. It is a nonclarifying activity called "getting off the

point." The learner is choosing between a form of clarifying (paraphrasing) and a form of nonclarifying (getting off the point). The essence of the problem with this question is that the answer is obvious.

Dealing with the Obvious

Sometimes the correct answer is too obvious probably because the question itself focuses on too obvious a distinction. Rather than asking learners to recognize the clarifying response, a far better kind of exercise would have tested the difference between the two different kinds of clarifying responses (there are two, paraphrasing and amplifying). That kind of question would have been worded like this:

Identify the response that best *amplifies* the customer's question:

CUSTOMER: As I was saying, my wife and I just moved into town. Got a new job, new car; ain't got no house yet. Been looking around. Kind of found a place. Thought you folks might be able to help us out.

LOAN OFFICER: Response #1: Sounds like you want a home loan.

RESPONSE #2: Of course, we can help, and we have three different home loan packages we can discuss.

In that example the learner must distinguish between the two types of clarifying responses. Therefore, the exercise really simulates the recognition of a less than obvious distinction. By the way, choice #2 is correct.

As the writer of the original question, I cringe every time it comes on. In spite of the high probability that the wrong answer ("How does your wife like it out here?") would be given in the real world, in the context of the question, it's obviously wrong. Writing an obviously wrong answer is an activity that really defeats the purpose of instruction, since all that is really being learned is how to distinguish the obvious. (Just for the record, the earlier version of the question wouldn't be much fun in a game either.) Being asked to recognize the obvious is never very rewarding.

Rules for Evaluating Exercises

From my earlier mistake, let's expand our rules for evaluating exercise construction. After you create an exercise, ask yourself these questions:

1. Does it simulate the behavior I'm trying to teach (whole or in part)?
2. If it simulates *part* of the behavior, is it the right part?
3. Are there other exercises that simulate all the other parts so that the learner learns the whole skill?

4. Does the exercise present enough choices so the exercise is meaningful?
5. Is the exercise difficult enough to make the learner consider the principles involved in making the decision, or is it just an exercise in recognizing the obvious?
6. If you use humorous wrong answers, are there enough *other* wrong choices to make the activity meaningful?

Keeping these principles in mind, we need to proceed to the next important segment of designing instructional interactive programs: creating and using tests. But before we do that, let's look at an entire compendium of interactive learning exercises that bring together all of the designs discussed in this chapter as well as many others.

14

Compendium of Interactive Learning Exercises

This compendium will help illustrate the broad range of possibilities available for the designer of interactive instructional media. In addition to the standard types of activities we have already talked about: Identification, Ordering, Multiple Choice, and Psychomotor Simulations, I have added three other major kinds of exercises. These are Interruption exercises that happen when you stop the action and do something, Pathfinding exercises and Database Usage exercises. Pathfinding requires that learners find their way through a labyrinth of interactive branches or a series of events. Database Usage exercises teach research skills by asking learners to look up information in databases in order to determine their answers.

Each of the exercises in this compendium references the major kind of learning problem it solves (discrimination, generalization, sequencing, or psychomotor). The order of the exercises generally moves from the most simple to the most complex with exercises group by their general type so that, for example all the multiple choice kinds of exercises are grouped together even though the most complex multiple choice is more complex than the simplest psychomotor simulation.

Type of Exercise	Interruption
Exercise Name	Answer and Compare
Learning Problem Addressed	Discrimination
Procedure	

Students are taken to a point at which they must perform an activity. The interactive media poses a question, then stops and waits. Students answer the question in a workbook or worksheet. When students have completed their answers, the

media presents the correct answer. Students compare their answers to the answer on the screen. Extensive feedback may also be provided with the correct answer.

In a CD-ROM or on-line format, imagine QuickTime Movies or streaming audio with pictures or streaming video providing the presentation of the material in a window surrounded by an interface that includes built-in worksheets. The video progresses, the students do some work with the computer worksheets while the video waits, then the video resumes.

Type of Exercise — Interruption

Exercise Name — Guided Discovery

Learning Problem Addressed — Generalization

Procedure

Rather than students just being taught straight out, they learn by finding things out for themselves. A goal is set, students work toward achieving that goal using tools that are provided by the interactive system. The steps in the process are structured so that, as they work through the problem, they learn a set of principles or procedures.

For example, in a multimedia lesson about finding your way through the woods, students are given a compass and a set of rules. As they work their way through the forest, they employ the compass and the rules and, in the process of finding their way home, they also learn direction, ecology, and personal safety.

Type of Exercise — Identification

Exercise Name — Stop When You See

Learning Problem Addressed — Discrimination

Procedure

Again a "picture-in-picture" kind of scenario with images playing within an interface that also includes controls of the images and worksheets on which students can enter observations. Viewers are then given a presentation in which certain activities need to be recognized. When the correct activity is spotted, viewers respond on the worksheet, and the system counts, sorts, and judges their responses.

The "spot the shoplifter" exercise developed by David Hon may be one of the best examples of the stop-when-you-see technique. David presents a store with four customers. One of the customers is a shoplifter. Using techniques that have been taught in the lesson, students are asked to identify the shoplifter. Whenever they think they see the shoplifter in action, they note the behavior and the computer records their response.

There are several ways to get feedback in an exercise such as this: audio cues giving positive or negative sounds per response or video or text feedback sequences placed at the end of the entire exercise.

Type of Exercise	Identification
Exercise Name	Identify the Area
Learning Problem Addressed	Discrimination
Procedure	

This technique is a great tool for teaching medical diagnostic skills. Students move a cursor (or other marker) over a background until they see something they have been asked to identify (a tumor, a fracture, etc.). Students then click on the object to get appropriate feedback.

Type of Exercise	Identification
Exercise Name	Matching
Learning Problem Addressed	Discrimination or Generalization
Procedure	

The best application of matching we've seen is Wilson Learning Company's *Managing Interpersonal Relations* (MIR) program. Learners are confronted with a list of personality types and images of four fictional characters they have gotten to know earlier in the lesson. Students choose one of the personality types and then the picture of the person who matches that type.

Of the available feedback techniques, the one the Wilson Group chose may be the best. The person identified appears on the screen and tells students why they were right or wrong.

Type of Exercise	Ordering
Exercise Name	Put in Order
Learning Problem Addressed	Sequencing
Procedure	

Students are presented with several steps that are listed as text or, better yet, portrayed as insert images on a composite picture. Students are required to indicate the order in which the steps must be performed. They can click and drag them into the right order or enter numbers or letters identifying the scenes. Feedback can illustrate the resulting consequences of doing things in order or out of order.

This type of exercise is a must for procedural training that requires sequencing skills. Put the engine together, and then start it up.

Type of Exercise	**Multiple-Choice**
Exercise Name	Remedial Loops
Learning Problem Addressed	All
Procedure	

Remedial loops are the most basic form of multiple-choice, interactive exercises. In this technique, students are asked a question that has several possible answers. If a student selects the correct answer, the exercise moves along. If the student selects the incorrect answer, the program loops back to the part of the lesson relating to that particular question.

Although it is tempting to use this technique because it is inexpensive and no additional production is required, it is weak because the feedback is not tailored to specific questions or responses. General feedback is usually not as effective as specific feedback.

Type of Exercise	**Multiple-Choice**
Exercise Name	Individualized Feedback
Learning Problem Addressed	All
Procedure	

Individualized feedback is the technique that improves on remedial loops. As with remedial loops, students are asked questions with several choices. In this case, however, when students answer, they move to a discreet sequence that explains exactly why they were right or wrong.

Type of Exercise	**Multiple-Choice**
Exercise Name	Consequence Remediation
Learning Problem Addressed	All
Procedure	

Consequence remediation is similar to individualized feedback. However, with this technique, when students answer, they are shown the results of their decisions. There may be a voice-over explanation of what happened or an elaborate video sequence, but the real power of this exercise comes from students' seeing the consequences of their very own decision.

Example: two old high school friends, Joan and Jean, meet years after graduating from high school. At a friendly lunch, Joan tells Jean that she is getting

married and tells her all about Eric, the wonderful guy who will soon become her husband. Jean is horrified to learn that it is the same Eric who broke her heart on a Caribbean cruise last summer.

What should Jean do when Joan invites her to the wedding? Choose a possible response and see what actually happens if Jean goes to the wedding, or does not, or tells Joan all about Eric's past. You will want to see the outcome of your recommendation, won't you?

Type of Exercise	**Multiple-Choice**
Exercise Name	Randomized Outcomes
Learning Problem Addressed	All
Procedure	

Randomized outcomes provide yet another twist to the multiple-choice format. In this exercise, a randomizer is put into the program so that the consequences of certain actions are not always the same.

For example, in our interactive story above, Eric could be nice to Jean when she shows up at the wedding. Eighty percent of the time he simply will not bringing up their recent past. But 20% of the time he will be in a bad mood, stage a big scene, and come close to ruining the wedding. That's the chance Joan takes by showing up. Of course, the other side of the randomized outcome needs to be accounted for somehow if real learning is to take place.

Type of Exercise	**Database Usage**
Exercise Name	Check Your Files
Learning Problem Addressed	Generalization
Procedure	

Database usage is an innovative technique that has been used effectively by Hewlett-Packard's Training Media Group. This technique involves the creation of a large database of information that is stored at a central location in the multimedia program. The information is organized in a logical order. However, the order should not be too easily discernible by students.

Management trainees, for example, may be presented with a problem employee who needs counseling. A low-level simulation would provide students with a menu that offers to show the employee's personnel file and any recent mail that specifically relates to the employee in question.

A high-level simulation would provide files for many different employees. There would also be general e-mail for the last few days. The intention here is to get students to dig deeper for the information they need and draw conclusions.

Is this second version of the exercise more difficult to create? Yes! Is it more effective? An evaluation conducted by Hewlett-Packard suggests that it is.

A management course, also designed at Hewlett-Packard, taught that long-term relationships between employer and employee are factors in management style choice. To demonstrate the length and depth of the relationship, Hewlett-Packard's course offered a memory bank through which the manager could search in order to reflect on the relationship with the employee before the counseling session actually began. A simple series of flashback scenes did the job. With the help of this input, students were able to determine the appropriate style.

Type of Exercise	Database Usage
Exercise Name	Market Research Simulations
Learning Problem Addressed	Generalization
Procedure	

Here is an especially effective technique for students in marketing courses. Offer learners files of demographic data that they can draw on when putting together marketing plans. Sources for this database might include statistics from company marketing research departments, recent articles from major magazines, and interviews with industry experts, which the students can draw on. Send the students out on to the Web to find even more information.

The easy and obvious exercise for this kind of database would be to supply a choice of several different creative advertising campaigns for a particular project, with resultant remediation showing the consequences of each choice. More imaginative or complex solutions could be carried out in a virtual or real classroom. There, students could be organized into teams to design advertising campaigns. They could see the prerecorded consequences of their campaigns in scenarios selected as appropriate by the course instructor.

Type of Exercise	Pathfinding
Exercise Name	Parallel Scenarios
Learning Problem Addressed	Primarily Discrimination but all others as well
Procedure	

Parallel scenarios are a little like spiderwebs in that they offer students a variety of decision points leading to different solutions to the same problem. However, in parallel scenarios the story keeps going in each of four discrete paths all the way through to the end. At key decision points, students are given a set of choices. Each choice allows students to switch between paths and approaches. Each path

uses similar data, but carries it out in a very different way to arrive at a unique outcome.

Example: a counseling session between employer and employee. Which of four styles should the employer use to communicate to the employee? If the employee acts with anger in response to one style, should the manager switch styles? Should the manager respond with anger, too, or try to calm the employee down by telling a joke or empathizing with the employee's situation? Any reaction on the part of the manager results in another reaction on the part of the employee. For each response, the manager is faced with yet another set of choices, each leading to a very different set of outcomes.

From the first decision point on, there are four parallel conversations going, each involving some of the same data, but each with its own special tone and style depending on the tactic chosen. Crossover points (points at which another counseling style can be accessed to continue the conversation using a different tack) are placed at logical breaks in the conversation where it would be natural to change direction. These points are dictated by the content and context of the conversation.

A parallel program must be created with very carefully written dialog so conversations can flow naturally from one scene to another. The emotional tone should also flow, even though there might be abrupt changes in mood. To accomplish this, transitional scenes have to be created so that a highly charged emotional scene in one scenario can flow into a more amiable scene that results when another tack has been taken.

Type of Exercise	Pathfinding
Exercise Name	Seamless Parallel Scenarios
Learning Problem Addressed	All
Procedure	

Scenarios that are not interrupted by menus or other decision-making devices are expensive and difficult to design and produce. Yet, many interactive game companies have worked wonders with this technique. The extremely high level of simulation offered by such scenarios makes them good prospects for both training and entertainment and games.

Because there are no menus, the interruptions cannot be seen and the transitions are said to be seamless. When you consider the difficulty of designing and creating a scenario in which the decision maker can switch the tone and mode of the conversation at a dozen or so different points, you can imagine how much more difficult it would be to create a scenario in which the decision maker can switch at any time — at will!

The way to write such a scenario is to lay the scripts down side by side and write each scene so that it is in total harmony with the spirit and the informational content of the other scenes — not an easy task.

Type of Exercise	Pathfinding
Exercise Name	Virtual Environments
Learning Problem Addressed	All

Procedure

Beginning with MIT's pioneer project that offered a tour of Aspen, CO, these projects enable designers to offer viewers a sense that they are moving up and down the streets of a town (real or imagined). Or, with very little change to the design, up and down the halls of a building (real or imagined), or within a room or some other virtual space.

The technique allows the user to decide which way to turn at appropriate intersections and even whether or not to go into buildings or rooms that are found along the way. A lot more will be said about this technique in Chapter 23.

Virtual environments offer training in recognizing landmarks and overall geographical navigation. They offer orientations to specific locations, buildings, and building complexes. They often provide the raw material for exciting adventure games, such as *Myst* and its imitators.

As a demonstration, Hewlett-Packard created a guide to the labyrinth of its offices by putting a 35-mm camera on a chair and rolling it up and down the corridors. The hundreds of still frames that were created could be arranged in many ways, including a "Type in the name and we'll show you the office" approach or "Here is the path that will take you there." These days, highly calculated matrices have been created to help plot out the number of images and angles needed to provide a realistic virtual reality representation of a place. Computerized cameras even perform those calculations and take the pictures at the same time.

Type of Exercise	Psychomotor Simulations
Exercise Name	Hunt and Shoot Simulations
Learning Problem Addressed	Psychomotor

Procedure

The most basic video games are those that require players to seek out a target and shoot it down. A generation of boys have become so skillful at hunt and shoot that it is hard for game designers to come up with games that are sophisticated enough for them. The return of some classic and simple hunt-and-shoot games gives the rest of us a chance to play.

When the designers apply training technology to the design of such activities, hand–eye coordination can be channeled in a very specific direction to meet very specific training goals.

Type of Exercise	Psychomotor Simulations
Exercise Name	Driving Simulations
Learning Problem Addressed	Psychomotor

Procedure

This hybrid of video games and virtual environments is perhaps one of the very best applications of interactive simulation. The player takes the controls of a futuristic car, and the multimedia images allow him or her to traverse the streets and highways of major cities of the present or the future. Simplified versions of this activity isolate parts of the task. For example, an interactive drag strip can work on shifting skills without having to worry about a design in which the left-to-right control of the car must be addressed. Dragsters only go in a straight line, and steering is not an issue.

Type of Exercise	Psychomotor Simulations
Exercise Name	Computer Software Simulations
Learning Problem Addressed	Psychomotor

Procedure

Some computer software applications require both psychomotor skill and a good deal of content knowledge. Multimedia programs have been created that demonstrate what to do with the software, what happens when you do it, and then present practice exercises with increasing degrees of difficulty.

 Because a computer is best at simulating its own activities, this kind of training media is a natural. Moreover, since much of the built-in instructional software and tutorials that come with the program are rather weak, creating licensed instruction in how to use important software is becoming an increasingly more lucrative business.

15

Test Construction and Evaluation

Unlike exercises, tests are designed not to teach, but to find out whether the learner has learned. For that reason there is no remediation following each question as there would be in an exercise; instead, questions are presented one after the other, the right and wrong answers are tabulated, and a score is given. Remediation may be provided depending on the overall structure of the lesson. In this chapter, we will look at the various testing options that can be integrated into an instructional interactive program.

TEST FEATURES

Unit tests are the tests given at the end of each lesson. Final examinations, at least in our terminology, are tests on the course. The final exam is the last activity the learner will complete before leaving the program to perform the new skills in the real world. Therefore, the final exam should integrate all the steps being taught into the fullest possible simulation of the activity to be performed.

Another important aspect of a good final exam is that, like the lesson itself, it should be *criterion-referenced*. The key element in this technique is the criterion item, which considers not only what learners will do, but how well they will do it. Ideally, all criteria for proper performance should be tested in the final exam. If learners are learning to perform a certain task and that task has to be performed within a given time frame, that time frame should be included in the test.

As noted, the final examination should offer a true simulation of the behavior being taught. Interactive simulation can never replace real-world performance, but it can often duplicate it very well. The challenge for a creative instructional designer is to construct tests that come as close as possible to actual performance. There are times, however, when the skills you are teaching may require live simulations in addition to those being presented through the interactive media.

For example, *People Skills*, the video I developed for Bank of America, taught principles of interpersonal relations and methods for applying them. In the final exam learners were asked to identify the best responses to comments from a customer during a simulated banking transaction. In addition to the video simulation, learners were given a script that they could use to role-play the interaction with the customer. This added activity, in our opinion, greatly strengthened the learners' ability to transfer the concepts to their job and offered a truer test of their ability to perform the skills we were teaching.

TEST STYLES

There are different types of tests that can be designed and integrated into interactive media. These can be divided into testing for understanding (concept tests) and testing for performance (simulation tests).

Concept Tests

Concept tests are administered to determine whether learners understand the principles involved in performing a skill. They do not test the actual performance itself. For example, let's say there are six steps involved in changing a spark plug. If you wanted to test for an understanding of this concept, you could have learners do any of the following:

1. List the steps.
2. Identify those steps that are *part* of the process.
3. Identify those steps that are *not* part of the process.
4. Arrange the steps in the correct order.
5. While a spark plug change is in progress, identify procedures being performed correctly or incorrectly.
6. After a spark plug change is shown, list the procedures done incorrectly.
7. Answer specific questions about critical parts of the process; for example, which wires to attach to which plugs to ensure proper firing order.

Note that at no time are you asking the learners to change plugs; rather, you are testing their grasp of the concepts and the activities involved. With an understanding of the concepts involved, learners will probably have an easier time performing the task in real life.

Simulation Tests

Simulation tests offer a reenactment of the skill being taught and allow you to come very close to testing learners' hands-on performance. For example, in the lesson on spark plug changing, you might move through the procedure to a

decision point, then ask, "Now what do you do?" Learners can then be given three choices:

1. Take out all the plugs.
2. Take out the plugs one at a time.
3. Take out one plug and check it.

Depending on the response given, the lesson would then proceed down one of three paths that eventually begin-crossing, resulting in the classic spiderweb design discussed in Chapter 13. Deciding one of three courses of action is, in fact, the necessary behavior needed at that point. You could not, of course, simulate the actual screwing in of the plug, although it is a critical activity as well. Unfortunately, screwing in a plug is a tactile skill: you have to feel the plug screwing in smoothly. Things that require learning a certain feel are among the very few that cannot be simulated in digital media.

Multimedia simulation tests are excellent ways to determine whether learners have learned from the program. Because they can portray the consequences of correct and incorrect answers, simulations make excellent transfer exercises. Transfer exercises are learning experiences designed to help learners bring the skills they have learned back to their real-world jobs. When designing simulation tests, it is important to include the entire job with all its details in a realistic setting. The goal is to let learners come as close as possible to real-world performance.

TEST SCORING

In determining when a learner is ready to begin applying a skill in the real world, the number of right answers or allowable misses required for passing is critical. Some skills require perfect or near-perfect performance on the part of learners. In other skill areas, however, perfection may not be as critical. Because setting a passing percentage begins with an arbitrary decision, test scoring should be adjusted after the program has been reviewed extensively and compared to competent performance in the real world. Setting criteria for adequate performance becomes a cycle in which criteria are established when performance is defined and are refined as skills are transferred to the real world and behavior is observed.

TEST FAIL AND PASS MENUS

As you create tests that assess learners' comprehension and skill levels, you will want to determine where they will go if they have passed or what kind of remediation they will get if they have failed. Here, as elsewhere, you can allow

learners to choose from a variety of options depending on their level of skill and rate of learning.

Test Fail Options

Usually, a lesson test failure requires a review or repeat of the whole lesson. However, you may want to give learners a choice of review options. Figure 15.1 presents a detailed schematic of a typical lesson.

The branching for the exercise feedback is not shown, but you can see three demonstrations (DEMOS) broken up with seven exercises (XQs) and a final review (REV). There are three logical ways to review this lesson:

1. Review the entire lesson (all demos and exercises).
2. Work through just the review and test.
3. Just take the test again.

I would bet that the last choice, the test-only option, would be the most popular with learners; however, it is probably the least effective. After all, there may have been no remediation at all, or perhaps learners may only have been told the number of answers they have gotten right. Not much feedback!

If learners want a quick way out, they can take the second choice, the review and then the final test. Reviewing the whole lesson is a very admirable option, though probably not a very popular one. Figure 15.2 represents a compromise: the program is playing the demonstrations but skipping the exercises. It will play

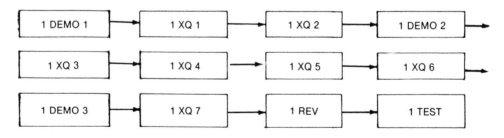

Figure 15.1 Typical Lesson

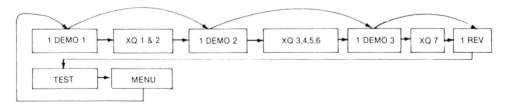

Figure 15.2 Review Option

Graphic	Narrator
You can review:	You should review the whole lesson; there are four ways to do that:
1. whole lesson	1. review the whole lesson
2. lesson without exercise	2. review the lesson without the practice exercises
3. key ideas	3. review the key ideas
4. individual concepts, or	4. review individual concepts which you think are giving you trouble, or
5. take a break	5. you may want to take a break
Indicate your choice.	Indicate your choice.

Figure 15.3 Test Fail Menu and Narrative

"1 DEMO 1" then automatically skip to "1 DEMO 2," to "1 DEMO 3," and then to "1 REV." What you have offered your learners is a chance to review the presentation part of the lesson and then take the test. This may be an excellent and popular remediation technique.

Another option is to offer a menu of the different subjects in the lesson. For example, "You can select an individual subject that seems to be giving you trouble."

Returning to the bank teller training example, a good remediation menu would say:

- Press #1 to review the concept of debits.
- Press #2 to review all debit forms.
- Press #3 to review the concept of credits.
- Press #4 to review all credit forms.
- Press #5 to review the one exception to the debit/credit rule.

Finally, you can offer learners a break frame, in which the system offers to pause and give the learners a chance to take a break. All of these options can be presented in a test fail menu. Figure 15.3 presents the script for such a menu. It shows both the text that would appear on the screen and the narration that would accompany it.

Test Pass Options

Test pass options are much simpler to design. Learners can proceed to the next lesson, choose among several lessons, or go right to the final exam. There is one creative alternative: to offer learners a review of the key ideas (review sections) from all the lessons, before going on to the final exam. People who pass tests

Graphic	Narrator
Choose:	You have some choices here:
	You can take the lesson on balancing or
1. the balancing lesson	the lesson on stamps, if you haven't
	already done so. If you have, you can pro-
2. the stamps lesson	ceed to a review of the key ideas for the
	entire program before going to the final
3. review of all key ideas	exam.
4. the final exam, or	If you don't feel you need a review, you
	can go directly to the final. We'll even let
5. a break	you take a break before you do any of
	that.
Indicate your choice.	Indicate your choice.

Figure 15.4 Test Pass Menu and Narrative

should also be given the option of taking a break. The narrative text for a test pass menu incorporating all these choices is given in Figure 15.4.

Pretest and Preview Options

Instructional interactive multimedia programs will usually be viewed by learners of varying skill or knowledge levels. Therefore, it is often useful to provide a pretest to enable learners who are already familiar with the material in one lesson to go on to others.

One form of pretest is to start each lesson with the option of taking the lesson test first. If the learner knows the material, he or she will pass the test and can skip the lesson. Another option is to provide just the review and test for those learners who want a slight brush-up. Finally, you can design the program to begin at the review, which serves as a *preview* of the lesson, followed by the entire lesson. As redundant as that seems, it does satisfy those who insist on the maxim, "Tell them what you're going to tell them, tell them, then tell them what you told them."

FINAL EXAMINATION SCORING

There should be a tabulation mechanism for scoring the final exam, as well as all the other tests in the program. Unlike the unit test, the final exam is a true measurement device and, if true to its real purpose, should exist only to determine whether the learner has passed or failed the program.

Of course, the ability of the computer to do innumerable calculations allows the system to tell the learners which questions they missed and what their percentage scores were. There is also the capability to do internal consistency checks and measures of answering patterns if needed. However, the general use of test

data relating to *final* exams is to move learners out of the learning experience. Those who fail are supposed to take the program all over again.

Creative designers may want to devise mechanisms to identify lessons or even particular concepts that are giving the learner trouble. The learners can then focus on the areas that have prevented them from mastering the material. Final examination data also help validate test items and testing techniques, and they should be studied carefully so that the program can be improved in the future.

PROGRAM EVALUATION

Evaluation of the instructional program itself is a way of answering all the questions that will be asked about it: "Did anyone like it? Did they dislike it? Did anyone learn anything? Did it improve things on the job? How did it affect the bottom line? And, oh, by the way, *was it worth the money?*"

There are several types of evaluations. Some are done as the program is being presented, others are done immediately after the program is over, others are completed back on the job weeks or months later. Ideally, the result of any evaluation is an honest report that shows column after column of positive data on improved performance.

Few systems of evaluation are completely reliable, and many can be misleading. Still, it is possible to have some sense of the program's effectiveness working with the following levels of evaluation.

Levels of Evaluation

I have always identified five different levels of evaluation for instructional programs. All of them apply to instructional multimedia, and many are appropriate for point-of-sale and game programs as well. Ranging from simple to complex, they are:

1. Do learners like the program?
2. Can learners pass a pretest or posttest on the skills taught?
3. Can they perform the skill immediately after training?
4. Can learners perform the skill back on the job?
5. What is the effect of improved performance on the company's operation and profits?

Level 1 evaluations are very basic, but they do give you feedback on how learners liked or disliked the program. This type of evaluation, of course, doesn't tell you how well the program worked or how much anyone learned.

Level 2 and level 3 evaluations may seem similar, but there is a big difference between them. Think of them in terms of a written driving test versus an actual driving test or driving simulation.

Level 4 evaluation (whether people can perform the skill back on the job) is critical. Ideally, this should be measured through on-site observation by training analysts. That will require a commitment of personnel to do the observing, but it provides a much more concrete measurement.

Many people feel that level 5 evaluation is difficult, if not impossible, to compute. The problem lies in being able to make a clear link between training and increased profits. For many years, a good training program's worth was said to be 10 times the cost of producing it. Thus, if a training program cost $100,000, the company would have to save or earn $1 million to justify the cost of the program. All worth ratios in these cases must be based on a decision by the company to attribute some percentage of new profit to the success of the training. Unfortunately, the dollar value assigned to a training program is arbitrary.

An interesting argument can be made that *all* increased profits from a new product result from training. After all, untrained personnel may not be able to sell the product at all. Unfortunately, most companies will not accept that argument. They conclude, instead, that bottom line profit is just too complex a figure to tie directly to the cost of training. They recognize level 5 evaluation as an ideal, as an area so difficult to quantify that, in all likelihood, it will be quite misleading. If people need some yardstick or benchmark for value, simple metaphors seem to be very believable: for example, "If this training sells five new limousines, it will have paid for itself" is more believable than "There has been a 50% sales increase since the new model was introduced. We attribute 30% of that to advertising, 50% to the design and features of the new model itself, and 20% to training."

Instruction and training have always been areas that have pioneered the use of multimedia. From programmed instruction in the early 1970s, to interactive laser discs in the 1980s, to CD-ROM training and on-line classrooms, the design principles and activities that influence much of today's interactive entertainment and promotional multimedia were born in learning centers. The important thing to note, however, is that the new age of interactivity and connectivity brought on by the World Wide Web, CD-ROM, and other new media innovations offer even greater opportunity to help improve our performance, our careers, and even our lives. That is why we have begun our exploration of individual multimedia applications with these disciplines. But now it is time to move on to an area that is just as challenging, quite a bit more glamorous, and far more financially dangerous. I'm talking about *show biz*, the entertainment industry.

IV

Interactive Entertainment

16

Basic Structure

The key to entertainment is (or at least is supposed to be) creativity. And the key to creativity is "thinking outside the box." Remember that famous exercise about connecting nine dots? I don't either, and I could never do it anyway. But the point of the whole thing was that people were asked to connect nine dots arranged in a box without lifting their pencils from the paper. The only way to connect the nine dots was to draw lines that went *way* outside of the box and then came back in.

I'd put in an illustration here, but I know most creative people who open a book on creativity and see that illustration close it immediately. My point in starting this chapter with that concept is not that you have to think outside the box. It's far different. It's this: *How can you think outside the box if you don't know what the box is?*

My feeling is that a lot of the most creative work in the world was done within the tight constraints of boxes: Mozart symphonies, Shakespeare's sonnets and plays, the classic TV sitcoms of the 1960s and 1970s. These were all creative things built within the boundary of very tight rules.

You might be dead set against rules, you may not want to face anything that will constrain your imagination. If that is true, skip this chapter and go to the next one. But then come back later and read this chapter because there are some basic structures here—and you will miss something if you leave them out.

STARTING INSIDE THE BOX

Let's start with Web sites. My first experience with Web site design had to do with creating sites to promote movies. Promotional sites always feature something called an electronic press kit (EPK), press information about the movie— cast bios, pictures of the stars, the credits, running time, downloadable promotional trailers from TV commercials, anecdotal stories about the making of the movie. Movies sites always included EPK materials. So in the early days of Web sites, if you thought about a movie site, you either began with an EPK or you told the sponsors from Motion Picture Marketing, "we want this site to be different, we want to leave out the EPK entirely." They would never let you do it.

Figure 16.1 *Congo* Home Page Prototype. TM and Copyright © by Paramount Pictures. All rights reserved.

Electronic Press Kits

There is a logical progression from the EPK to the rest of the site. As soon as you have created a neat, little confined area called the EPK area, then the next piece that you need to think about is the flip side of the EPK. The EPK begins by answering the questions "Who are the stars, what do they look like, and what was going on behind the scenes during the making of the movie?" The next area answers the questions "Who are the characters, what do they look like and what is the story all about?" This area is generally called *the archives*.

The Archives

The Archives house not bios and photos of the stars, but bios and photos of the characters in the story, downloadable pictures of the leading man and woman in character, movie clips of them doing things, downloadable audio of their most memorable lines. Having created archives of the characters (the good guys), you need to tell your on-line users all about the bad guys, who they are and what they look like.

Now let's make a slight leap beyond this really standard stuff and ask about the locale, the setting, and the other things that go into the story. Really good movies create a whole world and the Archives give us everything there is about that world: what it looks like (downloadable photos), its history (photo and text essays and timelines), any unique terminology or colloquialisms (glossaries, etc.), gadgets (their pictures and animations of them, such as downloadable movies, QuickTime VR). In

addition to the real hot and not so hot things in the Archives there is one very important area that can actually spill over into the next big set of areas.

An important area in the Archives is *related content*. Many great movies are tied to important events, phenomena, or historic settings. In the site I created for the movie *Congo* the Archives included information about gorillas and volcanoes, but those areas were so big and important that they spilled over into their own sections.

Figure 16.1 shows an early prototype of the home screen for the *Congo* Web site. *Congo* Preview, Diary, and Production Notes are made up of content from the EPK. The Image Database contributed to the Archives. Save the Mountain Gorillas was an area of related content.

Special Content and Links

We devoted an entire section of the *Congo* site to the Diane Fossey Gorilla Fund. We had downloadable pictures of gorillas and tons of data on the mountain gorilla—why it was endangered and what you could do about it. Then we added the first element that actually let the users *do* something other than look at pages of information. We allowed users to send messages to members of the Diane Fossey Gorilla Fund who were actually on expedition in Rwanda. Moreover, the members of the Fund agreed to send messages back.

We also created links to sites that were dedicated to gorilla preservation. Because another topic was volcanoes, we also linked to all the volcano sites we could find, and then we did the same with high-tech surveillance (another subtopic of the movie).

Communication

Now that we had people linking to people in the Congo, we had people branching out to other sites on related topics, we might as well let them talk to each other. So we created the communication area of the site so that people could share their feelings about the movie and the topics that were included in it: nature versus the machine, nature versus man, the fate of endangered species. Bulletin boards and chat rooms were the communication features that helped people, months before the movie came out and months after its run, share their feelings and their opinions and form a sense of community around the subject matter.

We are close to completing the box (the one you need to think outside of if you are to be truly creative). However, there are two more sections that generally are often included in such sites.

Merchandising

Whether or not the mountains of merchandise that are created for each blockbuster movie need to be sold through the site itself is an interesting question. So far, few people have succeeded in making a lot of money through this means of sales. Yet it is a logical thing to do, and, at least from a marketing

Figure 16.2 Prototype Merchandising Page. TM and Copyright © by Paramount Pictures. All rights reserved.

standpoint, it can help leave no stone unturned in promoting a movie. Selling products inside a Web site involves product stills or video clips, promotional copy, ordering forms and processes, and order fulfillment. It is not a simple task and one that is talked about in detail in Chapter 22. Figure 16.2 shows our merchandising page.

The last, and in everyone's mind the most important, element inside the box of a typical promotional Web site (or any other kind of Web site) is the most interactive part — the fun part of the site: the game, the simulation, the activity. It is the element that actually consists of everything that *is* outside the box. I suggest we think of its starting at least *inside* the box because there is no alternative to it. *You have to have it.* These days, leaving the game or adventure out of your site makes it unworthy of review by any national media (and that is desirable for promotional Web sites). More important, it makes your site unworthy of attention by most Web site users. You'll certainly never make it into any listings of The Cool Site of the Day or the like.

The Adventure!

I have my own name for this area I call it: The adventure! There doesn't have to be *one* adventure in a Web site, there can be lots of them. They can be games, they can be quizzes, they can be role-play simulations or branching story lines. To get away from Web sites for just a moment and consider CD-ROM titles and Interactive TV, The Adventure! is the stuff that those things are made of. And because The Adventure! is so central to all these areas — and indeed requires thinking outside the box — it gets its own chapter, coming up next.

Before we end this chapter, however, let's consider one last element of this basic structure for on-line promotional Web sites. I have alluded to the fact that there is a generic design here, and I think there is. To be specific, the Archives, the links to other Web sites, the communications area, the store, even "the making of" are elements that also fit very well into CD-ROMs and interactive TV. Maybe those items need to have a connection to the Web so that some of this functionality can be incorporated into them. But the truth is that adding Archives, links to related topics on the Web, communications areas, and the like is a natural extension of any content. They should be added to CD-ROM games, to interactive TV (when it finally shows up), etc.

Now, as a final review of these concepts, take a look Figure 16.3, the final version of the site map for the *Congo* Web site with identifiers that reflect the structure that I have been talking about.

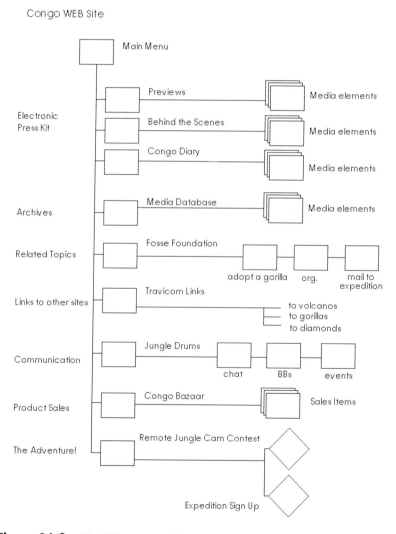

Figure 16.3 Final Structure of the *Congo* Movie Promotion Web Site

COMMUNI-CATION	RELATED CONTENT & LINKS	THE ADVENTURE!
ELECTRONIC PRESS KIT STUFF	MERCHANDIS-ING	ARCHIVES

Figure 16.4 What's Inside the Box

And now consider Figure 16.4, a diagram of the box I have been talking about throughout this chapter, the one all creative people feel that they need to get out of. This box contains the content that forms the basic structure of a Web site. As I have argued, many of its elements are essential to story-based CD-ROMs and Interactive television. Note that the upper corner of the box is left open, to lead the way to all that "outside-the-box" thinking. And that, of course is what we will be doing next.

17

The Adventure!

This is where designing interactive entertainment really gets to be fun. This is where people really envy my job because I get to deal with entertainment content, story telling, and game playing. They may never know that there is this deep, dark, terrible moment when I look at the blank computer screen and try to figure out what to do next. There is an empty, almost terrifying, feeling there. That feeling comes during meetings, too, as designers sit around a table, waiting and hoping for a good idea to come. It may come as a flash of original inspiration. But just as likely it may come from something I, or others like me, have done before. There is great danger there because, in essence, what that can lead us to is to copy ourselves.

As Mozart said when accused of such a thing, "At least I'm copying from the best!"—or words to that effect. But the problem is that most of us are not Mozart, and not all of us have his impeccable taste, so we may just as easily copy our worst rather than our best—or just copy and recopy and recopy until there is not a shred of originality left in our work.

Fortunately there is a way to force your thinking away from the process of just doing what you have done before. You can break out of the trap and break into the realm of creative interactive design. That way is simple, tried, and true. All you have to do is ask yourself that question I posed at the top of this book, "Who are the users and what is their role?"

STORY-BASED ACTIVITIES

It is hoped that the user's role is to share in the experience of the people in any story that the site is trying to tell. If that is true, then, the next thing you have to figure out is, What are the people in the story doing that the users can share in? That should be pretty obvious. To go back to our example about the movie *Congo*, the people in that story were going on an expedition into the heart of Africa. So,

then, there was only one more question to be asked: How do we let the on-line users share in that experience?

In the *Congo* Web site, the trick was to let people sign up for an adventure. Because the parent company of the *Congo* expedition, Travicom, Inc., was in the business of sending expeditions all over the world, one great idea was to create a database of upcoming expeditions that were heading to exotic places for unbelievable reasons, and then invite people to apply for those expeditions.

We could create a long and complex application form that users would have to fill out to apply. Moreover, it could be written in the third person so users would have to write about themselves as though they were someone else, as though they were fictional characters in an adventure. In the end people could tell the story of their history as adventurers and about their strengths and weaknesses in the face of imminent danger. The response might be fantastic. We then could post the applications that were accepted on the site and even assign people to various fictional adventures.

That was one of the better concepts, but the idea we finally used involved the creation of a *game* as part of the *Congo* site. Figure 17.1 shows one sample frame. In the game, users received daily coded messages from the jungle. In the film *Congo* the Travicom company had first learned of the dangers to the Congo expedition when the signals at its remote jungle camera became garbled. With just a slight twist to the basic story, we said that the camera continued to function and was sending back random signals every two or three

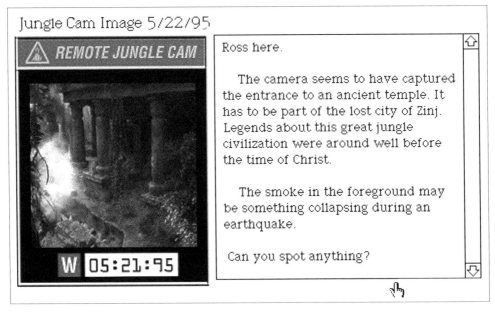

Figure 17.1 Prototype Frame from the Remote Jungle Cam Contest. TM and Copyright © by Paramount Pictures. All rights reserved.

days. As such, there was a message in the signals that could be translated, and when it was, those who figured it out and sent it in to Travicom Headquarters would receive a set of prizes. We had lots of applicants and gave away lots of prizes.

SIMULATIONS BASED ON STORY

Another spin on this simple idea is to determine the activity in the story that lends itself best to simulation. In a Web site designed to promote a hypothetical TV show about the Highway Patrol, the story revolves around a supercar of the future. The obvious activity is to give the users a way to simulate driving. Now, trying to create the feeling that people are actually driving a car through a Web site is extremely difficult to do, but creating the feeling that they are participating in a "training simulation" about driving a car can be very believable.

So we might simply invent a training area within the Highway Patrol Headquarters where users could go through a series of activities that would help them learn how to handle the car. People don't expect learning simulations to be perfect replicas of the real world, and they accept a little clunkiness. But the idea that you (the on-line user) can become part of a group who is going off on an important mission and participate in its training sessions, and even gain some rank for the level and quality of your participation, that is exciting.

Of course, for those who don't need to explain away the clunkiness there are plenty of Web sites that offer driving, fighting, or chasing simulations. The technology to create these games is getting better and better, too. The clunkiness quotient is going down.

Of course there may be an even better way to allow users to share in the experience of a story. In those stories where the common denominator is interpersonal interaction rather than action, it might be possible to construct a game in which on-line users pick roles and play them in a simulation of the actual experiences of the characters themselves.

ROLE-PLAY SIMULATIONS

Web sites have started to take advantage of unique role-play technologies. In these applications, often called *persona chats*, the characters are listed, along with their interests, their personalities and their goals. Players of the game then select a character they want to be (there can only be one per session), and then they are turned loose, in character, in a simulated environment where they can meet other role players and have the time of their lives.

The physical representation of the site on the Web looks and feels like an enormous chat room, but the location is defined. There is a map of the room that people are in at the time and indications on how to get to other rooms. The whole place has rules, monitors, and managers, and, of course, all those involved are pretending to be someone they are not. (Maybe it's not unlike a typical chat.)

There doesn't have to be a tremendous amount of structure to a persona chat, but there has to be some. The locations have to be identified. Props have to be listed and their uses have to be stated. There have to be one or two events that occur during the course of the role-play. These events are tied to the motivation of the characters in the game. That motivation spurs much of the interaction that takes place.

Avatars are physical representations of the characters in the persona chats. Several advanced Web site design companies are offering to build persona chats that feature avatars. So, when you pick the character you become in the persona chat, you also pick his or her physical appearance. This adds a higher level of reality to the game, even when the avatars are poorly rendered. Add movement through 3D virtual reality space (again being offered by some of the major Web site development houses) and the whole persona chat starts to move closer and closer to becoming one of those immersive experiences we will be talking about in Chapter 23.

ON-LINE STORY TELLING

I've talked about the story in on-line sites as though it were central to the existence of any site. The truth is that very few sites actually try to tell stories. Most of them present information. Many of them refer to stories that exist in some other medium. Even in entertainment sites, the existence of the story itself may be tangential to the goings-on within the site. Sometimes the story is presented in a very simple direct, prose narrative that is tucked away at the far end of some long line of links.

There are however a few, very brave Web sites that actually try to tell stories. The most famous of these sites, was *The Spot* which finally had to close down in late 1996. Figure 17.2 shows one of the screens from *The Spot*. If the pages of the site didn't tell the story of *The Spot*, then their lead line did: "Immerse yourself in the sun, sand, and secret journals of five twenty-somethings living under one roof."

The Spot can be thought of as MTV's *RealWorld* or the sitcom *Friends* on the Internet. Its story was told through the journals of five people living together in a house in Santa Monica, which they called "The Spot." The friends were called "Spotmates," and their dog, who was a character in his own right, was called "Spotnik." Most of the inside-the-box features noted in the preceding chapter were there, such as communication or archives.

If the story exposition was in the daily journals (complete with easy-to-read large text and pictures), then the archives, called "BackTrack," were made up of

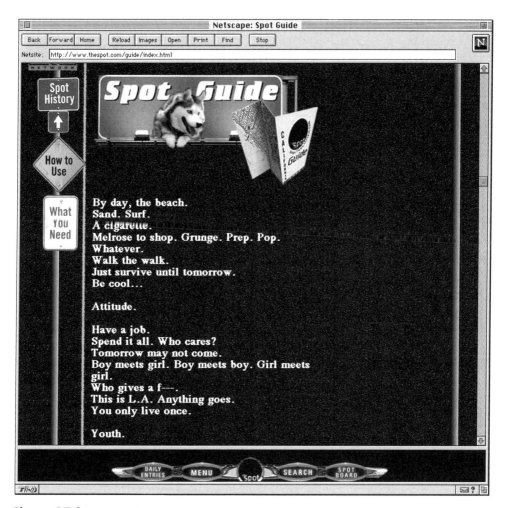

Figure 17.2 Screen from *The Spot.* Used by permission of Cyber Oasys Corporation.

all the past journals. Just to make it easier to follow the long and winding story, the archives also included a variety of summaries, as well as a Who's Who. The lead summary section was call "Spotgate." Communication also was a big feature of *The Spot*. The "Spotboard" bulletin boards had their own rules, ambiance, and personality.

You may be asking where the adventure in that site was. Maybe the story telling part of the site was as close to an adventure as there is. Of course, there was also the random access, which allowed users to jump between journals and skip back and forth between other parts of the site, and there was the communications feature.

In any event, in spite of its high usage figures, its wall-to-wall banner sponsorship, and its Cool Site of the Year designation, *The Spot* is no longer with us.

Interactive Story Telling

So, you come up with, find, or are given a story line and are asked to produce a piece of interactive multimedia from it. You look at the content, you know that you don't want to produce a set of linear pages with which people can do nothing more than move back and forth. You want something *really* interactive. How do you do that? How do you make this straightforward story line truly interactive? Well, begin by asking yourself these questions:

1. First and foremost, you have to ask yourself who are the users of the system and what is their role in the story. Specifically, are they playing the role of characters in the story, are they advising from afar, are they observing and helping the characters make decisions? Are they making decisions *for* the characters?

2. Is the story one that lends itself naturally to interactivity? Does it involve decision making, the sorting out of information, or the processing of several complex and different paths, as in a mystery, a comedy of errors, or an adventure? Or is the story very straightforward and linear with few possible diversion to its path? If it is, then additional circumstances will have to be invented to make the story more interactive.

3. Having determined the role of the users and the nature of the story, the next question you have to ask yourself is what are the devices needed to help users participate? Is there some unique form of interface? Are there a series of tools or techniques that allow the user some believable way to influence the direction of the story? Is there something in the nature of the story itself that could be simulated as an interface device? Are there characters who could serve as this device? Who talk directly to the users? Do all of the characters do so, or do none of them?

4. Is there important supportive information that has to be reviewed, studied, and investigated to understand the story? Are there topics involved in that story that have the kind of interesting depth that would make users want to study them? Is there a way to make a review of the related topics an important element in the progress of the story? Are there points in the story that depend on it?

5. Are there opportunities for parallelisms? When one set of events is going on in one location, is it possible that another set of events could be going on in another, and could the users be at one place or the other and have that presence affect their knowledge of events and their capabilities for interaction as the story progresses?

6. Are there obvious simulations that fall out of the content or the action of the story? Does the story involve driving, shooting, finding a route somewhere, applying for anything, learning how to do anything (training), doing research, using a computer, using any one of a number of specialized electronic devices? Would it distract from the story to build those simulations into the story for the user?

7. Are there obvious and dramatic consequences of decisions that would be made during the course of the story? Is it possible for the users to make or to influence these decisions? Are there devices that would allow them to do this seamlessly?

8. Is subjective camera appropriate to present the user's point of view? (Subjective camera means that the camera represents the user and characters turn and talk to the camera as though it represented a character—who is in fact, the user.) Can the story be written in such a way that the characters are always aware of and acknowledging the presence of the user as a character?

9. Are there areas in the Web site or CD-ROM attached to a Web site outside the actual story telling area where users could meet with other users and discuss the events of the story.

10. Is it possible for the users themselves to take over the story and play several roles; and, in that case, how does that influence the progress of the story?

11. How is the drama presented in multimedia? How are the users told about their characters and what is going on? Is there an obvious mechanism for exposition, and does it allow for an interactive user?

12. How does the story resolve itself? Can the users contribute along the way so that they are involved as things progress and again at the ending of the story? Does the user have a critical role to play in the ending, or does the end occur regardless of what the user does?

13. Are there rewards for the user, prizes, awards, or at least recognition on a list somewhere?

These are the questions that you have to ask yourself when you are presented with a story line and have to make it interactive. What might you come up with? Well, the best examples of this kind of interactivity may soon be appearing on digital video discs (DVD), but right now you will find them on CD-ROM, as illustrated in Figure 17.3:

Figure 17.3 Image from the CD-ROM game: 9™. Used by permission of GT Interactive Software Corp. © 1996 Tribeca Interactive Inc. All rights reserved.

> Imagine that an enigmatic relative, your distant Uncle Thurston, has bequeathed you his entire estate, including the centerpiece of his holdings, the famed Last Resort. . . .
>
> A will, a postcard, a tourist's brochure . . . all indicative of the splendor that once graced this faded temple to the creative spirit . . . but those days, apparently, were long ago. . . .
>
> Now you are entrusted with the care of the Last Resort . . . and soon you will realize you've inherited not just a deteriorating mansion, but also your family's twisted legacy. . . ."

So reads the instruction to one of the greatest of the CD-ROM adventure games, *9*, from Tribeca Interactive.

If you call the *9* hotline-hintline, you will hear that it was your late uncle Thurston's muse machine that provided art and inspiration for all the inhabitants of the Last Resort. You will also learn that what you have to do to preserve your inheritance is to win a race against a pair of evil twins who are intent on destroying the Last Resort and all that it could become again. Aided by the Last Resort's nine muses, you must find and solve every puzzle in the last resort to restore the missing pieces of the muse machine before the twins complete their own machine and bring the place to its downfall.

Get a copy of the CD-ROM and get inspired.

POWERFUL PRESENTATION FORMATS

All this notwithstanding, you could argue that the adventure in a Web site *can* be a set of linear stories if the *presentation* of those stories is strong enough. In today's "sound bite/quick-cut world" maybe large text and one or two pictures per page is not enough. It may take ten times that.

Or maybe there is another way to go. Let's consider, for example, what we might do with lots of graphics, animation, and audio.

There already is a broad range of sites that are doing that right now: the comic strip sites. *Argon Zark* (Figure 17.4) is one of the best original comic Web sites, and it may have something to teach us all. We'll study audio, motion, and what we can learn from comic strip Web sites in the next chapter.

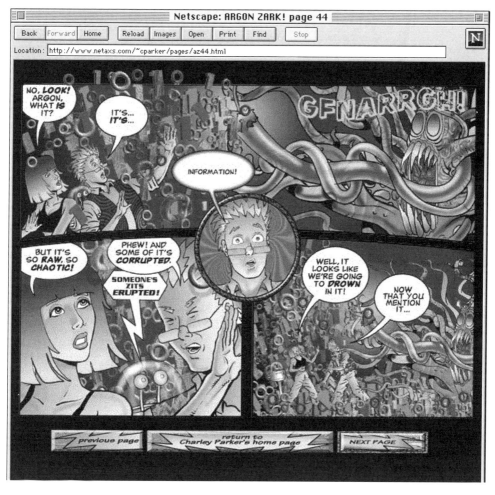

Figure 17.4 *Argon Zark*®. © 1997 Charles R. Parker.

18

Comics and Games on the Internet

Comic strips and comic superheroes have begun to appear on the Internet in such great numbers that they seem to have formed a unique genre of interactive entertainment. Where sites were once simply static comic strip presentations, more and more bells and whistles have been added until these sites have become some of the most advanced examples of the interactive form. Moreover, because their presence is growing so rapidly and because animation is extremely well suited to comics, they offer a convenient set of content to study the various uses of animation and motion on the Web. So, here is a review of the variety of comic strip Web sites and some of the interesting games they have spawned.

BASIC COMIC STRIP SITES

There are a number of reasons why comics can and should be on the Internet. The first is simple convenience. You may not get your favorite comic strip in your local paper, or you may not have time to read it before you leave for work in the morning. No matter. You can probably find your favorite strip on-line. And once you locate it and begin reading it daily over the Internet, you'll have just one more reason to cancel your newspaper subscription. Just putting comic strips on the Web offers two very good examples of the basic value of the Internet, updatability and easy access from anywhere.

The simplest kinds of comic strip Web sites are designed to do little more than present comic strips on the Web in their current static form. Nevertheless, being able to get to your favorite strip any time and anywhere and see it change daily or weekly is pretty great. But the Internet always seems to offer something extra. Even in the case of the static comic strip Web sites, you get the added benefit of comic archives from recent weeks and months along with this week's strip.

Figure 18.1 *Raunchy Roach* Panel. © 1996 M. Berry.

The *Dilbert Zone* goes one step further: it adds clever and interesting puzzles and activities to our daily on-line dose of *Dilbert*. Among the puzzles are interesting word games and an especially hilarious manager's version of the same games.

On the less intellectual side of the coin, the *Raunchy Roach* site begins with an animated opening that shows Raunchy holding up a sign and a credit for the strip's author followed by his daily risqué statement or gesture. (What else would you expect from a guy named Raunchy?) The animation cycles, and then the user can go on and review the strip of the day. Figure 18.1 shows a typical daily panel from the show.

ANIMATION IN WEB COMICS

Cyber-Chicken's Web site offers a much richer locale, with animated images throughout. There is a biweekly comic presentation that turns pages for the user and pops in word balloons after each automatic page turn. At the end of the five or six panel strips, the presentation repeats the entire work one more time. This

Chapter 18 • Comics and Games on the Internet 153

Figure 18.2 *Cyber-Chicken*™. © 1996 WHOA! Multimedia Entertainment Inc.

concept of making the weekly strip the centerpiece of the Web site is becoming standard stuff in comic Web sites and reflects a very natural, almost theatrical, use of the medium.

The comic strip section of *Cyber-Chicken* is enhanced with a series of additional areas that allow users to hear Cyber-Chicken sing, to ask his advice, or to buy his products. Figure 18.2 shows a typical *Cyber-Chicken* panel, as well as the icons used throughout the site to access other areas (strip, home, feedback, store, etc.).

MORE HIGHLY ANIMATED SITES

Perhaps the most highly developed and highly irreverent comic site of all is not based on a comic strip, but on a TV series. The *Duckman* site, currently available on the Microsoft Network, features the Private Dick/Family Man as

the host of his own talk show, while promoting his TV series. Standard features of the site are weekly monologs by the star, the celebrity Hot Seat (in which various comic celebrity invariably ends up getting fried in what is really an electric chair), the Patented Rant Generator, which allows users to access Duckman's preposterous point of view, and Hot Babes, which is what has become of the Duckman EPK. Go there to see a sexy cartoon goddess and come face to face with the credits and background info for the site. The proportion of the inside-the-box thinking (hidden in Hot Babes) to the outside-the-box thinking is pretty inspirational.

The *Duckman* site features a variety of interesting games as well as a spectacular use of a streaming audio. Duckman's rants, and his opening monolog are created in Real Audio, a streaming audio delivery system that allows users to hear their hero's obnoxious droning streaming in real time.

AUDIO AND THE COMICS

Streaming audio appears in several comic Web sites in addition to *Duckman*. Users can download an audio player or a plug-in that lets them hear audio while they view images of the comic. In the Duckman site the animation of Duckman's beak is actually lip-synched to the streaming narrative.

Many other sites use more disjointed audio tracks to provide a nonspecific sound bed that accompanies the pictures, but does not match it frame by frame. Often musical backgrounds or generic sound effects are provided in this way. The music sets the mood and allows the user to proceed at his or her own pace through the material.

GAME APPLETS

Some of the most ambitious Web sites are offering a full compliment of games to support their central features. This is not only true of comics but also of promotional and action sites. The invention of new forms of game applets has become big business for on-line development houses, and many of the applets appear in several sites.

One of the most impressive games currently on the Web is *The Celebrity Slugfest* (Figure 18.3). In this interactive grudge match, viewers box with various celebrities. The Z and X keys control the punches the users can throw, the period and comma keys move the player left and right. Users throw punches at opponents as they bob and weave and strike back. Opponents get bloodied as the match goes on and end up unrecognizable. Adversaries range from wusses like Blarney to much tougher guys and gals.

Chapter 18 • Comics and Games on the Internet 155

Figure 18.3 *Celebrity Slugfest.* Used by permission of Kaizen Works, Inc.

Having considered comic strip Web sites and individual games for the Internet, let's take a closer look at more elaborate versions of games that exist on the Web, CD-ROM, and interactive TV: game shows!

19

Game Shows

More spectacular than the individual games that exist for the Internet are game shows, the large, complex, and very popular entertainments that exist on the radio, on TV, on CD-ROMs, and on the Internet. Corporate sales departments have used game shows for everything from sales training to customer prospecting. The format has become so varied in its application and so promising in its possibilities that we felt it was necessary to cover it in detail here.

THE BASICS OF GAME SHOWS

Fundamentally game shows are usually variations on multiple-choice questions. Take away the bells and whistles for a moment and you have a core that includes a question with three or four response choices. The wrong choices are almost more important than the right ones because it is these choices that determine the difficulty of the question. Building game shows then becomes a question of first creating a database of questions and answers on different topics.

For on-line Web sites, the handful of questions that are used in a TV or radio game show give way to thousands of questions that have to be stored and cross-referenced for use on a regular basis. Some Web sites go so far as to run their trivia games 24 hours a day and the games are of extremely short duration, sometimes no more than 10 minutes a game. Even with 15-minute breaks in between the games, that amounts to a staggering number of questions and answers.

CLASSIC WEB SITE TRIVIA GAMES

If you are building a Web site and want to create a simple trivia game that is going to appear once a month, things should be pretty easy for you. You can create that sort of game and run it with simple HTML code. However, if you are charged with providing ongoing trivia games that run 24 hours a day and are never repeated, then you are into thousands of questions and you had better ask yourself where you are going to get all that content.

If you are able somehow to find the content, you still have to go one step further and figure out how you are going to process all the scoring information that will be generated by game players on an ongoing basis.

Fortunately, several very clever companies will sell you the questions and the engine used to ask and store the questions. They will also build questions around any topic you want to consider. They will probably even administer the game on-line for you so that people can jump into a site for a few minutes, play a quick trivia game, receive their score, and jump out.

Figure 19.1 shows a page from the classic *Nick at Nite Trivia* game, which runs continuously, 15 questions at a time with ongoing winners and cumulative scores. Even though the screen looks very simple and is entirely text based, it doesn't mean that the game isn't addictive, attracting users who come back to the site time and time again. Of course, these sites require professional trivia game development companies and they are quite expensive to develop.

If you are charged with creating this type of game, you are faced with a rather formidable task. But there is hope. One way to cut the cost and difficulty of game development is simply to adjust your expectations about the game's fre-

Figure 19.1 Screen from the *Nick at Nite Trivia* Game. © 1997 MTV Networks, a division of Viacom International Inc.

quency. In other words, don't keep it going 24 hours a day. If the game is good enough and enough fun to play, you may be able to run it for limited hours and spend the cost savings on production values. Of course, production values are a whole story in themselves. Let's tell it.

CLASSIC TV STYLE GAME SHOWS

To see the opposite end of the spectrum from the text-only, rapid-fire trivia games such as the *Nick at Night Trivia* game, consider TV-style game show formats that cut down on rapid-fire questions by adding a host, music, flashy graphics, long explanations of the rules and variations on game play that include different kinds of questions, including matching, quick response drills, and even some fill in the blanks.

High-end game shows created for interactive TV pilots in the early 1990s offered users the same kind of game milieu that is present on traditional TV games such as *Jeopardy*. They even allowed "at home players" to compete with on-screen contestants. In designing that form of game show I have had some success with games that allow *home* viewers to play against on-screen contestants. In those games I allowed the home viewers to ring in first, answer the questions and then, if wrong, see the answers go to the on-screen contestants. Because these games were prerecorded in true interactive video style, the responses of the on-screen contestants were always taped with both right or wrong answers. When the home viewer answered the question incorrectly, a randomizer determined whether or not the onscreen contestant gave a right or wrong answer. Scores were tabulated and users won or lost with all the hoopla of syndicated prime time television.

Because of the extensive production values of this kind of game, the need for vast question databases was reduced. Questions could focus on very specific topics and really target their audiences. Moreover, the production of a game show, although it may require an expensive set, was not really all that costly since the games could be produced in large numbers by shooting several in a day. This low-cost product was possible because of the real-time nature of the game play.

Of course, these interactive TV game formats tested extremely well with pilot audiences. But then those games were designed for interactive TV, and because the interactive TV pilots were short-lived, there is no telling how well those game would have done with real audiences over time. The main point is that interactive TV game show designs, adapted to CD-ROM, DVD, or even on-line services (with only a little more capability than is available on-line today), could produce very entertaining and rewarding experiences for on-line users and for the people who develop them. Figure 19.2 shows the flow and organization of such a high production value TV-style interactive game show.

Now, because everything needed to produce a great interactive TV game show already exists in CD-ROM, it should come as no surprise that it was in that complex marketing arena that one of the first, true masterpieces of interactive design was created.

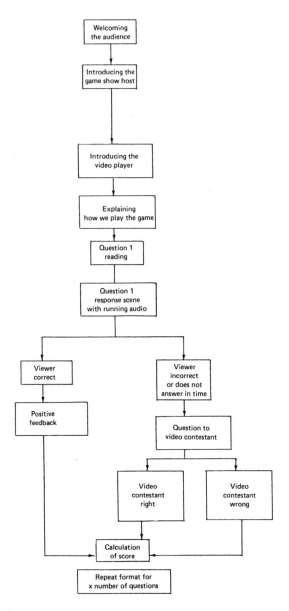

Figure 19.2 Flow of a TV-Style Game Show

YOU DON'T KNOW JACK

You Don't Know Jack, the highly successful CD-ROM-based interactive game, is a perfect example of taking a basic design structure, stripping it down to its essentials, and then rebuilding it with a very fresh and very creative point of view. All

the hoopla called for in our flowchart is there, but the expensive set and the living breathing faces of TV cast and crew are replaced with voices and sounds. So we *hear* the director, the assistant director, the floor manager, and all the various participants in the production of a live TV show talking to each other and to us as they prep for the production. They are kibitzing as only media production people can.

This cacophony of voices provides the background for the opening of the game. But mingled in among the noise are real questions being asked: "Give us your name" "Do you want to play a 7-question game or a 21-question game?" "How many players are there?"

The graphics that accompany these disembodied voices are bright, colorful, animated text and numbers. They dance, they sparkle, and they pretty much entertain without the need for what would actually be the more mundane presence of a physical being. We are getting plenty of personality from the voices on the screen, why see faces? There is music, too, and singing. It introduces each question category and moves the game along. Figure 19.3 shows one question screen from *You Don't Know Jack*.

The questions are the standard stuff of game shows, largely multiple-choice, but there are also very clever matching exercises and very difficult and very

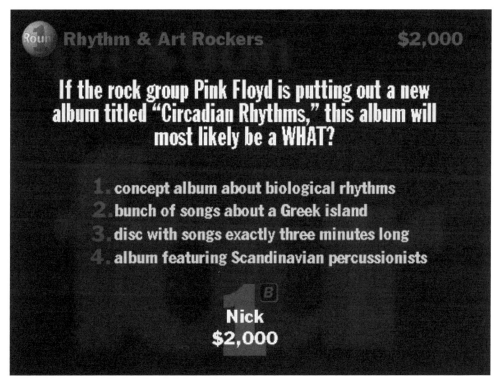

Figure 19.3 Sample Screen from *You Don't Know Jack*. © Berkeley Systems, Inc.

clever rhyming fill-in-the-blanks sets of questions. It is the writing of the questions, more than anything else, that makes this game so brilliant. Typical topics to choose from include "That's Pretty Big, Mac," "Charlie's Angels in Hell," and "Projectile Cometh." Yes, they are irreverent and brilliant!

Players pick their topic, and then they choose the right answer using one or two keys on their computer keyboard. As noted, this is a multiplayer game, so you and your partner sit side by side and "duke it out" using single key strokes to identify yourself and select your answers.

The system evaluates your answer and sets your score. You get a witty and not very polite critique from the game show host when you are done. Then you get a chance to play again . . . and again . . . and again. Like all great interactive games, it is addictive.

Whenever we talk about interactive media the concept of game shows invariably comes up. That, quite simply, is because games are so intrinsically interactive. People tend to interact with the games even if the game show format that they are watching doesn't allow interactivity.

Game shows are also a form of popular entertainment. As such, they come and go. Game shows are fairly popular these days. They were far less popular a few years ago and were extremely popular two decades ago. To some degree, they are fads.

That statement is made as a precautionary measure so that no one goes out and necessarily bets the bank on a great interactive game show concept. It may turn out to be as successful as *You Don't Know Jack*, or it may just not be the in-thing of the moment.

20

Special Development Tools for Motion and Animation

The previous chapters have stressed the advantages of motion and animation in interactive multimedia, especially on the Internet. A raft of new software is becoming available to make these features easy to execute. Certainly that software will continue to evolve and change over the next few years. Some of the leading software that is available today will may not even be available a few months from now. Still it is probably worth the effort at this time to try and offer a snapshot of the leading software that is available at this time. Even though some of it is sure to become dated, much of it will not. The technologies that you can use to create animation and applets for the Web include GIF animation, QuickTime Movies, Java, and various plug-in-based technologies.

Plug-ins normally have to be downloaded and installed in browsers, a laborious process that slows down the flow of the entertainment and that may not even work without several tries. A built-in plug-in that is part of the browser package is infinitely more desirable for users, developers, and inventors. Those that achieve that status will be around for a long time to come; those that do not may disappear. With all that volatility on the plug-in side of the house, let's begin this review by considering those animation tools that do not need plug-ins.

GIF ANIMATION

GIF animation is easy to create and build into any HTML document. It is also extremely easy for web users to access. Regardless of their browser, the animations appear without fail. The only limitation of GIF animations is that they do not contain interactivity or sound. But if you need to add small animated elements to any kind of Web page, animated GIFs are ideal.

Animated GIFs are made of multiple images that are stored inside a single GIF document. When played back, the images appear in the Web page in rapid

succession, creating the effect of motion. GIF animations can also loop, jumping back to the beginning, starting over again, and continuing the loop infinitely. Animated GIFs can be created with the freeware GifBuilder, which is available on the World Wide Web.

QUICKTIME: MOVIES ON THE WEB

QuickTime Movies offer traditional video complete with motion and sound. More than that, in the QuickTime file format, movies are transformed into digital data and compressed into separate documents. From the start QuickTime fought a battle with computer memory and processing speed, trading computer speed and memory size for image size and frame rate (5 to 10 or 15 frames per second, not 30, as in normal video). Today QuickTime is a very robust system with good-quality movies of relatively small size. The only real drawback is that users can't interact with the images other than in standard VCR ways (pause, scan back, scan forward, etc.).

QuickTime Movies can be downloaded and played as a separate application or with the QuickTime Fast Start Plug-In, which plays them immediately as streaming video. But there is that plug-in and its related problems.

PLUG-INS

Plug-ins are proprietary software formats that must be installed separately by the end user. Because the user usually does not find out about the required installation until the moment he or she wants to use the plug-in, the process interrupts the experience. Moreover, some older browsers may not be able to work with the plug-in after all is said and done. The whole thing can be a totally frustrating experience for the user. But, as new versions of the major browsers begin to include plug-ins as part of their package, plug-ins will be preinstalled and the situation will become simpler. Here are a few of the notable plug-in animation applications.

mBED

mBED Software's authoring solution provides an open file format like HTML that can describe interactivity, with streaming, caching, easy authoring, and a small runtime that support Web standard formats such as GIF and JPEG. The mBED Solution includes (1) the mBED language and file format; (2) the mBED runtime; and (3) the mBED Interactor.

The mBED language and text-based file format enable interactive features such as clickable buttons, slider controls, scriptable RealAudio playback, ani-

mated graphics, and much more. The mBED runtime extends the capabilities of popular Web browsing applications and is implemented as both an ActiveX control and Navigator plug-in.

mBED Interactor is an easy-to-learn application for designers and developers looking to build interactivity, sound, and animation into their Web sites. In addition to traditional "author and ship" multimedia, mBED's text file format and database posting allow custom multimedia applets with up-to-date information. The runtime and mBED language are freely licensed without restriction. mBED Interactor is now being sold commercially.

ShockWave

Developed by MacroMedia, ShockWave is a method for putting Macromedia Director documents on the Internet. As such, it is capable of creating motion sequences or movies for Web sites, but, it can also create extremely sophisticated interactive applets.

Lingo, Macromedia's scripting language, allows developers to create interactive presentations with motion, streaming sounds, and advanced branching. Lingo does have a steep learning curve, but its capabilities are profound. One drawback is that ShockWave files are not very compact, making download time and memory requirements something of an issue.

Macromedia Flash

Macromedia's Flash technology provides fast, scalable vector-based (solid-color) animation. Flash features a powerful Creation Interface that has a variety of special controls that allow developers to create extremely high-quality animation. The creation tool also allows developers to work with multiple layers of artwork. It can create interactive buttons with rollover effects without special programming. A "Save As" function allows files to be saved as GIF or Picts or in the proprietary .spl format.

JAVA

Developed at Sun MicroSystems, Java was originally an attempt at creating an alternative authoring language. However, it became a way to build small Web applications (applets) that are compact and totally platform-independent. Both Netscape Navigator and Microsoft Internet Explorer support Java without the need for plug-ins. So Java can be used anywhere and everywhere.

The issue with Java is that it is a major programming language and requires high-level programming skills. To achieve quality interactive programs with Java you need to dedicate quite a bit of time to your own skill building or to find a developer who has interactive programming skills that are up to the challenge.

Fortunately there are several programs whose excellent drag-and-drop graphical user interfaces allow you to create Java applets with a minimum of programming. These include Liquid Motion, WebBurst, and ActionLine.

THE NEXT GENERATION: 3D WEB SITE DESIGN

Moving beyond the simple 2-D plains that bound most Web sites is the world of three-dimensional images as displayed in animated films and most obvious in computer-generated movies such as *Toy Story*.

As April Streeter pointed out:

> The current language for creating 3-D on the web is VRML (Virtual Reality Modeling Language). VRML is the 3-D equivalent of HTML in that it provides a common language for creating three dimensional web pages and implements a standard graphics interchange format for displaying those environments. Web-surfers with a VRML-enabled browser can enter interactive 3-D worlds and move around within those spaces playing games and exploring.[*]

As of this writing the strong, highly visible adaptation of VRML to a Web site has yet to happen. After more than a year of hype many people are starting to wonder whether VRML can measure up to its promises. By the time you are reading this book, that question may have been answered.

One of the most sophisticated simulations of virtual reality I have seen can be found on the *Star Trek: Continuum* Web site on the Microsoft Network. There, all the top level menus offer a viewer through which you can have a 360° view of the virtual location. Look out across the lobby of StarFleet Academy, turn to the left or right, or completely around.

In the "behind the scenes" area you get a 360° look at the Paramount lot with the Starship Enterprise lurking near the sound stages. Turn and look all around the lot.

The imagery for these *Star Trek* views was rendered for Paramount Digital Entertainment by Digital Network Access (dna) of Hollywood using surround video technology from Black Diamond which is very much like QuickTime VR.

After this brief look at the software that is currently available for adding motion and animation to Web products, we now move on to our last set of digital media applications and their designs.

[*] April Streeter, "VRML Paving the Way for 3-D Web Designers," *MacWeek*, December 16, 1996.

V

Other Interactive Applications

21

Corporate and Informational Web Sites

Corporate and informational applications are still growing in popularity on the World Wide Web. Therefore, although many digital media serve as sources for this kind of information, it seems like a good idea to focus this chapter on the Internet and generalize from that point.

Let's start by making one critical distinction. Corporate and informational sites are not the same as point-of-sale sites in that they are intended to disseminate information, not *sell* products directly. Even when there is a sales area within an information site, the basic design of the site remains fundamentally different from that for sales sites.

The structure of an interactive sales situation can be thought of as an inverted pyramid in which all interactions funnel the viewer to a single action—a purchase. By contrast, the interactive information dissemination structure can be considered as a series of opening doorways that lead to more doorways. In such a structure, viewers' options expand and movement through the material becomes more and more flexible. Figure 21.1 illustrates the difference between information and point-of-sale structures.

Even though the structures of informational and point-of-sale programs are exact opposites, the two applications share similar requirements. In both cases, for example, the architecture should be easy to use and not get in the way of the user's ability to find information or complete transactions.

CONTENT SELECTION

In previous chapters we noted that, because of the nature of the medium, the content makeup of many Web sites is the same. We moved from promotional movie sites to entertainment sites and found that we were identifying a set of areas that can or should appear in almost all sites. The areas we identified were:

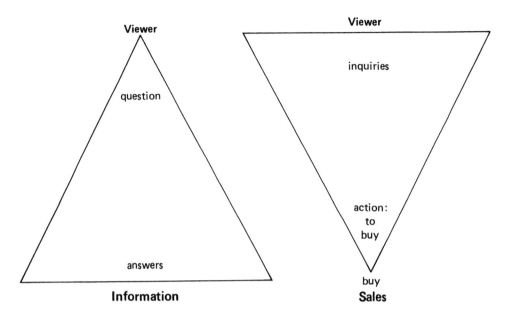

Figure 21.1 Information and Point-of-Sale Structures

- Promotional materials
- Archives
- Related content and links
- Communication
- The Adventure!
- Merchandising

How could that structure possibly relate to corporate sites, you ask? Here is that list again with an expansion of the categories based on corporate content. See how well they hold up?

- *Promo materials* (your basic package of product and corporate content)
 All about your company
 Your corporate philosophy and point of view
 All about your products (what they are)
 Tools that help customers select the specific model of product that is right for them
 How to use your products
 Video of ads for your products
 Anything else you can think of to help your customers understand the value of your products
 A complete product catalog

- *Archives* (putting all your past customer publications on-line)
 Any series of useful booklets you have sponsored relating to your products or their functions
 Training materials
 Decision tables and matrices
 CD-ROM content modified for the Internet
 A collection of past features from this site

- *Related content and links* (information and materials appropriate to your target audience, although it does not directly promote your product line)
 Anything that ties your world to theirs
 Information about the general category of content that your product relates to
 Anything interesting or entertaining to your users as a unique demographic group
 Tools that will help them do their job
 Articles or presentations about the contribution of members of their demographic group to the arts
 Travel and leisure topics of interest to them
 Links to related sites

- *Communication* (ways to build a direct link between you and your customers)
 Mechanisms for customers to send you messages
 Answers from the experts on your staff
 Bulletin boards where customers can post
 Opinions on any subject to gain a sense of community
 Opinion surveys about your products
 Questionnaires to help you both gather demographic data on your customers and generate mailing lists

- *The Adventure!*
 Active user involvement with your content
 An on-line version of your service
 Attention-grabbing games and activities designed to bring traffic to your site

- *Merchandising*
 Selling your product
 Offering coupons
 Other activities to promote the product
 Simple contests

I recently worked on creating a corporate Web site for Bristol-Myers Squibb. The site was designed to offer information to women as a group and to feature those areas at which Bristol-Myers Squibb excelled at providing care for women. In the depths of the site, the various brands of products (Excedrin, Clairol) gave details about dealing with headache pain or choosing a hair color. Let me just map part of that site against our newly redefined set of categories.

- *Promo material.* Product directory, *About Bristol-Myers Squibb*

- *Archives.* *Momness* and all the existing great publications on motherhood, headache management publications, skin care materials.

- *Related content and links.* Articles on fashion, style, glamor in general
Articles for women on how to use technology
Homemaking tips—a stain removal guide

- *Communication.* Exit poll upon leaving the site
Ask the headache specialist, ask Clairol

- *The Adventure!* Highly interactive product guides, games built into the site to draw traffic

- *Merchandising.* Gift certificates, giveaways

An important point about The Adventure! is that I have used the term to designate the most interactive features of the site. So, for those sites which actually provide a service on-line . . . *that is* the adventure. Consider on-line banking which gives you instant access to account activity (with my spending habits, it is indeed an adventure). Negotiating a deal on a car or learning how to negotiate a deal on a car is an adventure as well. Sure, it has all the downside of an adventure (danger, risk, loss of fortune, and self-respect), but at its heart there still lies an adventure.

DATABASE-DRIVEN CONTENT AREAS

One interesting set of corporate or informational sites are those that offer so great an assortment of information that they require databases to archive and deliver the content. Anytime you are talking about hundreds or thousands of products, you are talking databases. Consider, for example, a project to present all the titles offered by a home video service. To design such a system, it would be necessary to digitize and store descriptions of all the titles, digital images of the boxes, clips of scenes from the movies, quotes from the best scenes, as well as summary data about each video (cast, director, running time, rating, color, closed captioning, even genre).

Templates would have to be built to structure the data and offer a consistent way to present it. In the same way the images, too, would have to be accessed and displayed in a consistent way. Databases are the best way to put a site such as this one together. When constant updating and a variety of ways to access the data are added to the equation, databases become the *only* way to do it.

Having considered a way of selecting and organizing a great variety of content for corporate and informational sites, let's spend a moment considering how to get people to come into the site to begin with.

THE HOME SCREEN AS AN ATTRACT MODE

In a free-standing interactive information kiosk, the attract mode is a video segment designed to get the attention of passers-by. It invites them to come up to the information center and explains a little about how the system works. If you think about it, that is exactly the purpose of the home page of a Web site: to invite users into the site, attract them to explore further, while giving them enough information to see that they navigate the site correctly.

When you think of the home page of an information site as an attract mode, the idea of a static page that consists largely of a solid block of text with little more than a text headline across the top seems quite out of place. The purpose of a Web site home page is to get people into the spirit of the site immediately and then to get people to dig deeper. To that end, bright illustrations, streaming audio, and animated GIFs are all appropriate and necessary.

Figure 21.2 pictures the home page of the Bristol-Myers Squibb site, *Women's Link*. On the home page we featured a metaphor about a women's club and pictured a bright lobby whose rooms represented the various departments of the site. This top line metaphor was our way of getting women to get in the spirit of the site and then to dig deeper.

In a similar Web site about home video, it might be best to feature the newest products available on the site as this is what nine out of ten people want to know when they enter a video store. What's new and what's coming? Allowing the home video site to answer that question directly is just a good solid design strategy. Building a framework around the product information would also enhance attendance at the site.

One of the latest strategies in the home video cyberwars is to position a game about the hottest title right at the very top of the site. When people see the ads for the game, they go to the site, they play the game, and then they go on and visit the other areas of the site exploring and, one hopes, deciding to rent other home videos. The game becomes a traffic builder for the whole Web site experience.

In information kiosk systems, attract modes catch people's attention by featuring cycles of images that represent various categories within the system. That, of course, is easy to present on a videodisc-based kiosk information system, but with a little creative design work, the same principle can also be built into a Web

Welcome to Women's Link! Inside Bristol-Myers Squibb's cyberclub for women you'll find information on personal care, health, beauty, nutrition and motherhood designed to help you be your best. We've got experts and enthusiasts, tips and tactics, and places for personal expression.

Figure 21.2 The Home Page from the *Women's Link* Site. © 1997 Bristol-Myers Squibb.

site. After all, most of the raw material for its construction already are imbedded in the site. It is only a matter of finding the best images on the site and bringing them to the top, then finding some software with which to present them. Animated GIFs work great for this purpose. They can turn your home page into a slide show. Add streaming audio, and you have a complete multimedia package. You will, of course, have to provide a *graphics lite version* for your less fortunate users who are stuck with low-speed computers and modems, but they know their plight and they have long since resigned themselves to trading slow modems and computers for low monthly credit card payments.

Again, if you are building a free-standing information center you have to have an attract mode or passers-by just won't stop. If you are running a Web site, users are surfing through just as fast. If you don't have something to attract them, to capture their attention, they won't stop either. Make your home page an attract mode and see what happens.

MENUS

When designing menus for interactive information systems, special attention should be paid to selecting the categories that the information is divided into. It is

important that the category name match the feeling that the site is trying to convey, and yet be complete enough to tell people what the contents of that category are.

In the *Women's Link* site, such terms as *Momness*, *Beauty Central*, and even the *Health and Fitness Center* were tested and retried before they were finally agreed upon as having the right feel as well as the right content clarity for the site.

In travel information sites, the problem gets more complicated. If the first menu a user encounters features six categories of information and there is a good deal of overlap in those categories, the user may get confused and just give up in frustration. For example, if a user wants information about the local production of the musical *Cats* and encounters a menu that lists "Nightlife," "Things to do," "Places to go," "Entertainment," and "Sports and events," what category should he or she choose to find out about *Cats*? Is that feline opera "Nightlife," "Entertainment," "Events," "Things to do," "Places to go"? The play could fit all the categories on the menu except "Sports." However, if the user looked for the play under "Nightlife" and didn't find it there, he or she might just give up and go somewhere else for information, feeling that this site was incomplete. The problem in travel sites (and those like it) is that there is a temptation to create menus with overlapping categories to facilitate the sale of ad space within more than one category (à la the telephone book). But a Web site's need to sell ad space may lead to clients who choose to be represented in the wrong area. In the end the net effect is that the site seems incomplete and loses customers because of it. Defining categories carefully and correctly and getting the right products into the right categories is paramount to the creation of a successful site.

Let's say I created *The San Francisco City Tourist Information Center*, funded by ad revenue from restaurants and theaters. If I have six nebulous categories I can sell ad space to advertisers in all six different categories. So I get revenues from the Fog City Diner as one of the "Places to Go" and as "Nightlife." Of course, when Joe's Seafood Fiesta wants to buy space only in the "Events" category to promote a special discount day in May, Joe is misleading his customers who won't realize that Joe's is a fine restaurant that is open (without discounts) 365 days a year.

Get the point? Make your menu categories sexy and appropriate to the mood of your site, but also make their content and purpose clear and distinct.

SEARCH CAPABILITIES

Of course, some of the problems of overlapping categories can be overcome by using any one of the numerous search engines that have become so common on the Web. Search functions are second nature to most Web surfers. But for small info sites with lots of "fun" categories and local charm, search functions seem to break the mood and will never be sought out by the infrequent visitors.

Bristol-Myers Squibb's *Women's Link* site did have a search function, and the magnitude of the site dictated it. But it was offered as a subcategory off the home

Figure 21.3 The Search Function from *Women's Link.* © 1997 Bristol-Myers Squibb.

page, not as the primary navigational tool of the site. Figure 21.3 shows the search functionality.

SUBCATEGORY MENUS

Once you get past what is hopefully a transparent main screen with its crystal-clear categories, the users' options can easily expand. The restaurant category could lead to a subcategory menu, but here the plot thickens. While the rule about main menus is to make them as clear and simple as possible, rules about subcategory menus are far more difficult to pin down. You can give the obvious subdivision of the category (restaurant subcategoires could be: French, Italian, Chinese, California Cuisine), or, if there are many different ways to subdivide the category, you can offer the user a choice, such as, "Do you want restaurants classified primarily according to price, location, or type of food?"

Designers must decide whether they want to give users lots of choices at the subcategory level or to simplify things and avoid the confusion that occurs when users are offered too many choices before they get to the information they seek. In designing information programs, our rule of thumb is: Don't offer users more than three choices before they get to the information.

Figure 21.4 shows one path of a flowchart. It represents an information dissemination system about restaurants that begins with a main menu and then leads to a specific "high-priced" restaurant. Notice the number of decision levels that the user has to go through before he or she gets to the actual information module. This may be too many, and it might be better for information organizers to "bite the bullet" and pick one way to organize their information, at least for

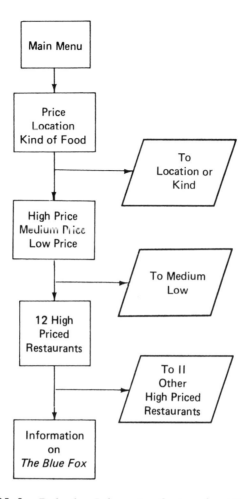

Figure 21.4 Path of an Information System about Restaurants

those users coming at the information from the start of the program. People who have been in the system for a while might be offered more complex menus with more discrete choices through a separate set of branches.

NAVIGATION

For an in-depth discussion of navigation and navigation controls, see Chapter 10 on interface design. The important point here is that navigation controls are essential to *all* sites. In corporate sites it is especially critical that they reflect the character and functionality of the site.

Figure 21.5 shows the navigation controls from the Bristol-Myers Squibb *Women's Link* site. This navigator is positioned at the very top of the page.

Figure 21.5 The Nav Bar for the Momness Area of *Women's Link.* © 1997 Bristol-Myers Squibb.

Content about the page is below it. Notice that the navigation control reflects the spirit of the site. The names of the site areas are condensations of more complete names (e.g., "Express" denotes the "Express Yourself Lounge"). In this case, although you can't see them in the illustration, the more global controls, such as search and return to the home page, are positioned across the bottom of the page rather than at the top.

LINKS TO OTHER SITES

Informational sites are designed to help people get all the information they want any way they want to get it. So, providing lots of links to other sites is an ideal way to support that mission. In corporate sites, offering links out of the site takes people away from your area—and, once they leave, it may be hard to get them back. There are a variety of solutions for the corporate Web developer. You can design navigators that go with your users when they visit other sites so that they have an easy way to get back to your site. A simpler solution is to create "link pages," points at which all the links out of the site are brought together into one spot so that users must get to a single launch point to leave the site rather than being able to jump away from the site from a variety of points. This reduces the chance of people leaving the corporate site before seeing all there is to see and finding out all there is to know about your corporation.

PRINTOUTS

Being able to print out pages of content is a natural and easy function for Web sites to offer. People want to be able to take away some of the information that you have for them. Printing out fact sheets about your company, or price lists, or whatever is a great benefit. Coupon printouts on the other hand, present special problems. Any coupon that can be printed can be duplicated en masse. So, if you are considering printing out coupons as a promotion on your Web site, ask yourself whether the loss of revenue through piracy is worth the promotion. With some services it may be, but in others it could result in a great loss. Coupons will be duplicated if for no other reason than it is extremely easy to do.

Printing out maps is a valuable service that travel sites can offer. In the travel site mentioned earlier, the user could be offered a variety of local maps in greater or lesser detail. A collection of downloadable map graphics is one easy way to provide this service. Taking advantage of propriety software, more sophisticated travel information sites can trace visual paths to and from various destinations. What is the best way to get from your hotel to your favorite restaurant? Print out the map and you'll know.

Corporate sites currently seem to be one of the most successful parts of the Web. For some time they were being created as experiments to see whether people would come and how they would be effected. Today, a more and more global vision is growing, and in that vision the Web itself seems to be turning into an enormous, ever-growing encyclopedia, one that is explored by people whose need for information is often critical. The quality of that entire encyclopedia depends on the quality of the sites that go into it. Many of them are simple homegrown efforts, which is good. But to the extent that major corporations choose to tell their story on the Web, they should do it with all the style and skill that their company deserves. Great corporations can't be represented by halfhearted efforts in an arena that is expanding with such ferocity.

Having discussed the possible architecture and content organization for corporate and informational sites on the Web, let's now move on to those interactive applications dedicated to selling products.

22

Commerce Systems

In Chapter 21 we briefly discussed the distinction between interactive information systems and interactive commerce or sales sites. In that chapter we defined the structure of the information system as a series of ever-opening doors leading the user to more choices and more information. By contrast, the commerce system was described as a series of fewer and fewer choices leading the viewer to a single action . . . a purchase.

Interactive shopping systems can be divided into two major categories: "promo" systems that show off products and offer information but don't take the order, and "buy" systems that actually allow the shoppers to place their order through the computer. However, because "promo" systems also are eventually designed to get users to buy by referring them to a store or a phone line, we will consider all shopping systems here to be "buy" systems.

SALES FLOW

A major concern of professional salespeople who deal with interactive shopping is sales flow. To complete a sale successfully, events must move smoothly from one stage to the next. The smoother the flow, the easier the sale. The worst thing that can happen to a sale is to interrupt the flow. Unfortunately, this occurs quite often with interactive commerce systems because mechanical or technical problems or software difficulties created by faulty logic can easily interrupt the order-taking procedure, resulting in user frustration.

User Frustration

Assume that a shopper knows just what he or she wants to purchase on an interactive commerce system. If that shopper is unable to determine the breath of

products being offered by the system or how to enter order information, there will be an interruption to the sales flow. This can occur at any point during the sale. If the user finds the system too cumbersome or frustrating to use, he or she will most likely just give up. To avoid user frustration, designers of commerce systems must make sure that they take into account the goals of the shopper. They must also be sure that the controls of the system are obvious and easy to understand and that product information is crystal-clear.

KINDS OF INTERACTIVE SHOPPERS

To determine how information should be organized to make it as clear as possible, designers must first take into consideration the different types of on-line shoppers. I like to divide shoppers into four different types: the first-time user, the browser, the person ready to buy, and the inquirer. The needs of each group must be served.

The First-Time User

The first-time user of an on-line commerce system does not usually want to get from the "start" to the "buy decision" as fast as possible. The first-time user wants to begin by learning something about the site or system. This might include a general discussion of the different products available on the system as well as a brief explanation of how the system is run, where goods come from, and how orders are fulfilled. The additional information required by the first-time user distinguishes him or her from the person ready to buy and the browser. Once the first-time user understands how the system works, however, he or she may then become interested in browsing through the products available on the system.

The Browser

The needs of the browser are different from those of the first-time user and the person ready to buy. The browser wants to explore the products by looking at several of them, comparing them, and seeing them in action. The browser is the person to whom most of the space of interactive commerce systems is devoted.

Because the browser does a great deal of bouncing around among products, it is important to remember that the goal of the shopping system is to close the sale. With all the bouncing around, if the sales flow gets interrupted, a potential sale may be lost. This is one good reason why, on Web sites dedicated to sales of

products, links to other sites are very big problems. Even if they are bringing in substantial revenue, links to other sites definitely interrupt the sales flow and are therefore to be avoided. In any event, even though the organization required for the browser is different from that needed by the first-time shopper or the person ready to buy, it, too, must be crystal-clear.

Another important thing to remember about browsers is that they are not buyers when they enter the site. Therefore, it is a good idea to insert some "close-the-sale" activities into the presentation to turn browsers into buyers.

The Person Ready to Buy

The person ready to buy is prepared to make a purchase the moment he or she arrives at the site. For this person, the process of browsing is superfluous and may even get in the way of closing the final sale. What this person needs is a structure that gives immediate access to order entry, a "main line" from the start of the shopping process to the very end.

The Inquirer

The inquirer is someone who needs guidance to decide upon a particular product. He or she does not really want to browse around, but does not know what is available, either. What is needed here is help. The mechanism for that guidance (the way the system helps the user determine what he or she wants) is present in the very best interactive commerce systems and may be nothing more than a series of questions about specific products or even questions about demographic data that zero in on a specific category of items. This technique may seem obvious, but it will increase sales sharply if the information is easy to access and the system easy to use.

RULES FOR CREATING INTERACTIVE COMMERCE SYSTEMS

Now that we have looked at the requirements of a continuous sales flow and the various kinds of shoppers, it may be possible to summarize what we have discussed in a few rules:

1. Make sure that the controls of the interactive commerce system are obvious and easy to understand.
2. Make sure that the organization of the system is crystal-clear.
3. Provide a path by which first-time users can get the background information they need to feel comfortable making a purchase.

4. Allow the browser an easy method to explore, learn about, and look at products in action.
5. Build in a method for closing a sale for browsers who want to do nothing more than "look around."
6. Provide the person ready to buy with a method to get right to the buy decision in the shortest possible number of steps.
7. Offer a method by which the inquirer can be guided to a product by asking a series of questions.
8. Devise an order entry mechanism that will not get in the way of the sales flow.

Controls

Methods for creating navigation bars (menu bars, control strips) have been reviewed in several previous chapters. In many ways the nav bar needed for a interactive shopping system would be similar to that needed for an information system. One or two additional keys might provide all the added control required. Figure 22.1 shows the main controls needed for a shopping system. A "Products" button allow the user to access pages of information about the product. A "Home page" accesses the previous menu, "Order" goes directly to a purchase, and "Newcomers" provides background information.

```
Order | Products | Home Page | New Comers | Contact Us
```

Figure 22.1 Nav Controls Needed for a Shopping System

Organization

The best way to make sure that the organization of the commerce site is crystal-clear is to pay special attention to the structure of the decision points in the site (think of them as a series of menus) and the clarity of the welcome statement that gets everything started.

The Welcome Statement

The welcome statement is a short presentation (in graphics, text, or video) that appears on the home Web page or (in interactive sales systems based on CD-ROMs) when a user begins to use the program. Its purpose is to explain as clearly and directly as possible the goals of the site, how to move through it, who is running the site, and customer benefits.

Figure 22.2 shows the home page from an on-line service called Worldwide Jeans. The home page offers a paragraph that acts as the welcome statement.

Figure 22.2 Sample Home Page for Worldwide Jeans. © 1997 Great Gifts Online.

Menu Construction

In a Web site, each page of a sales area is in fact a menu. In interactive CD-ROM or interactive video sales efforts the menus stand alone as individual screens that must be dealt with. In both cases menu construction is a difficult business. Each menu must contain a clear presentation of all choices plus instruction about any action that must be taken to make the menu work. It is also important that menus be looked at in series so that there is a logical flow from one menu to the next. Sometimes people go from menu to menu to menu.

There should be little or no redundancy in the names of the categories used in the menu because this can lead to confusion. We covered this point ad nauseam in Chapter 21, but the same principle applies to shopping systems. It is critical that in a large shopping system, people know what they are getting within each shopping category.

Moreover, enough instruction should be included in the menu area so that the user will know what the menu is for and how to use it. In interactive video presentations, and even on Web sites where streaming audio is possible, it is usually a good idea to have a narrator describe the use of each menu the first time it is used. After the first set of instructions the system can just eliminate the narration.

PROVIDING A PATH TO THE SALE

The Direct Route

Rules 3 through 7 on our list of rules for creating commerce systems relate to the separate paths that should be created for the four different kinds of shoppers. Because the most important customer is the customer ready to buy, the best place to start is by creating a path by which that customer can get to the buy decision as quickly as possible. Figure 22.3 shows such a path.

In spite of our best intentions, the sales path described in Figure 22.3 requires the customer to complete a sale by clicking on buttons at least four times and advancing through three menus. A faster way to accomplish this may be to place a buy key on the home screen so that the customer can go directly to the order entry frame. A product list at the order entry frame can then clarify the item information as the customer is entering the order. Figure 22.4 shows the location of such a product list or index.

In the organization illustrated by Figure 22.4 the buyer jumps right to the order entry. At this point the buyer is either presented with an index or types in the name of the product that he or she desires to purchase. The selection is then matched to the appropriate product information on the product list. This technique, which is similar to that used by computerized directory services, saves the user time. Note that in the Worldwide Jeans home screen there is a category on

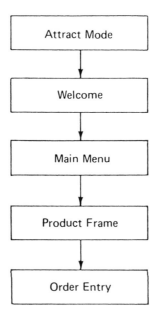

Figure 22.3 Direct Path to the Buy Decision

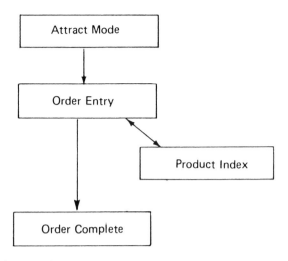

Figure 22.4 Short Path for the Person Ready to Buy

Figure 22.5 Worldwide Jeans Order Entry Frame. © 1997 Great Gifts Online.

the menu bar called "Checkout." That is how purchasers can go right to the order entry frame, as pictured in Figure 22.5.

Each order entry point provides a pull-down menu ("Select your jeans here") that offers a full selection of different styles of jeans. By matching pull-downs of jeans to pull-down menus of color, this innovative site has in fact offered a complete jeans inventory in a few very-easy-to-use sections.

The "Additional Information" Block

Now that we have created the main trunk of the organization tree of our commerce site and satisfied the needs of the customer ready to buy, it is necessary to

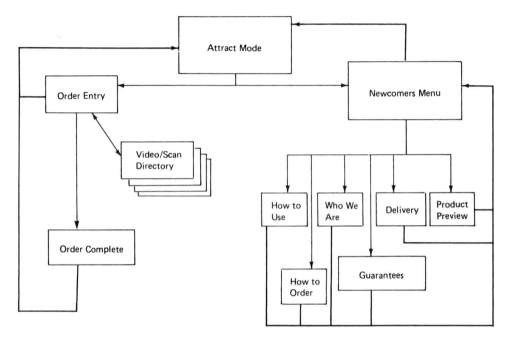

Figure 22.6 Information Module for the First-Time User

deal with the requirements of the other customers—the first-time user, the browser, and the inquirer.

The first-time user should have access to a special block of information that has been placed out of the main informational flow. This special information can be accessed by a button on the navigation bar designated as "Background information" or in the case of our example, "Contact us," which is both a communication tool and an additional information block.

Such a button should accesses a first-time user's menu complete with detailed information explaining the operation of the system, an introduction to the sponsors of the system, an overview of the product selection, an explanation of how orders are processed and products delivered, as well as information concerning special offers and guarantees. Figure 22.6 illustrates the flowchart for this module of the sales system.

The Product Information Module

Our next step is to add the module on product information. This is the material with which the browser spends the most time. Let's consider how the information is organized.

Products should be divided into categories for easiest access. Figure 22.7 shows the on-line College Shop, accessed through the Worldwide Jeans page.

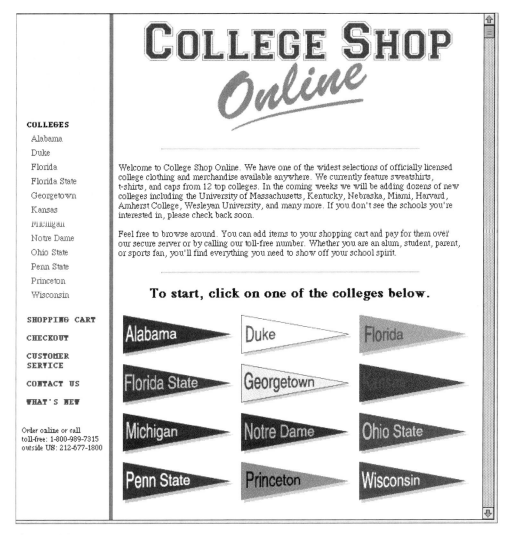

Figure 22.7 Category Screen for the College Shop. © 1997 NetVentures.

This is really the home page for a whole new site, but if Worldwide Jeans were a giant clothing emporium, this would be a category screen within that larger site. From this page we can access information about each school's products. Each product includes a picture, a benefit statements, a list of features, and pricing information. Figure 22.8 shows a product screen.

The whole segment could begin with a brief motion sequence. It is not the case in many commerce Web sites. But, as the technology improves and download times become shorter there will be more motion and animation in these sites. Figure 22.9 shows how such a media-rich product information module could be put together.

Figure 22.8 Product Screen for Sweatshirt. © 1997 NetVentures.

The Shopping Cart Function

Note the indication of the shopping cart in the graphic. Shopping carts have become a very workable metaphor in on-line commerce sites. They provide a virtual space in which users can accumulate items as they move through the Web site. The advantage of accumulating items in a shopping cart is that they can be purchased in a single act. Users don't have to enter order information separately for each item they are buying. Figure 22.10 shows the position of the shopping cart function as well as the position of the product information module (which is encapsulated into a single box) within the entire sales flow, from the welcome frame to the purchase.

The Inquirer Sequence

The material for the inquirer can be treated as a separate block of information. As noted, this block is made up of questions that would allow the user to be directed to the product just right for him or her. The questions could lead into the product information sequence or (less efficiently) to a frame or frames cre-

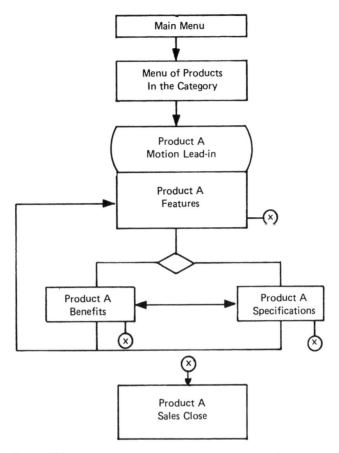

Figure 22.9 Flow in a Product Information Module

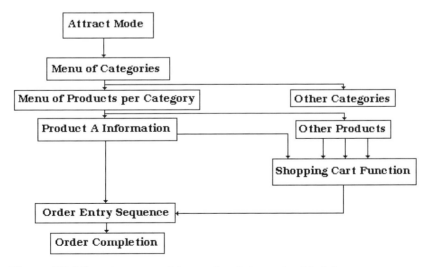

Figure 22.10 Placement of the Product Information Module

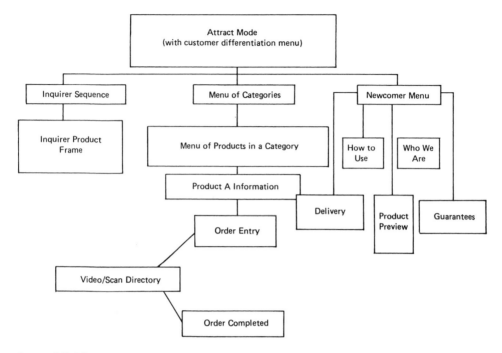

Figure 22.11 Flow Including the Inquirer Sequence

ated just for the "Inquirer sequence." In any case they would fit into the overall flowchart, shown in Figure 22.11. Note that the variety of approaches to the material necessitates the creation of a navigation bar that identifies the customer type from the very start.

Needless to say, keeping clear menus and directions in the face of an organization so complex seems like a difficult task. But the fact is, if the designers traced every path through every possible twist and turn, they could, in fact, come up with an organization that does not get in the way of the sales flow, an organization that is *transparent*.

THE USE OF MOTION AND ANIMATION

We have touched on the placement of motion and audio sequences in a commerce site. Where are the best places to put these elements? There are a few obvious places, as well as a few that are not so obvious.

The obvious places include the "welcome" sequence and several elements within the "newcomers" or first-time users sequence (i.e., who we are, how to use, and product overview). There is also good reason to use motion in brief sequences that show individual products at work. These sequences can range from simple GIF animations to full-blow streaming video segments or downloadable 10-second commercials.

The not so obvious places for video motion or animated sequences in interactive commerce sites are as part of each menu for a group of products. These menus have been called *category menus* because they represent a category of items. In the College Shop example motion sequences could be provided in the area that related to each school. A few bars of the school song would work well. In my case, for example, a few bars of the Notre Dame Victory March would have definitely helped get me to sign up for yet another Notre Dame sweatshirt to add to the hundreds I already own.

ORDER ENTRY SYSTEMS

Order entry systems finalize a sale by getting the customer's name, address, and credit card information into the point-of-sale system. This enables the ordered product to be paid for and delivered to the right place. Currently there is some resistance to entering personal information and credit card numbers into the computer because of concerns about security on the Internet. However many banks and credit card companies are working diligently to perfect a universally secure on-line purchasing system. In the case of Worldwide Jeans, a secured area is offered.

The bottom line is that people are trusting on-line ordering systems more and more. Telephone call-in (calling a number posted on-line) is still a good alternative to direct credit card number entry and offers a solid solution to CD-ROM–based commerce systems. Certainly it should be an alternative offered to all on-line shoppers. Of course, it is only a matter of time before the security problems are overcome but it is true that in the mean time sales over the Internet are being depressed because of the problem.

In this chapter we showed that the ideal interactive commerce system serves four very different kinds of shoppers and provides a flexible design that can accommodate any one of them. The ideal system is also dynamic enough to adapt to the shopper as he or she changes from one kind of shopping pattern to another. We pointed out fundamental rules: the need for crystal-clear organization, the importance of welcome sequences to get the customer started on the right foot, and menus that are complete, clear, and easy to use. We also presented program designs that offer background information, security, and reassurance to the first-time user, an interesting product database for the browser, and an "expert-system-type" question format for the inquirer who needs product recommendations. We also suggested the need for a direct path to the order entry segment for those who are ready to buy.

Currently on-line commerce is one of the most promising of all applications, but one that probably won't reach its full potential until customers feel that systems are more secure and experience shows them that they can be as comfortable with on-line shopping as they are with catalog shopping. Fortunately that may all happen within this next year, in which case on-line shopping is, or so I believe, a natural boom just waiting happen.

23

The Virtual Immersive Experience

What may be most amazing about the vision of the Ray Bradbury's PlayRoom is how well it dramatized the entertainment medium of the future. I feel that he described it as clearly as Jules Verne described the submarine in his book *20,000 Leagues under the Sea*. Yet, as gripping as it was, Bradbury's PlayRoom was never as fully realized as the same concept has become in the films and television programs of recent years.

Virtuosity, the 1996 action film, told of a massive virtual reality (VR) Police Training Simulator whose main feature was a virtual adversary with a personality that was a mix of the greatest villains in history. *Virtuosity*'s forte was to create the perfect character to live within its virtual space. Of course, all hell broke loose when he got out of the simulator.

Mentioned earlier in this book (and more fully developed by far than any other vision of a virtual entertainment center) is the Holodeck. The Holodeck is the virtual playground and learning simulator that exits on most of the starships in the *Star Trek* series. The Holodeck is programmable and creates virtual people and places as specified by its users. The users, of course, are members of the crew of the ship. The technology that produces images within the Holodeck uses a mix of energy and force fields that allow the virtual characters and settings that emerge in the space to take on a look and feel that is very solid and very real.

Crew members can enter the Holodeck for extended periods and have long, complex adventures. Captain Picard and Data, for example, love to participate in Sherlock Holmes mysteries. Captain Janeway enjoys being a Victorian governess. Riker plays a trombone in a jazz band in his own virtual bar. The doctor on *Star Trek Voyager*, a Vulcan himself, simulated the mating rituals of the Vulcans, because, in fact, he was the only Vulcan on the ship. Warf keeps his skills sharp with Klingon combat training exercises that he programmed into the Holodeck.

The Holodeck requires a great deal of energy to operate, but somehow its power source is totally separate from the main energy driving the starships. So, even when there are problems with the fuel supply of the ships, the Holodecks keep chugging away.

No one knows the programming language of the Holodeck or much about its human interface. But, somehow, most crew members can enter their specifications and create the experience of their choosing. Of course, true to the principles of consequence remediation discussed in this book, choosing a scenario does not guarantee the outcome that you are hoping for. This is especially clear in those episodes in which the characters within the Holodeck become self-aware, escape their confines, and try to carry out their existence in the real world.

Through story devices such as the PlayRoom, the Police Training Simulator of the Future, and the Holodeck, it is becoming clear that virtual immersive experiences are the full realization of interactive entertainment. So, many of our greatest entertainment visionaries and storytellers are calling for it and expecting it.

If that is the case, why aren't the underpinnings of the virtual experience being put in place today? Why aren't our media conglomerates "laying pipe" for the emergence of this newest and most mesmerizing of all entertainment media? The answer is easy . . . they are.

CD-ROM AND DIGITAL VIDEO DISCS

As noted, on the Internet, QuickTime VR offers the ability at least to take a look around at 360° views of any item or place you want to get to know. So, now when you visit the Montreal site, for example, each of its streets has been laid out and developed for your virtual visit.

VRML (the authoring language discussed in Chapter 20) promises to go even further in turning the Internet into a three-dimensional space in which people can explore whole new places on-line. Even without virtual reality built into the Internet, the medium stands ready to deliver streams of updated information that infinitely deep and easily accessible.

At the same time, following the principles we have talked about in previous chapters, sophisticated CD-ROM games continue to refine the possibilities of branched story telling with multiple outcomes and consequence remediation. Digital video disc, the next latest and best incarnation of CD data delivery now offers the high resolution of Hollywood's master tapes, super hi-fi sound, and the storage capacity of 4.7 gigabytes (seven times that of a CD-ROM). The delivery of CD-ROM content devices and story formulae through the added power of DVD technology will offer richer storytelling environments on our computer and television screens.

The Daedalus Encounter is an interactive, interplanetary adventure from Mechadeus Studios in San Francisco. Originally a CD-ROM game, it has now been rereleased on DVD. The story is simple: You are part of the crew of a spacecraft on its first salvage mission. As you exit hyperspace you collide violently with an immense alien ship on a journey of its own. After the catastrophe, you and the rest of your crew find yourselves trapped inside the monstrous vessel. You have to save your cohorts from solar cremation by exploring and somehow taking control of the ship before time runs out.

The Daedalus Encounter features 3D graphics, a Hollywood cast including Tia Carrere (of *Wayne's World*), and the latest advancements in multimedia technology (more highly integrated video and CD-quality sound). Moreover, DVD's increased storage capacity and rapid transfer rates eliminate interruptions for load times and generally smooths out the entire experience. Figure 23.1 shows a promotional image from *The Deadalus Encounter*.

Figure 23.1 Promo Image from *The Daedalus Encounter.* Used by permission of Mondo Media, Inc.

So, the underpinnings of immersive experiences are already being worked out. And the principles that have been evolving for on-line learning and entertainment and CD-ROM/DVD hopefully have been documented in this book.

At the same time, stories are getting stronger, and the balance between game play and story development is being refined. The critical issue of the proper mix of game play, branching stories, and guided discovery is working itself out through the plot lines of the hundreds of interactive stories that are being created each year. I hope that we have covered those principles adequately in the previous chapters.

So too the question "How much branching?" is finally being understood and answered.

As we have tried to point out, the right answer is not branching into infinity, but, rather, more realistically, into limited paths that cross, dovetail, and recross. So, the ongoing evolution of entertainment Web sites and CD-ROM/DVD action and adventure games and stories is well on its way to providing much of the content design answers that will lead to truly immersive media.

VIRTUAL REALITY CENTERS

Away from the computer screen, virtual reality games that require players to wear headgear, stand in physical space, and move about in the virtual environment are becoming more and more popular. Times Square's XXS, The ESPN Sports Club at Walt Disney World, and the Monte Carlo Resort in Las Vegas all offer a VR experience that is fully interactive and immersive, and require a complex mix of skill and spirit. It's called *MagBall,* and was designed by Greystone Technologies. *MagBall* is a fast-paced VR team sport that demands physical coordination, tactical decision-making, and cooperation between players.

The game offers action and competition without violence. Players control magnetically levitated MagPods within an arena that looks something like a hockey rink. The objective is to maneuver within range of the MagBall, magnetically attract it with your pod, and then shoot the MagBall into the proper goal.

The game allows sophisticated control of turning, advance, retreat, and sideslip, as well as realistic motion of the MagBall throughout the arena. Multiple game configurations are available and a camera view allows observers to enjoy the action. The simulated crowd responds to the game action interactively, and the entire experience is completed with fully digital stereo sound effects. Figure 23.2 shows two sample images from the *MagBall* Web site.

What VR games are contributing to the emergence of the totally immersive interactive experience is a grounding in movement within the virtual space, movement that is not based on the click of a mouse or the twist of a trackball but by your own actual physical movement. It's the topology and mechanics of how VR works away from the computer screen and its keyboard. And it is happening. What's next?

Figure 23.2 Images from the *MagBall* Web Site. Image of MagBall® supplied by Greystone Technology, Inc. © 1997. All Rights Reserved.

SITECAMS, VIDEO WALLS, AND HIGH-DEFINITION TV

Here's a quote from the March 1997 issue of *Wired* magazine:

> You are sitting in your study answering e-mail from the office when you notice something happening on the walls. Ordinarily, the large expanse in front of you features a montage generated by sci-viz a global news feed of scientific

discoveries plus classic movie scenes and 30-second comedy routines. You picked up the service because it doesn't show any of the usual disaster crap, yet the content is very lively, a sort of huge screen saver.

Imagine that the wall of your den or media room is a giant-screen TV that, when it is not showing ordinary TV programming is featuring some animated graphic of flying toasters and the like (*After Dark*), or scrolls of news, weather, sports, and other info (*Point Cast*), or moving images live from your favorite place in the world (sitecams). Figure 23.3 shows an mythical sitecam image from the kind of mountain location that I would like to tap into.

We have discussed how the wall-size TV screen is emerging through efforts that range from industrial media walls and jumbo trons to projection TV and the eventual emergence of high-definition TV (HDTV). Feed in realistic images; mix together live data and image feeds via the broad-band Internet with finely crafted locally stored imagery from DVD; add the interactive story designs and principles that have been evolving since the mid-1980s; and you have the groundwork for totally immersive interactive experiences. As usual, the technology is way ahead of the art form, but at last the art is starting to catch up, and by the time DVD, broad-band Internet connections, and giant-size TVs are in enough homes to make it economically viable to do so, there will be enough *Mysts*, *Dooms*, *Daedaluses*, *9s*, and other media models to show us what to do.

Figure 23.3 A Hypothetical Image from a Sitecam in the Sierra

AND DON'T FORGET THE MILITARY

For decades, the U.S. military has been using simulators to train their troops. As the quality of simulation technology got stronger and stronger, the demands of the militray rose with them. Where are they now? To quote an article in the April 1997 issue of *Wired* Magazine:

> By 1990 the [BBN]* team had turned over 238 network simulators to the U.S. Army. Meanwhile the salability of the architecture allowed combat training exercises to grow from dozens to hundreds of players and incorporated a growing number of vehicle types. Today a large distributed interactive simulation or DIS exercise might have 1,000 humans (the system could support 10,000 human players just as easily) and 9,000 software robots, representing the interactions of jets, tanks, ships, satellites, armored personnel carriers, and helicopters. By the end of the decade [the Army] hopes to be running exercises with 100,000 participants that will include smoke weather, and a variety of microterrains (forest, swamp, dessert etc.).

As they have in the creation of so much digital media technology, the Army, Navy, and Air Force, with their massive training needs, are paving the way for the creation of media types that will have a profound impact on consumer products.

BUT DO CONSUMERS REALLY WANT THEM?

A funny thing has happened to media in the last couple of years. People stopped not wanting interactive video and laser discs and other forms of new media and instead began demanding new media. They demanded CD audio and were willing to accept it so completely that within 2 years the LP record was obsolete. People convinced themselves that they wanted the information superhighway, and when interactive television (which they thought would be the information superhighway) didn't happen, they found the Internet, and they demanded it so forcefully that Internet service providers, and Net browsers, and Web development companies, and even phone companies sprang to attention to answer their demand.

Now PUSH technology, which *comes at you* rather than *waiting for you* to find it, is starting to work its way through the browsers and the screen savers, and, because it offers an economic model for new media success, it is being pushed as hard by advertisers and media companies as by technology manufacturers. That is a pretty strong impetus!

The immersive experience, the ultimate interactive technology, do people really want it? Can it be as addictive as video games or network television? Two-

* Bolt, Beranek, and Newman, winners of the 1983 contract to build a new generation of simulators for the Army.

thousand-pound gorilla, HBO late night personality, and political commentator Dennis Miller, while generally negative on the whole idea of new technology, described the immersive experience and its addictive properties very well in his best selling book *The Rants*[*] I paraphrase for obvious reasons:

> "Listen, the day when an unemployed iron worker can lock himself in his TV room with a Fosters, his channel flicker, and a virtual Caludia Schiffer it will make crack look like Sanka, All right?"

I don't always have the energy to fight off aliens, solve the "Murders in the Rue Morgue," save the world, or rescue the damsel in distress (even if she is Claudia Schiffer). I sometimes don't even have the energy to have the damsel rescue me when *I* am in distress (even if she is Claudia Schiffer).

But I have a feeling that I will gladly come home any night of the week and step out into a meadow beside a lake in the High Sierra and watch the sunset reflected off the mountain peaks. I'd gladly sit around a campfire any night of the week and talk to virtual and real friends about things friends talk about. I'd rather hike to mountain passes and if I get my daily exercise doing it, that's all the better.

Sure, I'll have a little TV set going by the campfire so I can grab my weekly dose of *Seinfeld* or *The Dick Van Dyke Show* on Nick at Nite. And if, in the middle of that half hour, I happen to hit that great episode in which Rob Petrie turns to his wife Laura and asks what "dolce farniente" means I will surely know. According to Laura Petrie in "The Two Faces of Rob" it means how sweet it is to do nothing.

"How sweet it is to do nothing." It's just that, most of the people in the rest of the world would rather be doing nothing by doing something *other* than watching television all night long, but they have few other choices. Perhaps they have *no* other real choices.

Let's give them some real choices. Let's give them a way to do nothing that is more to their choosing and more to their design than simply surfing an all-too-imitative selection of daily TV fare. Let's build them a Holodeck, even in its most rudimentary form . . . one that lets them build their own world in which to do nothing or to do something. That is where all this effort is going anyway, you know. It's just that most people in the media biz don't really realize that yet. Let's build a Holodeck. And eventually, I'll bet it will become so compelling and even so addictive that it just might make today's television look like Sanka. All right?

[*] *The Rants*, Dennis Miller, Doubleday, 1996.

Index

After Dark, 25
America Online, 22
Animation
 3-D, 166
 development tools for, 163–167
 with Flash, 165
 GIF, 163–164
 with JAVA, 165–166
 with mBED, 164–165
 plug-ins, 163, 164–165
 QuickTime, 164
 with ShockWave, 165
 in shopping systems, 192–193
 in Web comics, 152–154
Answer and Compare exercise, 115–116
Apple Human Interface Guidelines, 65–69
Applets
 game, 154–155
 and Java, 165–166
Argon Zark, 149
Artificial intelligence (AI), 34–35
Atkinson, Bill, 79
Audio
 in shopping systems, 192–193
 in Web comics, 154
Authoring tools, 84–86
Avatars, 22, 144

Bandwidth, 15–16
Bookmarks, 66–67
Bradbury, Ray: "PlayRoom," 4–6, 27, 195
Branching
 determining amount of, 198
 in exercises, 98
Bristol-Myers Squibb Web site, 173, 174, 175–176, 177–178
Bulletin boards, online, 17
Buttons, creating, 80–81

Category menus, 193
CD-ROMs, 29–35
 adventure games, 147–149
 games characteristics, 30–34
 as information source, 29–30
 multiplayer games, 34–35
 tools in, 66–67
 virtual reality, 196–198
Celebrity Slugfest, The, 154–155
Chats, online, 17
 and America Online, 22
Check Your Files exercise, 119–120
Clueless Web site, 68, 70
College Shop Web site, 189
Comic strip Web sites, 149–154
 animation in, 152–154
 audio in, 154
Command & Conquer, 32–34
Commerce systems, 181–193
Compression, video, 8–9
 and bandwidth, 15–16
Computers
 digital video on, 8–9
 and ITV, 14–15
 as opponent in games, 34–35
 and roots of interactive digital, 20
 software simulations, 123
Concept statements, 44–45
Concept tests, 126
Congo Web site, 136–140
 story-based activities, 141–143
Consequence remediation exercises, 107–108, 118–119

non sequiturs in, 108
Consistency, in interfaces, 66
Controls
 creating in HyperCard, 80–81
 navigational, 69
 in shopping systems, 184
Copying, and DVDs, 10–11
Corporate/information Web sites, 169–179
 adventure in, 171, 172
 archives in, 171
 attracting visitors to, 173–174
 communication areas in, 171
 content for, 169–172
 database-driven content areas in, 172–173
 links in, 178
 menus in, 174–175, 176–177
 merchandising in, 171
 navigation in, 177–178
 printout capabilities, 179
 promo materials in, 170
 related content/links in, 171
 search capabilities in, 175–176
 structure of, 169, 170
 subcategory menus in, 176–177
Creativity, 135
Criterion-referenced tests, 125
Cyber-Chicken Web site, 152–153

Daedalus Encounter, The, 197
Database usage exercises, 119–120
Decision-making windows, 111
Decision trees, 109. *See also* Spiderwebs
Demos
 costs for, 75
 Gantt code for, 62–63
 vs prototypes/pilots, 74–75
Design documents, 43–51
 concept statement, 44–45
 flowcharts for, 54, 59
 flow of, 44
 formats for, 48–51
 for prototypes, 47–51
 sales presentation, 45–47
Digital technology, 7–11
 in computer video, 8–9
 and laser discs, 3–4
 in television, 7–8
 in video discs, 9–11
Digital video discs (DVDs), 9–11
 recordable, 29
 storage capacity of, 29
 virtual reality, 196–198

Dilbert Zone, 152
Dimension X, 4–6
Director5 Demystified (Roberts), 76–77
Discrimination learning exercises, 97–100, 106, 115–117, 120–121
Discussions, spiderwebs for, 109–111
Drill and practice exercises, 103–104
Driving simulations, 123
Duckman Web site, 153–154

Electronic press kits (EPKs), 135–140
Environment, in games, 31
Exercises, 89. *See also* Interactive instruction
 advanced designs, 109–113
 for consequence remediation, 107–108
 database usage, 119–120
 designing, 97–113
 for discrimination learning, 97–100, 106, 115–117, 120–121
 drill and practice, 103–104
 evaluating construction of, 111–113
 feedback in, 98–99
 Gantt code for, 62–63
 generalization learning, 100–101, 105–106, 116, 117, 119–120
 identification, 116–117
 identification drills, 100–101
 intermediate designs, 105–108
 interruption, 115–116
 and learning problem types, 97–105
 matching, 105–106
 matching type to learning problem, 105
 multiple-choice, 97–98, 101, 107, 118–119
 obvious answers in, 112
 ordering, 117–118
 pathfinding, 120–122
 for psychomotor learning, 103–105, 122–123
 for sequence learning, 102–103, 117–118
 spiderwebs in, 109–111
 visual discrimination, 106

Federal Communications Commission (FCC), 8
Feedback
 common, 98–99
 in exercises, 98–99
 Gantt code for, 62–63
 general vs specific, 118
 individualized, 118
Flowcharts, 53–64
 Gantt code, 62–63

for interactive instruction, 91–96
lesson design, 89–91
levels of, 53–54, 59–61
online, 53
in prototypes, 47
software for, 53, 54
symbols for, 55–58
Functional specifications, 47, 48–51
purpose of, 50
templates for, 50–51
worksheet for, 49–50

Games. *See also* Interactive entertainment
CD-ROM, 30–35
characteristics of best, 31–32
levels of play in, 32
multiplayer, 34–35
pacing in, 33–34
side, 40–41
twitch, 3–4
in Web sites, 138–140
Game shows, 157–162
basics of, 157
ITV, 17
popularity of, 162
TV style, 159–162
Web trivia games, 158–159
Gantt code, 62–63
Gantt, Rodger, 62
Generalization learning exercises, 100–101, 105–106, 116, 117, 119–120
GIF animation, 163–164
Global controls, 69–70
Guided Discovery exercise, 116

High-definition television (HDTV), 8, 199–200
Home pages, 173–174
Hon, David, 116
Hunt and Shoot simulations, 122
HyperCard, 66
creating buttons in, 80–81
drawing tools, 81–82
history of, 79
prototyping with, 79–83
version 3.0, 82–83
video/audio features, 82
working with stacks in, 82
HyperTalk, 83
Hypertext markup language (HTML)
and NetObjects Fusion, 86–87
and PageMill, 85–86

Identification exercises, 100–101, 116–117
Identify the Area exercise, 117
Immersive experiences. *See* Virtual immersive experiences (VIE)
Indian in the Cupboard Web site, 68
Inspiration software, 53, 54
Interactive design, 39–42
design documents, 43–51
lookups, 40
minimalist, 39–41
navigation/page turning, 39–40
side games, 40–41
talkabouts, 41
users in, 41–42
Interactive entertainment
basic structure of, 135–140
comic strip, 149–155
and electronic press kits, 135–140
game shows, 157–162
motion/animation tools for, 163–167
simulations, 143–144
story-based, 141–143
storytelling online, 144–148
user role in, 141
Interactive instruction
basic structure of, 89–96
evaluation of, 131–132
exercise design, 97–113
exercise types, 115–123
flowcharts for, 91–96
introductions in, 92–93
and profits, 132
reviews in, 94–95
tests, 125–132
Interactive television (ITV). *See* Television, interactive
Interactive video, history of, 3–4
Interface
Apple guidelines for, 65–69
consistency in, 66
description, 47
design, 32
human, 65–71
look and feel, 67–68
maximizing media capabilities in, 71
navigation, 69
and sense of experience, 70
stability of, 71
tools in, 66–67
Internet, the, 19–23. *See also* World Wide Web
and CD-ROMs, 29–30

206 Index

creating links on, 84, 137, 171, 178
elements of pages on, 21–22
and growth of interactive digital, 20
as information source, 29–30
multiplayer games on, 34–35
prototyping to, 83–86
on TV, 23
and virtual reality, 22–23
Interruption exercises, 115–116
ITV (interactive television). *See* Television, interactive

Java, 165–166
Jones, Chuck, 41

Laser discs, 3–4
Learning problems, exercises for, 97–105
Lessons, 89. *See also* Interactive instruction
breaks during, 129, 130
design flowcharts, 89–91
Gantt code for, 62–63
order of, 91–92
reviews in, 94–96, 128–129
Lingo control language, 79
Links, 84, 137, 171, 178
Look and feel, 67–68
Lookups, 40

MacroMedia
Director, 76–79
Flash, 165
MagBall, 198–199
Managing Interpersonal Relations, 117
Matching exercises, 117
Mavis Beacon Teaches Typing!, 103–104
mBED, 164–165
Menus
category, 193
in shopping systems, 185
Web site, 174–175, 176–177
Merchandising, 171
Miller, Dennis, 202
Mission: Impossible Web site, 102–103
Motion Picture Experts Group (MPEG) standard, 9
Motion picture industry
and cable TV, 13–14
and ITV, 14–15
origins of, 20
Movies on Demand, 16
Multiple-choice exercises, 97–98, 101, 107, 118–119

Myst, 30–32
pacing in, 33–34

National Lampoon's Blind Date, 99–100
consequence remediation in, 107–108
Navigation, 39–40
bar, 69–70
controls and interface design, 69
in corporate/information sites, 177–178
of Web sites, 177–178
Navigational controls, 69
NetObjects Fusion, 85–86
News, interactive, 16–17
Nick at Nite Trivia game, 158
9, 148
Non sequiturs, 108
NTSC system, 7–8

Order entry, online, 187, 193
Ordering exercises, 117–118

Pacing, 33–34
PageMill, 84–85
Parallel scenarios exercise, 120–121
Pathfinding exercises, 120–121
Pay-per-view, 16
People Skills, 100–101, 102
spiderwebs in, 109–110
tests, 126
Persona chats, 143–144
Peter and the Wolf (Jones), 41
Pilots
costs for, 75
definition of, 47
vs demos/prototypes, 74–75
Playability, 31
"PlayRoom" (Bradbury), 4–6, 27, 195
Plug-ins, 163, 164–165
Point of view
changing in DVD, 10–11
subjective camera, 147
"PONG," 3
Power Point, 45–46
Pretests, 94–95, 130
Previews, lesson, 130
Printouts, Web site, 179
Product information online, 188–190
Prototypes
compared with demos/pilots, 74–75
costs for, 75
definition of, 47
design documents for, 47–51

directly to the Internet, 83–86
functionality in, 47–48
levels of, 76
reasons for, 73–74
tools for creating, 76–83
Psychomotor learning exercises, 103–105, 122–123
PUSH technology, 25–27
 and advertising, 26–27
 and education, 27
 and immersive experiences, 201–202
Put in Order exercise, 117–118

QTML (QuickTime media layer), 83
QuickTime, 9, 22, 164
 media layer (QTML), 83
 VR, 196

Randomized outcomes exercise, 119
Rants, The (Miller), 202
Raunchy Roach Web site, 152
Remedial loops, 118
Replayability, 32
Roberts, Jason, 76–77
Role-play simulations, 143–144

Sales presentation documents, 45–47
Satellite map/travel services, 25
Search capabilities, 175–176
Search engines, 67
Sequence learning exercises, 102–103, 117–118
ShockWave, 79
 animation, 165
Shopping cart function, 190, 191
Shopping systems, interactive, 16, 181–193
 additional information in, 187–188
 buy, 181
 controls in, 184
 inquirer sequence in, 190, 192
 kinds of shoppers in, 182–183
 motion/animation in, 192–193
 order entry in, 187, 193
 organization of, 183–185
 product information in, 188–190
 promo, 181
 rules for creation of, 183–185
 sales flow in, 181–182
 sales paths in, 186–187
 shopping cart function in, 190, 191
 user frustration in, 181–182
Side games, 40–41

Simulations
 computers software, 123
 determining possibilities for, 147
 driving, 123
 hunt and shoot, 122
 military use of, 201
 role-play, 143–144
 story-based, 143
 test, 126–127
Simulation tests, 126–127
Sitecams, 199–200
Site maps. *See also* Flowcharts
 definition of, 53
Software
 for flowcharts, 50, 54
 for prototyping, 76–83
 simulations, 123
 for Web authoring, 84–86
Specs. *See* Functional specifications
Spiderwebs, 109–111
 invisible, 110–111
 parallel scenarios, 120–121
Spot the shoplifter exercise, 116–117
Spot, The, Web site, 144–145
Star Trek
 Continuum Web site, 166
 holodeck, 27, 195–196
StopWhen You See exercise, 116–117
Story-based activities, 141–143
Storytelling, interactive, 11
 adding interactivity, 146–148
 and ITV, 17–18
 online, 144–148
Subjective camera, 147

Talkabouts, 41
Television
 bandwidth issues, 15–16
 digital video on, 7–8
 HDTV, 8
 interactive, 14–18
 interactive trials, 16–18
 Internet on, 23
 network vs cable, 13–14
Tests, 89, 92–93, 125–132. *See also* Interactive instruction
 concept, 126
 criterion-referenced, 125
 evaluation of, 131–132
 fail menus, 127–129
 features of, 125–126
 final, 125, 130–131

Gantt code for, 62–63
pass menus, 129–130
pretest/preview options, 130
scoring, 127, 130–131
simulation, 126–127
styles of, 126–127
unit, 125

Users
considering in interactive design, 41–42, 141
desire of for interactivity, 201–202
frustration in shopping systems, 181–182
increasing participation of, 146–147
and "look and feel," 67–68

Video, digital
advantages of, 10–11
compression, 8–9
shift to from analog, 7–11
storage requirements, 15–16
Video walls, 199–200
VideoWorks. *See* MacroMedia Director
Virtual environments exercises, 122
Virtual immersive experience (VIE), 35, 195–202
Virtual reality
CD-ROM/DVD, 196–198
centers, 198–199
on the Internet, 22–23
Virtual Reality Modeling Language (VRML), 22, 166, 196
Virtuosity, 195

Visual discrimination, 106
Visual QuickStart Guide to PageMill 2, 84–85
VRML (Virtual Reality Modeling Language), 22, 166, 196

Welcome statements, 184–185
Wired Magazine, 199, 201
Women's Link Web site, 173, 174, 175–176, 177–178
Worldwide Jeans Web site, 184–185, 186–187
World Wide Web. *See also* Internet, the
adventure on, 138–140
bookmarks, 66–67
links, 84, 137, 171, 178
prototyping to, 83–86
PUSH technology on, 25–27
shopping systems, 181–193
tools in, 66–67
World Wide Web sites
3-D, 166
archives in, 136–137
comic strip, 149–154
communication areas, 137
corporate/informational, 169–179
electronic press kits, 135–140
game applets in, 154–155
merchandising areas, 137–138
printouts from, 179
selecting categories for, 174–175, 176–177
special content areas, 137
user discussions in, 147

You Don't Know Jack, 160–162